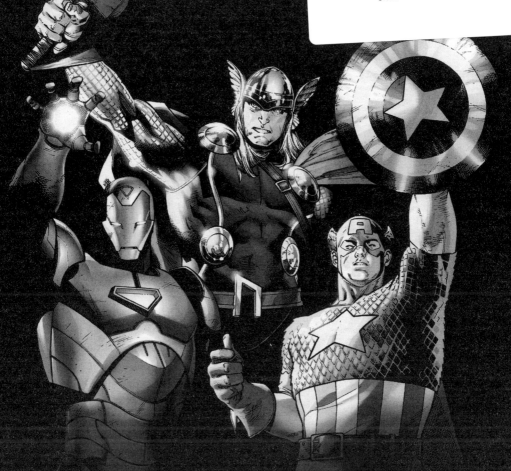

MARVEL

AVENGERS

SCRIPT TO PAGE

MARVEL'S AVENGERS: SCRIPT TO PAGE

Avengers created by Stan Lee and
Jack Kirby

Interviews by Andrew Sumner

MARVEL PUBLISHING

Jeff Youngquist, VP Production &
Special Projects

Brian Overton, Manager, Special Projects

Sarah Singer, Associate Editor,
Special Projects

Sven Larsen, Vice President,
Licensed Publishing

Jeremy West, Manager, Licensed Publishing

David Gabriel, SVP Print, Sales & Marketing

C.B. Cebulski, Editor in Chief

ISBN (print): 9781789095166

ISBN (ebook): 9781803360829

Published by

Titan Books
A division of Titan Publishing Group Ltd
144 Southwark St
London
SE1 0UP

www.titanbooks.com

First edition: December 2022

10 9 8 7 6 5 4 3 2 1

© 2022 MARVEL

To receive advance information, news,
competitions, and exclusive offers online,
please sign up for the Titan newsletter on our
website: **www.titanbooks.com**

Did you enjoy this book? We love to hear
from our readers. Please e-mail us at:
readerfeedback@titanemail.com or write to
Reader Feedback at the above address.

A CIP catalogue record for this title is available
from the British Library.

Printed and bound in the UK.

MARVEL AVENGERS
SCRIPT TO PAGE

SCRIPTS BY

Al Ewing

Jonathan Hickman

Mark Millar

Mark Waid

TITAN BOOKS

CONTENTS

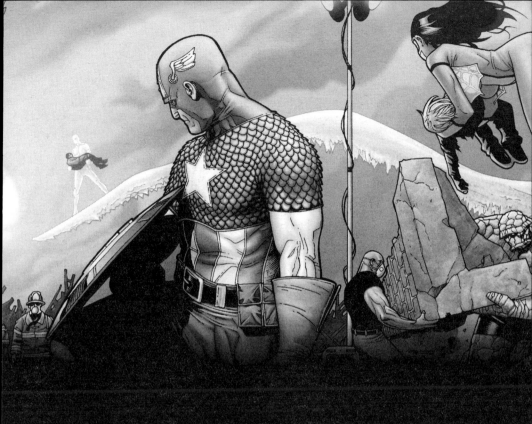

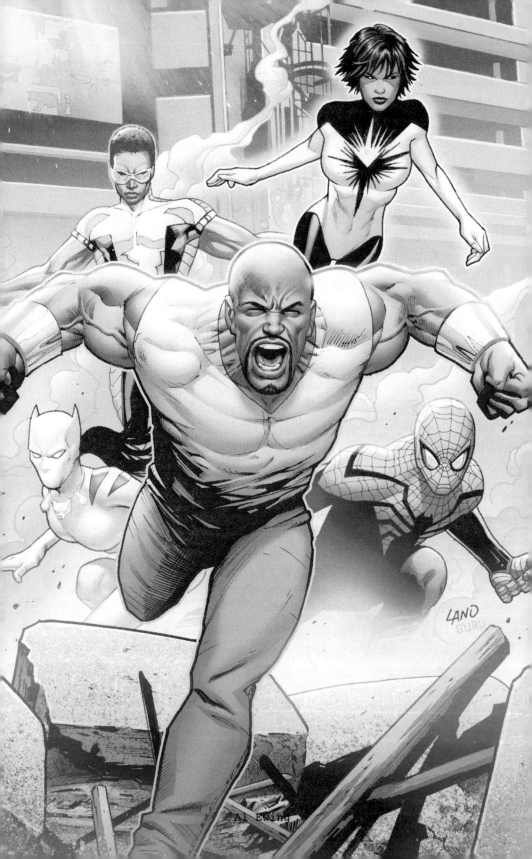

MIGHTY AVENGERS (2013) BY AL EWING

AN INTRODUCTION BY **TOM BREVOORT**
IN CONVERSATION WITH **ANDREW SUMNER**

Mighty Avengers was an Avengers book that was designed to be far more diverse in terms of its cast of characters, and more ground-level in terms of its viewpoint. A typical Avengers book by this point was often far more cosmic in tone, more interplanetary looking. Mighty Avengers, as written by Al Ewing (who is actually well-known for being a great cosmic writer), was specifically designed to take place on the ground, in cities and among people, and was therefore more humanistic in its approach, setting it apart from the other Avengers titles that we were publishing at the time. One of the difficulties with Avengers historically as a property—and this is true of many of the Marvel properties because they all stem from the 1960s—is that when you're talking about the early Avengers lineups, they tend to be very Caucasian; most of the characters that you associate with the early Avengers are white guys. That has everything to do with the fact that the Avengers were created in the early 1960s, when that was the standard approach, and those characters haven't really gone away: Thor, Iron Man, Captain America, The Hulk, Black Widow, Hank Pym, Hawkeye, they all still exist.

This was very much in my head at this time, and I wanted to put together an Avengers book that would be more balanced. The remit I was giving to the creators was that at least 50% of the Mighty Avengers should be characters of color, so that we have a greater diversity of character. I felt there were enough characters in the mix by this time where you could put a team like that together. I was also trying to find an appropriate writer, but the writers I was actively pursuing at the time were in the middle of other projects. In the meantime, Al Ewing had been doing a lot of great work and earning his chops on other things in and around my editorial sphere at Marvel. My associate editor had met him on a trip to the UK, and he'd written a couple of issues of Avengers Assemble for her. I liked Al's work, and I felt like he had the right sort of approach for this book.

So, I went out with this notion that I wanted to do a more inclusive *Avengers* book, a more ground-level *Avengers* book, that we would build around Luke Cage, because Luke had been so central to [long-time Marvel writer] Brian Michael Bendis' *New Avengers*. Al went away and thought about it, and came back with a team that was entirely non-white. We ended up steering into that, because there were plenty of characters of diverse ethnicities that Al loved. He liked Monica Rambeau from when he was reading Avengers stories that Roger Stern wrote in the '80s (Al read them when they were reprinted in the UK in the '90s), he was really interested in Adam Brashear AKA the Blue Marvel, he loved Luke Cage, and so forth. So, we built all of that into *Mighty Avengers* and it worked out well, it had a nice shelf life. I think issue #14 was the last of this iteration before it was retooled and relaunched as *Captain America and the Mighty Avengers*, starring Sam Wilson.

Sam [formerly the Falcon] had become Captain America in the main Cap book—and so, having him here as the leader of this decidedly non-white Avengers team seemed like a good thematic move, so we implemented that change. Our approach on this book, in terms of it being ground level, was to expand on the idea that anybody who exhibited a certain type of heroism and regard for their fellow human beings was worthy of being an Avenger. And the last issues of *Captain America and the Mighty Avengers* were tie-ins to the *Secret Wars* event that's also included in this book, where the world is literally ending. Al's last issue of *Mighty Avengers* was sliced into several different vignettes, focusing on different people having a last moment as the world is about to end, spotlighting

different characters from our cast. And Al wrote the last of these tales in the second person, designed to create a universal feel and effect—the character would be saying, "You rescue this person, and you are having an adventure in this last moment," etc. Al uses these vignettes to explore common ideas (and ideals) of heroism and sacrifice that bind everybody together far more closely than what their background happens to be or where they come from or where they grew up or what their culture is. These ideals are universal. And that central theory defined the attitude of *Mighty Avengers*, it was the core point of view that defined the book from the beginning.

I think Al Ewing is a very clever writer. He's a writer who's steeped in the history of Marvel, steeped in the history of these characters—without his stories being defined by this historical element. His work often turns, quite ingeniously, on a piece of continuity that might have been established by an earlier writer in a story five or ten years ago. But his scripts aren't defined by that ingenious element—you could strip all that stuff away and you still have a working engine underneath that. Al always crafts a story that's got a strong beginning, middle, and end, with a clear point of view and something very specific to say. In that regard, he's the modern-day equivalent of [legendary Marvel writer] Steve Englehart, who would take pieces from Marvel's past and create something new out of them or expand them into a clever new direction. Al's a totally different style of writer to Steve Englehart—but he's got exactly that same sort of Marvel DNA, where he's stacking the blocks of the Marvel Universe to build interesting structures.

MIGHTY AVENGERS
ISSUE #1
2013

"Assemble -- Part One"

By Al Ewing

Art by Greg Land, Jay Leisten,
and Frank D'Armata

Some adjustments made to bring it more into line with *Infinity* #2. Fortunately, this means more action down the line in #2 and #3.

Greg--this is about my third try with the Marvel Method, and I'm trying to give you space to work in without giving you too little. Any questions or problems, feel free to email me any time and I'll get back to you with anything you need. Hope there's some fun stuff in there for you!

PAGE ONE:

Open on a HOLOGRAPHIC EARTH, on board THANOS' ship. At this magnification, we can see a little hologram of the Avengers' spaceship roaring away from the planet. The Earth is without her Avengers.

Pan out. THANOS stares at the holographic model, contemplating strategy. Behind him, PROXIMA MIDNIGHT stands ready, her gold killing-staff in her hand, reporting for orders.

> **THANOS:** Atlantis will not interfere?
>
> **PROXIMA:** They understand their situation.
>
> **THANOS:** Then I have another task for you. New York City--the nexus of this world's plague of superhumanity.

THANOS conjures a holographic image of BLACK MAW, looking suitably evil.

> **THANOS:** Black Maw is already there, whispering his poison. His way is sure... but slow.
>
> **THANOS:** If that which I seek is in their city of marvels... their Manhattan... I would know now.
>
> **THANOS:** Join him there. Help him... search.

PROXIMA smiles. A vicious predator.

> **PROXIMA:** As you command, Lord Thanos. But... a boon?

PROXIMA: May I kill this city?

THANOS reaches out, grinning, dragging his fingertips through the eastern seaboard of the holographic United States, dispersing it in a shower of pixels.

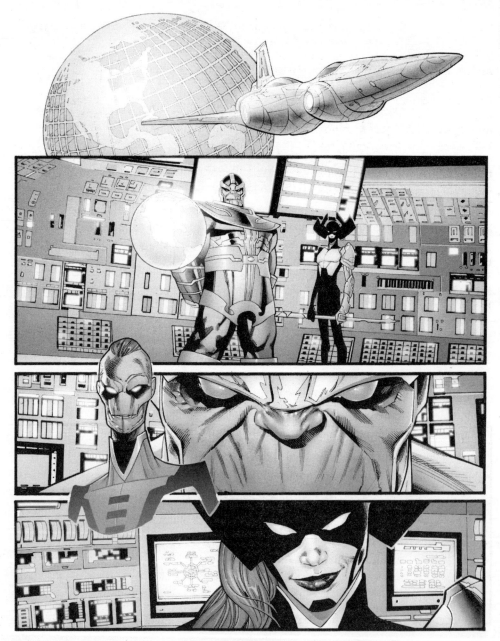

> **THANOS:** Ah, Proxima. My dear Midnight.
>
> **THANOS:** You may kill this planet.

PAGE TWO:

Cut to--the PLUNDERER. He's furiously yelling orders to his goons.

Pan out--it's early morning, and we're outside, in or around the APPLE WAREHOUSE DISTRICT in BROOKLYN, around the docks.

So what we have here is the Plunderer's GOONS--a motley crew of about eight guys--being taken to school by LUKE CAGE, POWER MAN and the WHITE TIGER, who are currently operating as the HEROES FOR HIRE. We can see they're battling over a couple of shipping containers, marked HORIZON LABS, that the Plunderer is trying to heist. They're full of experimental tech that Horizon is shipping out for testing across country, and they've hired H4H to guard them.

The GOONS are armed with ray guns--high-tech-looking things--firing little laser-like pulses. (Plunderer's got something similar, but bigger and badder.) They don't get through Luke's skin. We could, if you wanted, get an emphasis close-up of that, with Cage wincing a little--they sting badly, even though they don't penetrate. I kind of want to use this fight to establish everyone's powers.

PAGE THREE:

The bad guys react in horror as their weapons prove useless.
They only sting Cage, WHITE TIGER can dodge them and POWER
MAN'S chi field just absorbs them.

Power Man and White Tiger take out a few more of the goons--
Power Man with a chi punch, White Tiger with a kick to the
face. Maybe have some kind of power effect when White Tiger's
fighting--like an astral ghost tiger hovering around her? Up
to you. The important thing is that they get some nice, big
establishing action shots to bring new readers up to speed on
what Their Thing is.

Plunderer levels his own weapon--it's much bigger and more
powerful than the one he's given his goons. He snarls,
promising it'll drill through even Cage like a hot knife
through butter...

...but then he's distracted by something coming down on him
from above...

PAGE FOUR:

...which is Spider-Man, swinging down to kick the Plunderer
right in the face and send him sprawling.

I'd like there to be some reaction from Luke and especially
Vic--neither of them want Spider-Man there, Vic because
Spidey's hogging the glory and Luke because Spidey's turned
into an obnoxious asshole lately--but whether you want to
have that here or move it to the next page and leave this as
a splash is up to you.

PAGE FIVE:

The Heroes for Hire and Spidey finish off the remaining
goons--Spidey webbing most of them up while Luke and his
team punch out the rest. It's a quick mop-up. Spidey's making
lots of snide, Octavius-level 'wisecracks' about how 'real
heroes' don't take money. (Conveniently ignoring, say, first
responders, which Luke will likely challenge him on.)

Once the fight's over, everyone's webbed up--the argument's
continuing. Spidey's still launching snide barbs at Luke, PM
and WT--he's saying that Luke and the Heroes For Hire should
just close up shop, since as long as the Superior Spider-Man

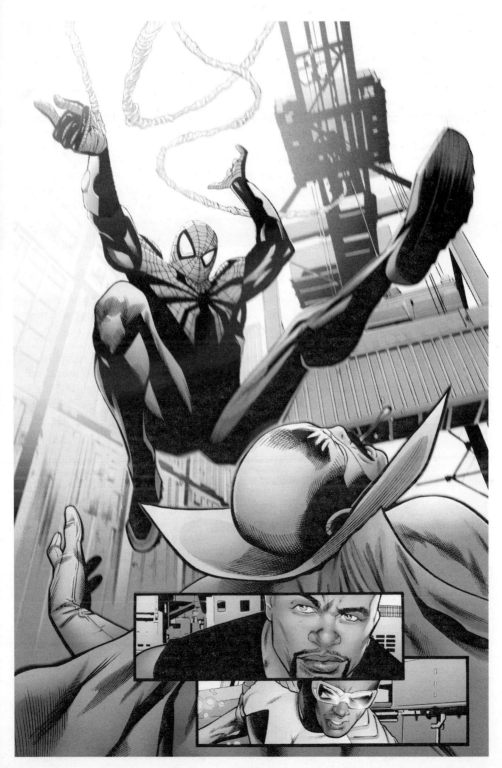

is in town, their services are simply not needed--and he's absolutely certain that Horizon won't be wasting their money on them again. Luke's just standing by, rolling his eyes at this ██████--his body language from here on in is a little subdued, like he's not really sure if this is what he wants to be doing with his life and he's had more than enough of this kind of petty ██████ already. Vic, meanwhile, launches forward angrily, jabbing his finger at Spidey and all but challenging him to a fight.

In response to this, White Tiger walks away in disgust, saying maybe Spidey's right and this isn't what they should be doing with their powers. Vic turns to call after her-- "Ava, wait--"--but she's not turning around.

PAGE SIX:

Vic's doubly angry now--he really leans into Spidey's face, powering his chi-glow up. Spidey just says something snippy at him...

...and then swings off, with the Plunderer webbed up under his arm, saying that Luke and Vic can clear out the rest of the trash, that's about all they're good for. Vic's left

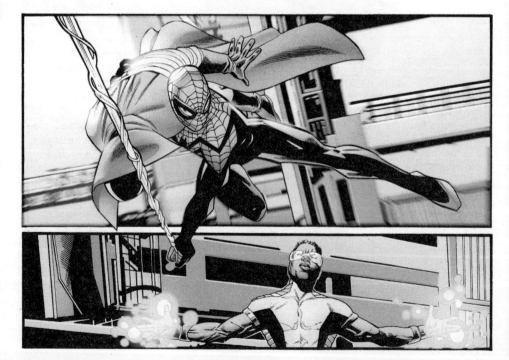

shouting after him impotently while Luke just stands, arms folded, shaking his head. This argument's old news for him.

Close in as Luke lays a hand on Vic's shoulder. Vic's still pissed at Spidey, yelling after him. Luke's resigned. "Come on, kid. Let's head back to midtown and get a coffee."

PAGES SEVEN-NINE: Going to do these pages as a unit, to let you decide the pacing.

Cut to: BLUE STREAK.

There's been more than one of this guy--at least one is dead--but for the purposes of the issue it can just as easily be a totally new person in the suit. He's basically barreling down Broadway on his jet-powered roller-skates with a sack full of loot in one hand and a Glock in the other, keeping ahead of a phalanx of pursuing cop cars and generally making them look sick.

In their cars, the cops are desperately trying to keep up without success. They're using their radios to call for more units, and asking where the hell the Avengers are and how a geek on super roller-skates can be making asses out of the entire NYPD...

Blue Streak's exulting in his heist--he's in it as much for the thrill as for whatever meager cash bag he's managed to grab (probably from an armored truck unloading)--but in the sky above him, a streak of light arcs down...

The light beam draws level with Blue Streak as he runs, weirding him out a little--then it morphs into MONICA RAMBEAU in her light form. She's wearing her new costume. She explains to a dumbfounded Blue Streak that she's currently pure light energy, mixed with a little sound so he can hear her. She's actually breaking a couple of the laws of physics just to match his snail's pace. She can become hard radiation by thinking about it--so she *could* give him a lethal cancer as easily as saying the words...

By now, Blue Streak's crapping his pants. Wide eyed under the mask.

But... she's trying not to be that person any more. So she's just going to do *this*. We see her reach a hand in front of his face--both of them still traveling at however many hundred miles an hour down Broadway--

Then she snaps her fingers--and creates a massive explosion right in his face that blows him backwards into the windscreen of the nearest pursuing cop car. We leave Blue Streak stunned, looking half-dead, with the cops reading him his rights and telling him he's lucky Monica was in a good mood.

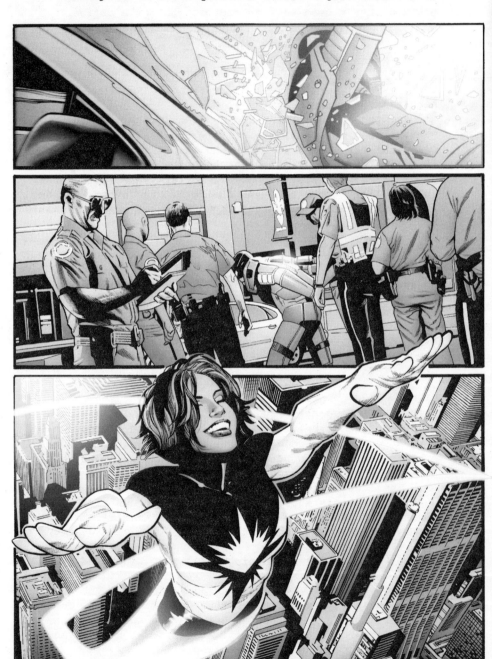

Back to Monica--laughing, zipping across New York at lightspeed, on the way to her appointment with an old friend.

PAGE TEN:

Establishing shot of a costume shop--"Luc, Costumier"--in the middle of Seventh Avenue, close to Times Square. It's a high-end boutique.

So it's super hero costuming for the high-end set. Spandex as high fashion. Tony Stark does a lot of shopping there with the Avengers credit card. Monica beams in through the front windows as a ray of light.

(LUC himself is an old friend of Monica's from New Orleans who makes costumes--I like the idea that they met because she robbed his costume shop back in *ASM Annual* #16 to make her first costume, which led to him getting national recognition as a designer, but this is all backstory that can remain in the background.)

Inside--various supercostumes, arranged like high fashion. The layout here needs to have an open door to a back room, with plenty of shadows in there. Inside, Monica's fully materialized in her new costume--she's happy with a successful test drive. It looks great, it feels great, she'll take it. The store owner, Luc, still thinks he can tinker with it a little--he's still fond of jackets--but Monica won't hear of it.

Close on Luc, explaining that this one's on the house--payback for an earlier good turn in the New Orleans days--and also mentioning that someone came by looking for her while she was out. "Who?" Monica asks.

"Me." At this point, we switch angles to inside that back room--looking out at the main store. There's a silhouette in the doorway, leaning out--BLADE's. The reason I want to do it this way is so as not to let the readers know who this is until further down the line. So we hide Blade's identity this way, and tell it in Monica's reaction--he's someone she knows or has heard of, and she's a little surprised to see him here, but she knows what it means if he shows up: vampires. Blade explains that he needs her help.

PAGES ELEVEN-THIRTEEN:

Cut to a coffee shop in midtown, not far away from Avengers Tower (or Times Square). Close on the TV—a news report replaying the Avengers ship leaving the tower for space.

Pan out—Luke's having a coffee, Vic's got a soda—still in costume. Vic's still angry, laying into Spider-Man for being such a jerk—and laying into Luke a little for not arguing back. Luke's barely listening to him—he's looking at his phone.

Close on the phone—a message from Jess. PICK UP DIAPERS ON UR WAY HOME? X.

It's like an anchor, reminding Luke what's important. He sips his coffee, telling Vic to simmer down a little. There's no anger in Luke—he looks a little tired, though, a mixture of life with a one-year-old bundle of joy and a growing disappointment with the work part of his life.

LUKE: Anyway, maybe he *was* right.

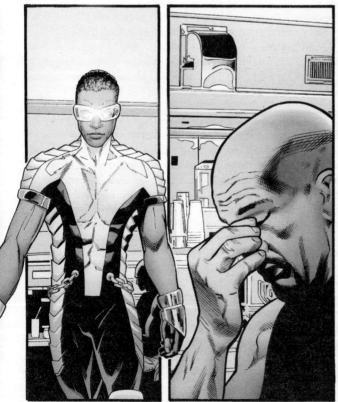

VIC: What?

LUKE: He's reinvented himself as an obnoxious ███████, but maybe he was right. (beat.) I don't know... I feel like--I quit the Avengers to take care of my daughter. To make her world safer. Better. That's the bottom line of everything I do in this world. And now... (beat. Luke looks away.) I'm looking at the society my baby girl has to grow up in. And it *needs* to *change*. And if you lead the Avengers, maybe you can actually *make* that change. (beat) And I don't do that anymore.

VIC: So what, we're not *good enough?*

Luke tries to get Vic to settle down, but he storms out angrily, leaving his soda. Luke sighs, finishes his coffee, and taps out a text message on his phone. Last shot is the phone screen, with his message on it: SURE. LOVE YOU. X

PAGE FOURTEEN:

Out in space, low Earth orbit. Thanos' craft, the new version of *Sanctuary*, emerging from its cloak.

A hatch on the underside of the thing opens, and capsules containing alien mercenaries--Thanos' army of bastards-- start to disgorge into the atmosphere. Dozens of them, or the implication of dozens, at any rate. The drop-capsules are cocooning these space bastards so they survive re-entry, but we can see their grinning faces through a couple of the windows of the things. These guys are bred for murder, pure and simple. And in the middle of all these capsules--leading the charge--we have Proxima Midnight, killing-staff at the ready. She doesn't need a capsule. She's going right into space just in her clothes.

Proxima and the capsules begin to tumble into the atmosphere, air friction giving them a red glow. Attitude jets on the sides and bases of the capsules aim them right where they need to be.

Close on Proxima, grinning with the bloodlust as the flames of re-entry flicker around her.

PAGE FIFTEEN:

Times Square. People stare up at what looks like meteorites plunging down from above--

We see they're looking at the plunging capsules--

And then the drop-capsules and Proxima impact. KABOOM. It's like a dozen bombs going off--massive collateral damage. The big panels for this page.

Cut to, for a panel--Dr Strange's Sanctum Sanctorum in Greenwich Village. He's pale and sweating, eyes glazed, drooling, while Black Maw whispers seductively in his ear. The Doctor's hands jerk spasmodically into summoning gestures. Around him, demonic shadows are appearing on the wall--winged and horned *things*. Mostly, though, we're focusing on the Maw's smirking reaction to his comrade's arrival.

PAGE SIXTEEN:

In the coffee shop--Luke, looking up from his coffee at the sound of the explosion.

In the costume shop--Monica, turning at the sound. (We'll repeat the sound effect, to make sure the readers get the idea.) Blade's still in the shadows, so the readers can't get a look at him.

On a Manhattan rooftop--Spider-Man, looking towards Times Square. Fire and smoke already rising up--a couple more outriders streaking down from above.

Close on Proxima Midnight, crouched in the crater she made from impact, looking at us through the smoke. Licking her teeth. Ready to kill. Around her, capsules lying in the rubble are opening, and things--alien warriors, armed with all manner of vicious weapons--are climbing out.

PAGE SEVENTEEN:

Back to the costume shop--Monica says she has to go. (We still don't get a clear shot of Blade--he's kept in silhouette or the shadows.)

> **BLADE:** We'll talk more later--

> **MONICA:** The hell we will. You want
> my help, you're coming with me now and
> helping deal with *this*.

> **BLADE:** I can't be seen to be
> in-country. If *they* figure out I'm here--

Monica reaches into a bin marked MUST GO--$5 OR LESS and
drags out something in Day-Glo pink and green. "You're in a
costume shop! Put something on!"

Then she blasts out of the front window in light form.

PAGE EIGHTEEN:

Back at Times Square--all around is flames, carnage, the
alien horde tearing everything up with Proxima in the center
of them. A big, brutal space bastard menaces a mother and
baby...

...then Luke Cage punches it away, breaking its weird alien
jaw, giving the mom and child time to make a run for it.

A second later, Monica shows, beaming through the nearest few
outriders as hard radiation, taking them out...

...and then Spider-Man swings down and kicks one in the face.

A panel as the three of them acknowledge each other while
pounding on the outriders--"Is this all we've got?"

> **MONICA:** I've got one more guy on
> the way--

PAGE NINETEEN:

Enter Blade, in the SPIDER HERO suit. This is basically
a spandex, old-style Spider-Man costume, in a hideous
combination of neon pink and neon green, with SPIDER HERO
written across the chest in place of the spider logo. It's
incredibly cheap looking. He's going to be wearing this
at least until issue #4, when probably he'll change into
the Ronin outfit. (Is it bad that I'm starting to want to
keep him in this? He could be the character find of 2013.)
Needless to say, he carries it like a total badass. He's
carrying a pair of vicious-looking nunchucks and breaking

alien heads with them in the Blade manner.

Panel of Spider-Man being horrified. "Take... take that off! Take it off RIGHT NOW! This is an OUTRAGE!"

Luke grabs Spidey by the shoulder, telling him to call the Avengers in right now--Spidey says that's not possible. The Avengers are in space.

Close on Proxima, giving one of her evil grins--maybe a little blood already on her--as she confirms this. "It's true, little man. Your Earth is without her Avengers."

PAGE TWENTY:

Close on Luke. Pissed off at that. "Guess again. You want Avengers, lady?"

"*We're* the Avengers." Zoom out--Cage, Spider-Man, Monica, and Spider Hero, getting ready to fight the army of approaching space bastards in Times Square. A good dozen of them or more. Behind the Avengers we see a crowd of civilians, some panicking, some already running, some filming it on their phones. The Avengers are standing between the alien mercs and the people of New York--that's our final shot.

TO BE CONTINUED!

ULTIMATES 2 (2016) & U.S.AVENGERS (2017) BY AL EWING

AN INTRODUCTION BY **TOM BREVOORT**
IN CONVERSATION WITH **ANDREW SUMNER**

oming in the aftermath of the *Secret Wars* event that took the Marvel Universe apart and put it back together in a slightly different fashion, *Ultimates* (which had started out as the equivalent of the Avengers in the now-deconstructed Ultimate Universe and inspired the portrayal of the Avengers in the MCU) and *U.S.Avengers* represent opposing poles in the pantheon of Avengers titles. *Ultimates 2* was the most expansive, mind-boggling, far-reaching, and metaphysical of all the various Avengers iterations up until that point, dealing with classic Al Ewing questions of cosmic significance. Whereas the *U.S.Avengers* is, as the name suggests, a more grounded, Earth-bound, and Earth-centric— but no less exciting and bombastic—take on an Avengers super hero team from Al.

While I was involved in helping to pull it together, I didn't edit Al Ewing's *Ultimates*; Wil Moss and Alanna Smith were the editors. So, coming back on the other side of the *Secret Wars* event, I was looking to change up the *Avengers* books and have a slightly different line of titles coming out of *Secret Wars*. And one of the ideas we had was to create a book called *The Ultimates* because the Ultimate Universe was no longer a separate concern. Now we'd be publishing in the Marvel Universe proper.

Al had a notion at one of the editorial retreats we were at, coming out of the conversations about *Secret Wars* and where everything would be left as it concluded. Al has a real interest in the cosmology and metaphysics of the Marvel Universe, and he envisioned a book that would have a team of characters who investigated and dealt with situations on a large, not quite galactic, but sort of metaphysical scale. And that became the post-*Secret Wars Ultimates*. Pieces of this series are an outgrowth of stuff he had done during *Mighty Avengers*—Adam Brashear, the Blue Marvel, goes

from one book to the other, and takes on a more central role in *Ultimates*. It was also a book where characters such as Black Panther and Captain Marvel could be featured in a more prominent way, as opposed to being sometimes lost among the crowd in the regular *Avengers* books up to that point. So again, the remit there was really to do a cosmic *Avengers*-style book that wasn't quite an *Avengers* book—and that was *Ultimates*. *Ultimates 2* is the beginning of the second iteration of that concept—the first run ran for twelve issues over a year. And then we did this refresh, a second iteration that ran for another ten issues.

U.S.Avengers was another outgrowth of our post-*Secret Wars* Avengers initiatives. We had launched *New Avengers*, which again had a slightly different cast to its previous iteration, a slightly different remit, and picked up on things that Jonathan had laid down in *Secret Wars*. One of the things Jonathan had done in his *Avengers* run was that he brought Sunspot and Cannonball (created for the *New Mutants* title in 1982) into the Avengers, because he loves the New Mutants, he loves those characters and was playing around with them. Al picked up on Sunspot as a motivator, and built him into the central character of *New Avengers*. By the end of Al's *New Avengers* run, Sunspot had used his wealth to get out of the situation they were dealing with by essentially buying A.I.M. (Advanced Idea Mechanics, a villainous network of technologically advanced scientists and arms dealers) and Al's New Avengers became a replacement for A.I.M. They became Avengers Idea Mechanics.

That series then ended up getting relaunched as Al's *U.S.Avengers*, in which A.I.M. morphed into American Intelligence Mechanics. The gimmick of the first issue of *U.S.Avengers*, which didn't necessarily have anything to do so much with the contents of the story, was a labor-intensive initiative where we determined an Avenger for every one of the fifty US states—plus about five others (there was an Avenger for Puerto Rico, Captain Britain was the Avenger for the United Kingdom, etc.). It was a big job, but we found characters who were specifically associated in some way, shape or form (even if, in certain instances, it was extremely tenuous), with every one of those states and locales. And we produced a variant cover for each one. So, there are something like sixty variant covers for *U.S.Avengers* issue #1, fifty-five or so of which are devoted to portraits of each of those

locale-indexed characters in front of the state or the country that they happen to represent. Artist Rod Reis, who was just starting out, did all those pieces for me, and it was a huge endeavor, but he got it all done. It was mostly a case of figuring it all out on a spreadsheet, which hero tied in with each location, and then getting Rod all the appropriate reference so that he could draw a good-looking Marvel Universe-style shot of Ant-Man (Florida), Two-Gun Kid (Montana), She-Hulk (Idaho) or whoever happened to be associated with each of the states in question. Rob produced a lot of nice pieces for this first issue.

I think *U.S.Avengers* was kind of a spiritual successor to Al's earlier *Mighty Avengers* in that, again, it was taking a slightly more ground-level approach. But not always *that* ground-level because Al has introduced some crazily extreme characters during his Avengers work, like American Kaiju (Corporal Todd Ziller is given a contemporary US government attempt to replicate Captain America's Super Soldier serum, which turns him into a giant lizard monster).

The A.I.M. association in *U.S.Avengers* allowed Al to use big science— magic science that might as well be out-and-out magic—to create characters and situations that were a bit more spectacular and perhaps more fanciful than the stuff that we had done in *Mighty Avengers*. But again, there was a certain similarity between Sunspot as the leader of the *U.S.Avengers* and Luke Cage as the leader of the *Mighty Avengers*—they weren't that different in their outlooks, they both wore a well-tailored suit, and they both presented themselves in a certain light. And so there's certainly a connectivity between what Al did in his earlier *Avengers* book and what he does here. I think the difference is that *U.S.Avengers* was, by design, more out-and-out bombastic and crazy in the sorts of stories Al was presenting than *Mighty Avengers* was.

Al is a great writer with a real interest in—and aptitude for—the cosmic, post-Jack Kirby widescreen aspects of the Marvel Universe; he's got a fascination with all of that, and these are themes that he comes back to again and again in the various Marvel books that he works on and that he's been successfully building on now for a long while. As you can see in Al's scripts presented here.

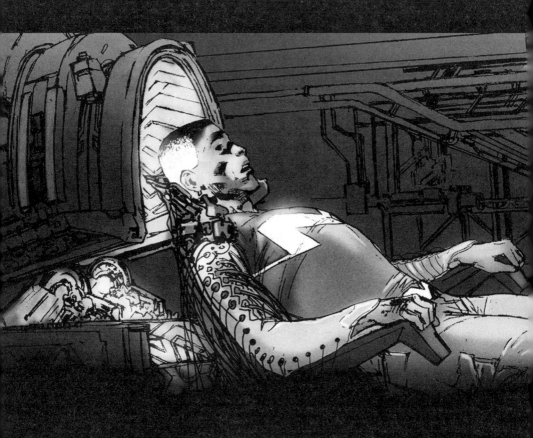

AVENGERS

ULTIMATES 2
ISSUE #1
2016

"What Do You Dream?"

By Al Ewing

Art by Travel Foreman
and Dan Brown

PAGE ONE:

(Leave space between the Header Captions here, so they function as beats.)

PANEL ONE:

HEADER CAPTION:
Everything is screaming.

PANEL TWO:

HEADER CAPTION:
Eternity. The Multiverse. Everything that is known.

HEADER CAPTION:
Shackled and helpless. Held in chains in the endless void.

HEADER CAPTION:
Screaming.

PANEL THREE:

HEADER CAPTION:
And behind the personification of all that is. Just out of sight.

HEADER CAPTION:
Something else takes hideous form. And laughs.

HEADER CAPTION:
And reaches.

PAGES TWO-THREE:

Header captions spread across the spread.

> **HEADER CAPTION:**
> And *touches*.

> **HEADER CAPTION:**
> And *leeches*.

> **HEADER CAPTION:**
> Leeching energy.

> **HEADER CAPTION:**
> Leeching joy. Leeching hope.

> **HEADER CAPTION:**
> The forces that bring life together
> weaken and corrode.

> **HEADER CAPTION:**
> War and horror spread through space and
> time like a slow poison.

> **HEADER CAPTION:**
> Strength weakens.
>
> Bad becomes worse. The balance trembles,
> ready to fall.

> **HEADER CAPTION:**
> And Eternity screams.

> **HEADER CAPTION:**
> And screams.

> **HEADER CAPTION:**
> But who could ever hear?

> **HEADER CAPTION:**
> Who could ever see?

PAGE FOUR: CREDITS could go on this page.

PANEL ONE:

> **HEADER CAPTION:**
> Who could bear the sight?
>
> **ADAM: (small)** My God...
>
> **COMPUTER: (crackly, no tail)**
> Warning.

PANEL TWO:

> **HEADER CAPTION:**
> Kadesh Base.
>
> **SUBHEADER CAPTION:**
> Undersea science-fortress inside the
> Marianas Trench.
>
> **COMPUTER: (crackly, no tail)**
> Warning. Input feed overloading.
>
> **ADAM:** Oh, not now--
>
> **COMPUTER: (crackly, no tail)**
> Norepinephrine levels approaching
> critical. Warning. Warning.
>
> **COMPUTER: (crackly, no tail)**
> Initiating safety cutout. System shutting
> down.
>
> **HEADER CAPTION:**
> Dr. Adam Brashear.
>
> **SUBHEADER CAPTION:**
> Codename: "Blue Marvel." Living anti-
> matter reactor. Super-scientist.

PANEL THREE:

> **COMPUTER: (crackly)** Please report
> to med-bay for examination regarding
> possible psychic trauma--
>
> **ADAM:** All right, all
> right. No need to fuss, computer.

ADAM: I'm _fine._

MONICA: (off-panel) It's just _worried_ about you, Adam.

PAGE FIVE: CREDITS could go on this page too.

PANEL ONE:

HEADER CAPTION:
Monica Rambeau.

SUBHEADER CAPTION:
Codename: "Spectrum." Able to transform into any form of electromagnetic energy.

MONICA: So am _I,_ frankly.

MONICA: What the hell _is_ that thing, anyway?

ADAM: This? It's a kind of _psionic resonator._ Something I built to help expand my _perceptions_--my _consciousness._

ADAM: I wanted to see the world the way _you_ see it.

PANEL TWO:

MONICA: The way _I_ see it?

ADAM: Sure. You're living _energy_-- even in your hard-light "human" form. _Think_ about it.

ADAM: How does _light_ enter your eyes when your eyes _are_ light? How do _any_ of your senses work?

PANEL THREE:

ADAM: My working theory is that your mind _automatically translates_ a form of _cosmic awareness_ into something _approximating_ normal human senses.

ADAM: So you <u>don't</u> hear, or see, or feel--in the <u>normal</u> sense. But all the <u>same...</u>

ADAM: ... you <u>know.</u>

PANEL FOUR:

ADAM: It might even be connected to your <u>photographic memory--</u>

MONICA: It <u>might</u> be a little creepy to <u>think</u> about, Adam.

MONICA: I'm not sure I like being one more <u>experiment</u> floating around your <u>laboratory...</u>

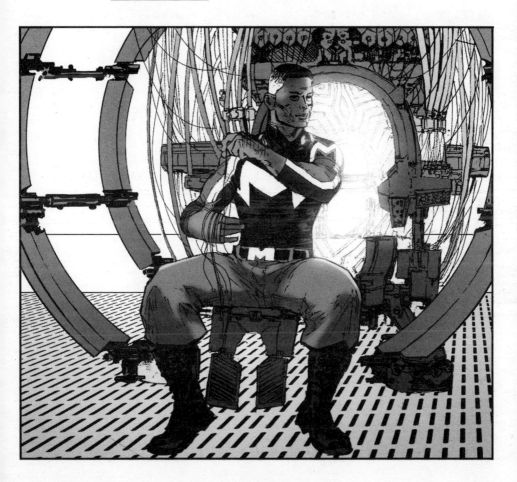

PAGE SIX:

PANEL ONE:

ADAM: Well... <u>life</u> is an experiment.

MONICA: <u>That's</u> it. Keep <u>digging.</u>

ADAM: Seriously, it is.

ADAM: A grand and never-ending <u>observation</u> of the <u>richness of the</u> <u>universe.</u> The laboratory of <u>everywhere,</u> constantly showing us new <u>truths,</u> new <u>patterns.</u>

PANEL TWO:

ADAM: (off-panel) Science is looking at the <u>magic</u> in the world... the <u>beauty...</u>

PANEL THREE:

ADAM: (link) ... and seeing the <u>inner</u> beauty that makes it work.

ADAM: (link) That makes us fall in <u>love</u> with it.

PANEL FOUR:

MONICA: You've got a way with a <u>phrase,</u> Dr. Brashear. I'll give you that.

MONICA: Did you get that from your <u>machine?</u>

ADAM: No. I saw... something <u>else.</u>

ADAM: And if you <u>are</u> connected to the cosmos... maybe <u>you've</u> seen it too.

PANEL FIVE:

MONICA: I've...

MONICA: ... had <u>dreams...</u> of...

CONNER: (off-panel) Let me guess.

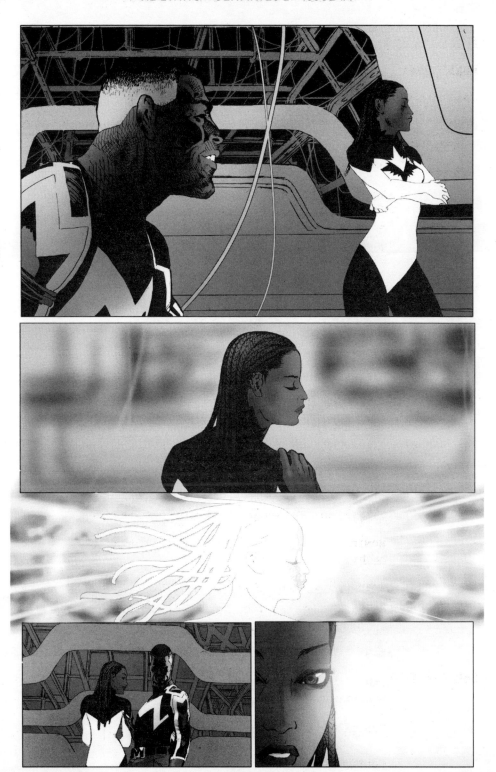

PAGE SEVEN:

PANEL ONE:

CONNER: Dreams of a <u>cage</u> around <u>everything.</u>

CONNER: Hello, Adam.

CONNER: I was <u>right</u> all along.

ADAM: (small) Conner?

HEADER CAPTION:
Conner Sims.

SUBHEADER CAPTION:
Codename: "Anti-Man." Adam Brashear's best friend and worst enemy. A being of vast cosmic power. Missing in action...

PANEL TWO:

SUBHEADER CAPTION:
... until now.

ADAM: (off-panel) After what happened at the <u>Triskelion</u>--I tried to <u>find</u> you, but--

CONNER: After what <u>happened</u>? You mean after my <u>power</u> ran out of control? After I <u>killed two men</u>?

CONNER: After you told me I was <u>safe</u>?

PANEL THREE:

CONNER: That I could never hurt anyone again?

ADAM: That was <u>Thanos,</u> Conner.

ADAM: He <u>pushed</u> you to let the power loose--it's <u>not your fault</u>--

PANEL FOUR:

> CONNER: That's right. It's <u>yours.</u>
>
> CONNER: I <u>owe</u> you this, Adam--

PANEL FIVE:

> MONICA: You're owed plenty <u>yourself.</u>
>
> CONNER: Aarrhh!
>
> ADAM: Monica, wait--

PAGE EIGHT:

PANEL ONE:

> CONNER: Yeah.
>
> CONNER: Wait in <u>there,</u> Monica.
>
> MONICA: <u>Aaaahh--</u>
>
> ADAM: <u>No!</u>

PANEL TWO:

> MONICA: (small) I'm all <u>right--</u>but--
>
> MONICA: (small) It's some kind of super-dense <u>energy screen--</u>
>
> ADAM: That's <u>enough,</u> Conner!
>
> ADAM: I've <u>tried</u> with you--I've spent my whole life trying to <u>help</u> you--

PANEL THREE:

> ADAM: --but I have my <u>limits.</u>
>
> ADAM: You come into my <u>home?</u> Attack my loved ones <u>again?</u>
>
> CONNER: Not--<u>unhh!</u>
>
> CONNER: --not <u>them--</u>

PANEL FOUR:

> **CONNER:** --I'm attacking <u>you.</u>
>
> **ADAM:** <u>Another</u> shell... ?
>
> **ADAM: (small)** How are you <u>doing</u> this?
>
> **CONNER:** Someone did more than <u>try,</u> Adam...

<u>PAGE NINE</u>: CREDITS could go on this page as well.

PANEL ONE:

> **CAPTION:**
> (Conner) "... and he wants to say <u>hello.</u>"
>
> **HEADER CAPTION:**
> The Vidalia Diner.
>
> **SUBHEADER CAPTION:**
> Even when it's busy, it's not busy.

PANEL TWO:

> **SUBHEADER CAPTION:**
> That's why she chose it.
>
> **WAITRESS:** Freshen your <u>coffee,</u> Ma'am?
>
> **CAROL:** Thanks.
>
> **WAITRESS:** You know--I'm so sorry, I know you must get this all the <u>time...</u> but you look <u>exactly</u> like Captain--

PANEL THREE:

> **CAROL:** Captain <u>Marvel?</u>
>
> **CAROL:** I, ah, I <u>do</u> get that a lot.
>
> **HEADER CAPTION:**
> Col. Carol Danvers.

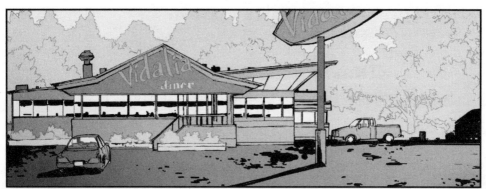

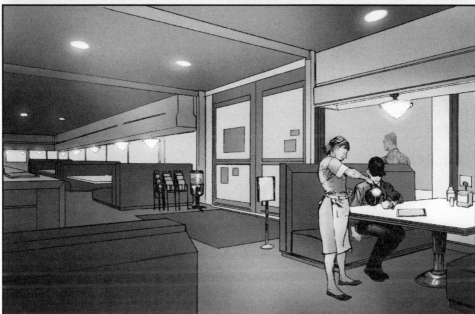

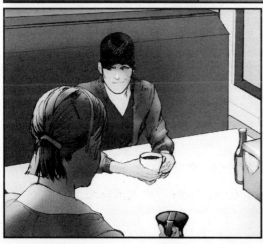

SUBHEADER CAPTION:
Codename: "Captain Marvel." Currently incognito.

WAITRESS: Well, I nearly had <u>kittens</u> when you walked in.

<u>PANEL FOUR</u>:

WAITRESS: I <u>swear</u>, I've got to be Carol Danvers' <u>biggest fan</u>--

CAROL: Really?

CAROL: 'Cause <u>I</u> think she's kind of a b--

T'CHALLA: (off-panel) <u>Brenda!</u>

<u>PAGE TEN</u>:

<u>PANEL ONE</u>:

T'CHALLA: <u>Luke Charles.</u> I'm <u>so</u> sorry I'm late.

T'CHALLA: Traffic was <u>insane.</u>

HEADER CAPTION:
King T'Challa of Wakanda.

SUBHEADER CAPTION:
Royal Title: "Black Panther." Also currently incognito.

CAROL: ...

<u>PANEL TWO</u>:

CAROL: ... no problem.

CAROL: I mean, you actually look like your <u>profile picture,</u> so <u>that's</u> something, right?

WAITRESS: Ooh! <u>Online date,</u> huh? Exciting!

> **WAITRESS:** How 'bout I give you folks some _privacy_?

PANEL THREE:

> **T'CHALLA:** Thanks _so_ much.

> **T'CHALLA:** Oh, and can I get a grande mocha _latte,_ not _too_ mocha, vegan milk and cinnamon? Thank you!

> **WAITRESS: (small)** I... I guess... ?

PANEL FOUR:

> **T'CHALLA:** And here we are.

> **T'CHALLA:** Nicely _done,_ by the way.

> **CAROL:** I was a _spy,_ T'Challa. I didn't lose the skills with the _memories._

> **CAROL:** Anyway, she's out of _earshot,_ and your _cinnamon vegan_ monstrosity's going to take a while...

PANEL FIVE:

> **CAROL:** ... so why not _start_ by telling me why you stabbed me in the _back?_

PAGE ELEVEN:

PANEL ONE:

> **BLACK PANTHER:** _I have seen_ too much, _Captain Marvel._

> **BLACK PANTHER:** _I can no longer defend_ any _of this--_

PANEL TWO:

> **GYRICH:** _That was when it became clear to_ everybody _that if Wakanda_ was _going to ally with the U.S., it wouldn't be via the_ Ultimates.

> **GYRICH:** _After that, it was just math._

PANEL THREE:

CAROL: You murdered the Ultimates program with a <u>word,</u> T'Challa. And I still don't know <u>why</u>--not <u>really.</u>

CAROL: Putting Spider-Man in a <u>room</u> for a few days? <u>That</u> was the hill you killed us on?

CAROL: Like you wouldn't <u>execute</u> him <u>tomorrow</u> if you thought Wakanda was in--

T'CHALLA: (off-panel) <u>Colonel...</u>

PANEL FOUR:

T'CHALLA: ... please.

T'CHALLA: Do not pretend you truly <u>know</u> me.

T'CHALLA: And do not <u>imagine</u> you know what I would <u>sacrifice</u>--what I am sacrificing even <u>now</u>--for the sake of <u>Wakanda.</u>

PANEL FIVE:

T'CHALLA: For if you <u>did... </u>you would not sleep <u>soundly</u> in the knowledge.

T'CHALLA: I <u>promise</u> you that.

PAGE TWELVE:

PANEL ONE:

CAROL: Touched a <u>nerve?</u>

T'CHALLA: ...

T'CHALLA: Trouble at home.

T'CHALLA: And no. I suppose my decision was not <u>entirely</u> about Spider-Man.

43

T'CHALLA: Or Ulysses. Or even the future.

PANEL TWO:

T'CHALLA: It was about you and I.

T'CHALLA: When we formed the Ultimates... we created a specific force for a specific role. A specific purpose.

CAROL: Solving problems before they became problems--

PANEL THREE:

T'CHALLA: But not just any problems.

T'CHALLA: Galactus. The Infinaut. Thanos. Problems of cosmic scope that could not be dealt with any other way.

T'CHALLA: Problems there could be no human answer for.

PANEL FOUR:

T'CHALLA: The moment you changed that--the moment the Ultimates became a force to aid you in your political goals--

T'CHALLA: --the moment we became a super-team in the traditional sense--

T'CHALLA: --I had to end it.

T'CHALLA: We were simply too powerful not to do so.

PAGE THIRTEEN:

PANEL ONE:

CAROL: Right. Except now you've ended it... you want it to start again. On your terms.

CAROL: That's what this little secret meeting's <u>about,</u> isn't it?

T'CHALLA: The ultimate solution is <u>gone.</u>

T'CHALLA: I fear the ultimate <u>problems</u> are <u>not.</u>

PANEL TWO:

CAPTION:
(T'Challa) "When we fought <u>Galactus</u>--I touched his <u>mind</u> for a moment. During <u>translocation.</u>

CAPTION:
(T'Challa) "I saw his transformation to the Lifebringer in my <u>dreams</u> that night.

CAPTION:
(T'Challa) "And on the dark nights <u>since...</u> when the crown hangs <u>heaviest,</u> when I hear my father's voice damning me <u>anew...</u>"

PANEL THREE:

T'CHALLA: ... I have had <u>other</u> dreams.

T'CHALLA: Dreams of <u>chains,</u> and <u>cages.</u> <u>Nightmares</u> of the sky itself <u>screaming.</u>

T'CHALLA: You have the powers of the <u>first</u> Captain Marvel, Colonel. On some level, you are in <u>tune</u> with the great all.

PANEL FOUR:

T'CHALLA: This terrible <u>anxiety</u> you feel.

T'CHALLA: The <u>fear</u> for us that led you to come to me in the <u>first</u> place. That <u>formed</u> the Ultimates.

T'CHALLA: Where did it <u>come</u> from?

PAGE FOURTEEN:

PANEL ONE:

> **T'CHALLA:** What do <u>you</u> dream?
>
> **CAROL:** ...
>
> **CAROL:** I...

PANEL TWO:

> **CAROL:** ... it doesn't matter. The Ultimates is <u>done,</u> T'Challa.
>
> **CAROL:** Even if I <u>trusted</u> you--or if you trusted <u>me</u>--it's <u>over.</u> <u>We're</u> over. By order of the <u>President.</u>
>
> **CAROL:** If the five of us all get <u>together</u> again, as a team--or, hell, even for <u>pizza</u>--

PANEL THREE:

> **CAROL:** --I'm pretty sure it's <u>treason.</u> For <u>me,</u> at least.
>
> **CAROL:** Gyrich would pitch a fit. I'd lose <u>Alpha Flight</u>--everything I've <u>built.</u> God knows <u>what</u> they'd do with you.
>
> **CAROL:** I don't want to say <u>"war",</u> but...

PAGE FIFTEEN:

PANEL ONE:

> **T'CHALLA:** <u>War?</u> Gosh, with <u>me?</u>
>
> **T'CHALLA:** Mild-mannered <u>Luke Charles?</u>
>
> **CAROL:** Oh God, <u>please</u> don't turn back into Luke Charles.
>
> **CAROL:** Your accent's <u>flawless</u> and it's <u>incredibly creepy</u>--

PANEL TWO:

T'CHALLA: Ooh! Speaking of creepy, have you seen Stranger Things?

T'CHALLA: It is such a good show...

CAROL: (small) Worst first date ever.

CAROL: Look, I get the point, Clark Kent. You know how to hide in plain sight.

PANEL THREE:

CAROL: And yes, the ultimate problems still need solving. And I'm happy to take your intel if you find one.

CAROL: But you can't just--just break us and put us back together when you feel like it. You can't.

CAROL: How can I ever trust you again, T'Challa?

PANEL FOUR:

CONNER: (no tail) Your trust isn't required, Captain Marvel.

CAROL: (small) What... ?

PAGE SIXTEEN:

PANEL ONE:

CONNER: But you are.

CONNER: See... the Boss wants a word.

CAROL: Oh, crap.

CAROL: Anti-Man.

PANEL TWO:

> **CAROL:** This is bad. Looks like he already visited Adam and Monica.
>
> **CAROL:** He's got them in some sort of cocoons--
>
> **T'CHALLA:** Indeed.

PANEL THREE:

> **T'CHALLA:** However, we have him, Colonel. The Panther is always prepared.
>
> **T'CHALLA:** I have spent months studying Anti-Man's unique energy frequency--

PAGE SEVENTEEN:

PANEL ONE:

> **T'CHALLA:** --and formulating a unique response.
>
> **T'CHALLA:** My energy dagger will create a chain reaction cascade within him--and in moments--

PANEL TWO:

> **CONNER:** --it will do nothing.
>
> **CONNER:** Things have changed, Panther.

PANEL THREE:

> **T'CHALLA:** ...
>
> **T'CHALLA:** Interesting.
>
> **CONNER:** I serve a higher power. A higher calling.
>
> **CONNER:** And from now on...

PANEL FOUR:

> **CONNER:** ... so will you.
>
> **CONNER:** You've been exposed, despite his efforts to protect you.
>
> **CONNER:** You've become aware.

PANEL FIVE:

> **CONNER:** Just like me.
>
> **CONNER:** And just like me... you've been drafted. To fight in a war.
>
> **CONNER:** The war of existence versus oblivion... the inside versus the outside...

PAGES EIGHTEEN–NINETEEN:

PANEL ONE:

HEADER CAPTION:
Taa II.

SUBHEADER CAPTION:
The World-ship.

CONNER: The war for everything that is.

T'CHALLA: (small) Unbelievable.

ADAM: He--he transported us across the universe with a thought--

GALACTUS: (no tail, loud) He did as I bid.

PANEL TWO:

GALACTUS: (loud) For I require new heralds--heralds of life itself.

GALACTUS: (loud) Heroes to fight the infinite crime--and un-chain the cosmos!

GALACTUS: (loud) As a new reality dawns--will you save it? Will you guard the flickering flame of being against the ultimate darkness?

GALACTUS: (SFX-size) Do you stand... with *GALACTUS?*

HEADER CAPTION:
Galactus.

SUBHEADER CAPTION:
The Lifebringer. Seeder of Worlds.

PANEL THREE:

CAROL: You--you knew about this, didn't you?

CAROL: All your talk of touching Galactus' mind--reforming the Ultimates--

T'CHALLA: Carol--I give my <u>word,</u> I did not--

CAROL: Your <u>word?</u>

PANEL FOUR:

CAROL: After <u>everything,</u> you want <u>me</u> to take <u>your</u> <u>word?</u>

CAROL: You know it'll take more than a <u>palette swap</u> to make me forget all the worlds Galactus <u>destroyed,</u> right?

CAROL: What makes you think I'd <u>ever</u> fight for--

PANEL FIVE:

MAC: (off-panel) You <u>wouldn't.</u>

PAGE TWENTY:

MAC: You'd be fighting for <u>me.</u> In the only fight that <u>matters.</u>

MAC: Welcome to the Ultimates.

HEADER CAPTION:
America Chavez.

SUBHEADER CAPTION:
Codename: "Ms. America." Paramedic for the Multiverse...

SUBHEADER CAPTION:
... leader of the Ultimates.

TITLE:
Marvel Comics presents...

TITLE:
ULTIMATES

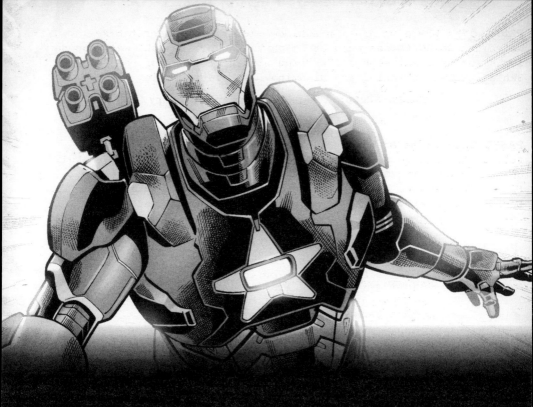

THE AVENGERS

U.S.AVENGERS
ISSUE #1
2017

"$kullocracy--Part One"

By Al Ewing

Art by Paco Medina, Juan Vlasco,
and Jesus Aburtov

PAGE ONE: SIX PANEL GRID.

PANEL ONE: Where we are--in a hidden location. A secret base.
We're not going to see much of it on this page, though--we're going
for a number of close-ups. Starting with a close-up of the Golden
Skull's teeth, grinning and gleaming. A skeleton smile.

> **GOLDEN SKULL:**　　　Imagine your country
> died.

PANEL TWO: Close on the Skull's hand--white-gloved, with a lace
ruff at the sleeve and an ornate signet ring, in gold, with a skull/
dollar symbol. The Golden Skull's dress sense remains as it was in
Ultron Forever--he dresses like a cross between a pirate captain and
Louis XIV. An aristocrat. I can get you reference if need be.

> **GOLDEN SKULL:**　　　Imagine the worst
> thing happened and you were left in the
> ruins.

> **GOLDEN SKULL:**　　　In the abyss. All
> your certainties, your reassurances, your
> couldn't-happen-heres--gone.

> **GOLDEN SKULL:**　　　And your moron of an
> uncle on Facespace thinks it's fantastic.

PANEL THREE: Close on the Skull's feet, walking on a stage, to and
fro. In front of the stage--the faces of his audience. Mostly men,
mostly white, henchman types, simmering with anger. He's whipping
them up. Also, they're all wearing sailor outfits--stripy tops,
pirate gear. Again, like his henchmen in *Ultron Forever*. The Skull
is addressing the troops.

> **GOLDEN SKULL:**　　　So where's your
> country now? Where's the ground under
> your feet? I'll tell you.

> **GOLDEN SKULL:**　　　It never existed.

PANEL FOUR: Close on the Skull's eye, in the darkness of the
golden socket. A human eye--the skull's just a mask. Staring
balefully.

> **GOLDEN SKULL:**　　　You always knew, deep
> down. It's why you're here. Why you came
> to me.

> **GOLDEN SKULL:**　　　You know there's no
> such thing as country. No such thing as
> community.

PANEL FIVE: Back to the audience of henchmen. It's a small group-- twenty or thirty--but enough to fill the panel. We can see their faces--see they're caught up in the rally, in the speech. They're on board with what the Skull's laying down.

> **GOLDEN SKULL:** (off-panel) Family. Faith. "Val-yoos."

> **GOLDEN SKULL:** (off-panel) All those words they toss around on their podiums.

> **GOLDEN SKULL:** (off-panel) You think they believe it?

PANEL SIX: And now we get a full close-up shot of the Golden Skull's face, the mask grinning as he holds one gloved finger up in front of it. Waving his finger, a "no-no-no" gesture.

> **GOLDEN SKULL:** No, no, no, my friends. They know the truth. They know what you know.

> **GOLDEN SKULL:** There's just one lone thing in this world that really, truly exists.

PAGE TWO: SPLASH PAGE.

PANEL ONE: The Golden Skull, onstage. He's gesturing behind him--where there's a massive pile of gold, jewels and money. He's completely surrounded by wealth--even the stage is ornate. It's his headquarters, and his place of power. (Maybe the same room from the cover of #2--so there could be screens in the background, and the golden throne. If so, on the screens is the skull/dollar symbol from his ring. Could be as simple as a skull with a dollar sign on the forehead, or something more ornate.) The Skull's looking triumphant--he knows he's got his audience.

> **GOLDEN SKULL:** Money.

> **GOLDEN SKULL:** Welcome to the Skullocracy.

> **TITLE:**
> $KULLOCRACY Part 1

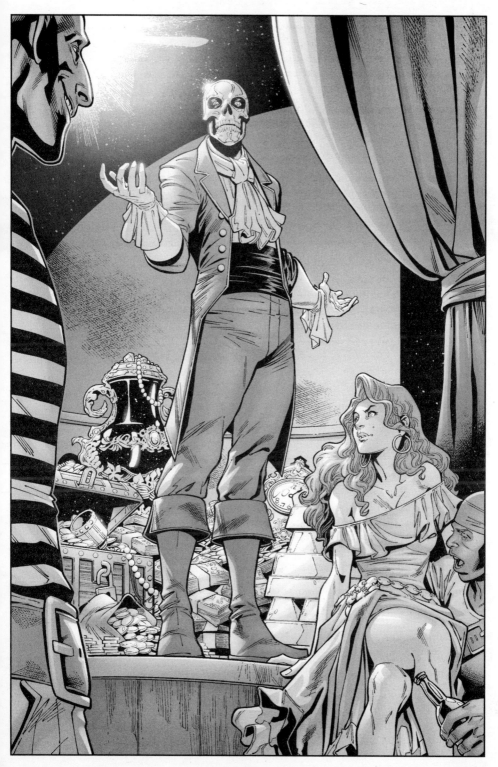

PAGE THREE: FIVE PANELS.

PANEL ONE: A panel of Roberto, talking to the reader. A wood-paneled office, maybe somewhere in the White House. It's a flashback, so colors are a little muted. Roberto's smiling.

> ROBERTO: I remember the exact moment
> I fell in love with America.

PANEL TWO: A TV-shaped panel.

(If we can't do likenesses--and we probably can't--make it a panel of Roberto's young face, as in panel four--I'll get to it in the description there--transfixed. Flashback colors warm. Then we'll have the line coming from off-panel.)

> MAGNUM: Did you see the sun rise
> this morning?

PANEL THREE: Cooler flashback colors--back to the timeframe of panel one. Roberto smiles, a little bashful. Looking down. He knows it's goofy and a little corny.

> ROBERTO: It wasn't the TV show. It
> was...

> ROBERTO: At the time, someone I
> cared very deeply for had died in my
> arms. Murdered.

> ROBERTO: I was dealing with that,
> and I was coming to terms with being a
> mutant, which was... scary.

PANEL FOUR: A big panel--the New Mutants, in their earliest days:

So Mirage, Karma, Wolfsbane, Sunspot and Cannonball.

They're either in their costumes or in civilian clothes of the era--I can find reference if need be--and they're gathered in the X-Mansion TV room, watching Magnum P.I. on a big cathode-ray TV. Flashback colors are warm and pleasant. Rahne is curled up with her knees up to her chin, the others are relaxing, maybe sharing a bowl of popcorn. Roberto's glued to the screen looking happy and at peace, as he does above.

> **ROBERTO: (Caption)**
> "But despite everything... I felt safe.
> And there was so much love in that room.

ROBERTO: (Caption)
"Sam, of course. And Dani, and Xi'an, and
Rahne--this strange little Scot, huddled
up in herself.

ROBERTO: (Caption)
All of us from such different places.

<u>PANEL FIVE:</u> Back to the cooler-color flashback. Roberto addressing
the reader with a smile. Leave room for dialogue.

 ROBERTO: And I thought--how wonderful
that we could come to this new country...
this place I'd only heard of...

 ROBERTO: ...and accept each other.
And be accepted by each other. No matter
where we were all from, we could come
here and move forward together.

 ROBERTO: And now Magnum P.I. is my
favorite show.

PAGES FOUR/FIVE: FOUR-PANEL DOUBLE SPREAD.

PANEL ONE: Close on Roberto, in flashback. His smile cracks a little wider. He's happy to be becoming an American citizen.

> **ROBERTO:** And America is my favorite country.

> **ROBERTO:** My name is Roberto Da Costa, and... well, I'll take that oath now.

PANEL TWO: Cut to--the present day. And a close shot of the Secret Emperor, head of an offshoot of the Secret Empire.

The Secret Emperor is wearing one of those hoods, unless you want to tweak it to make it more ornate, and his eyes underneath it are completely insane. He's got a couple of monk-like figures flanking him, wearing red robes--their faces are mostly in shadow. They're all stood in the control room for some massive craft--we'll see what it is in a moment.

> ### HEADER CAPTION:
> November 2.

> **SECRET EMPEROR:** Pledge your allegiance!

PANEL THREE: Zoom out--we're now looking at the Emperor and his men through a large glass or Perspex window, set into some kind of rock face. Maybe a trickle of lava running past the window. The Emperor's still ranting.

> **SECRET EMPEROR:** For our time has come at last! The new world--where all sins are forgiven! Where reality is ours to create!

> **SECRET EMPEROR:** Behold--the empire that cannot end! The Forever Empire--

PANEL FOUR: Big panel for the spread. We're looking at an active volcano--small to medium-size, about as big as an office block, but still fairly big--that's resting on a vast platform lined with helicopter rotors. Think a cross between a volcano and a Helicarrier. The Volcano has a headquarters built into it--we can just see the little window we were looking at last panel, and there are other signs of construction, including big pipes for ferrying the lava around the structure. But there's also lava erupting from the top, cascading down the sides and flowing down to the sea

below--if this were to park itself over a city, it'd destroy it. It's flying over the Pacific, being attacked by Air Force jets--the jets aren't doing much good.

> **SECRET EMPEROR:** (from inside) --secret no more!

PAGE SIX: FOUR PANELS.

PANEL ONE: Mission Control for the U.S.Avengers. This is going to be on board a Helicarrier-type deal--the Americarrier--but right now we're right in it. It should look fairly similar to previous Mission Control rooms. Roberto's here, wearing his suit, talking into a radio. Behind him, various people in the all-over AIM suits bustle about--most in blue, a couple in red.

> **ROBERTO:** General--this is Da Costa at Mission Control--
>
> **GENERAL: (crackly, no tail)** Use the dang codename!
>
> **ROBERTO: (small)** I liked my old codename.
>
> **ROBERTO:** This is Citizen V.

PANEL TWO: Cut back to the Volcano-Helicarrier--we see it's heading towards the coast. LA in the far distance. An aircraft carrier stationed a little way away.

> **ROBERTO: (crackly, no tail)** We have... and even I can't believe I'm saying this... a Helicarrier that's also a volcano base, moving at speed over the Pacific...
>
> **ROBERTO: (crackly, no tail)** ...about to pitch Hollywood the ultimate disaster movie.
>
> **ROBERTO: (crackly, no tail)** Now would be a really good time to wheel out the Big Guy, General.

PANEL THREE: Cut to the deck of the aircraft carrier--General Maverick talking angrily into his own radio. Another jet being set off behind him.

> **MAVERICK:** Sorry, Da Costa. Safety lock is still engaged--three minutes to go.

> **ROBERTO: (crackly, no tail)** We don't have three minutes!

PANEL FOUR: Close on Roberto, looking worried.

> **ROBERTO:** We're one minute from landfall and the jets aren't scratching it, guys.

> **ROBERTO:** Someone give me some good news.

PAGE SEVEN: SIX PANEL GRID.

PANEL ONE: Flashback. The same wood-paneled White House office, the same cool flashback colors, so we know it's a similar time period to the last one. Toni, wearing her lab coat, is talking directly to the camera. This is an interview situation--she's telling her story.

> **TONI:** So my Mom moved to Seattle from China in the late seventies.

TONI: That's where she met my
Dad--this brilliant medical researcher.
They fell in love, got married--very fast.

TONI: Too fast, maybe.

PANEL TWO: Toni looks down, a little sad. She's made her peace with her dad leaving, but it's still not fun to think about.

TONI: And then I came along, and
Dad's research grant dried up around the
same time, and money got tight... and...

TONI: I know it wasn't my fault.
I know that. It was just...

TONI: Some marriages don't make it.

PANEL THREE: Toni looks off to the side, clearly trying to find the right words. She doesn't really know how she feels about her dad, and he's dead now, so she can't work it out with him.

TONI: Dad moved back to Timbetpai
for a while, met someone else. I've
got a half-brother somewhere... it's
complicated...

TONI: He sent letters, made
sure we were okay... but I never felt
like he was... and then he died, and...

TONI: Yeah. Complicated.

PANEL FOUR: Toni looks right at the reader, looking a little irritated. Remembering some bullies at school, some memories that still annoy her.

TONI: And then I found out I
liked girls, and pretty soon everyone at
my high school figured it out too.

TONI: That was fun.

PANEL FIVE: Toni leans back--smiling. She showed everybody.

TONI: &%£$ 'em. Dirt off my
shoulders.

TONI: I got a scholarship to MIT.
Met some actual cool kids, like Max.

> **TONI:** Fast-tracked three PhD's at once, because I am the omnibadass, thank you.

PANEL SIX: Toni, still smiling, lifts the Iron Patriot helmet into frame. She's proud of it.

> **TONI:** And... I made this guy. Design's kind of Stark-y--no surprise I think about his career a lot, considering--

> **TONI:** --but the insides are all mine. Say hello, Iron Patriot.

> **TONI:** "Hello, Iron Patriot!"

PAGE EIGHT: THREE PANELS.

PANEL ONE: Still in the flashback--Toni looks off to the side, thinking about the answer to the question she's been asked. This is part of some vetting procedure.

> **TONI:** Anyway, do I like America? Sure. I was born here, I live here, it's home.

> **TONI:** Lord knows, there are a lot of worse places.

PANEL TWO: Toni looks at the reader, smiles and gives a little shrug. This PR stuff is fun, but she needs to get back to work.

> **TONI:** That's... all I've got?

> **TONI:** Can I get back to work now?

PANEL THREE: Back in the present day--big panel. The Iron Patriot, flying out of the sun towards us, and towards the Volcano-carrier.

> **IRON PATRIOT:** Relax, fearless leader.

> **IRON PATRIOT:** Good news coming up.

PAGE NINE: FOUR PANELS.

PANEL ONE: The Iron Patriot blazes out of the sky, on a collision course with the approaching flying volcano.

> **IRON PATRIOT:** On an approach course--impact in ten--

> **GENERAL: (crackly, no tail)** What? You gone crazy, Patriot?

> **GENERAL: (crackly, no tail)** You got no weapons on that rig, blast it! It's a gat-danged peacenik robot suit!

PANEL TWO: Close on Iron Patriot--looking determined, as much as it can with the inflexible helmet.

> **IRON PATRIOT:** No duh, General. I built it. You know I'm not a big fan of guns, right?

> **IRON PATRIOT:** And I'm no Tony Stark. I couldn't build a weapon if I tried.

> **IRON PATRIOT:** My specialty--

PANEL THREE: Pull out--Iron Patriot is suddenly surrounded by a visible force field that takes the rough shape of the suit. I know we played around with having the field invisible before, but for this book I think we'll get more use out of having the field be visible to the eye, if translucent. I can do a thumbnail of what it might look like if you need.

> **IRON PATRIOT:** --is defense.

> **IRON PATRIOT:** As in, force fields.

PANEL FOUR: Iron Patriot holds her hands up--quite small in the panel--and we see the field change its shape, pushing forward in front of her. She's going to try and use the field to stop the volcano base moving forwards.

> **IRON PATRIOT:** Okay--extending the field--Bracing for impact--

PAGE TEN: FIVE PANELS.

PANEL ONE: The flying volcano base slams into the wide force field Iron Patriot's projecting--the field is pushing up against the base, pushing at it like a kind of squidgy battering ram.

> **IRON PATRIOT:** Damn it--too much mass--

> **ROBERTO:** Patriot--

PANEL TWO: Close on Iron Patriot's helmet. Or maybe Toni's face, inside the helmet, Iron Man style.

> **IRON PATRIOT:** I can slow it down. But I can't stop it--it's still moving.

> **IRON PATRIOT:** New ETA is maybe seven minutes. Assuming this doesn't burn out that suit's energy cells.

PANEL THREE: Close on Roberto--he's being passed a piece of paper by one of the AIM goons milling around him.

> **IRON PATRIOT:** Tell me that's enough--

> **ROBERTO:** It might be, Toni. I just got the word--

PANEL FOUR: Back to the Secret Emperor--he's throwing up his hands, ranting maniacally. The hooded figures flanking him are bowing their heads--and a new hooded figure (Enigma, AKA Pod, in holographic disguise) is entering the command chamber. Enigma's entrance is the main focus of the panel.

> **ROBERTO: (caption)** "--Enigma is on site."

> **SECRET EMPEROR:** More power! Nothing must delay the Empire!

> **SECRET EMPEROR:** Dispatch the flying legions!

PANEL FIVE: Close on the hooded figure who just came in--Enigma in disguise. We're looking into the depths of the hood, and all we see in the darkness is a blue glowing circle--Enigma's face-light thing. The effect is a little creepy.

> **ENIGMA: (small)** I see you.

<u>PAGE ELEVEN:</u> Five panels. I'm thinking tier of three, then a BIG panel, then a little one.

<u>PANEL ONE</u>: And we're back to those flashback/flashforward shots of the interviews, the team members addressing the reader. This is Aikku Jokinen, the pilot of the Enigma suit--we've seen her before. She's wearing a jacket and a shirt--she's used to a much colder climate even than Washington DC, so her natural instinct is to bundle up. She's smiling slightly for the camera, thinking like a tourist on a long holiday. But she's a little homesick. Norway is still where her heart is.

> **AIKKU:** America is... it is very big, very different. I am missing the cold, is that strange? I miss the air.

> **AIKKU:** I think Alaska would be maybe more like home? But I have not seen there yet, so...

<u>PANEL TWO</u>: Aikku's smile drops as she acknowledges the reality of the choice she's having to make. This isn't a heart-wrenching thing--it's the expression of someone having to make a difficult decision about whether to move to another country, but it's still a practical decision. (I've looked it up--Norway does require you to give up citizenship if you become a citizen of somewhere else. No dual citizenship.)

> **AIKKU:** ...yes, I say "America" and I say "home" and they are still different places.

> **AIKKU:** If I stay here, I am no longer a citizen of Norway. Norway is, what is the word? Very strict about this.

<u>PANEL THREE</u>: Aikku looks away from the "camera"--she's a little shy, a little unsure of herself, always finding the right English words. She's trying to explain her thinking.

> **AIKKU:** But I have a girlfriend here, and friends, who were good friends even when I had to be a big robot...

> **AIKKU:** And I am... I feel that I am...

<u>PANEL FOUR</u>: And--for this big panel--back to the present day. We've established the Secret Emperor is flanked by two guys-- Enigma, without the disguise, is phasing through the wall, like Kitty Pride, surrounded by an aura of crackling energy. We'll have Header Captions here and over the next action sequence to lay out

her powers--stealth powers, phasing powers. I want to limit Enigma to spy-type powers, but she'll be displaying a broad array of those--primarily phasing herself and others to start with.

Anyway, she's phasing through the wall, leaping to grab the two henchmen--they're reacting, but too late.

PANEL FIVE: Back to a panel of Aikku, in the flashback/ flashforward, looking at the camera with a smile. Her life is back on track, after months or years trapped in the Pod armor.

> **AIKKU:** ...I feel I am finding my life again.

> **AIKKU:** So perhaps I will stay?

PAGE TWELVE: FIVE PANELS.

PANEL ONE: Enigma grabs the two henchmen, each in one hand--picking them up by any body part available. We see they're now surrounded by the same crackling energy she is--a phasing effect. (Maybe there's some Photoshop thing that could be done at the color stage to make it obvious when people and things are phased?)

PANEL TWO: Enigma hurls the two men (still phased) at the wall of the chamber--much stronger than she looks--again, we'll put in Header Captions showing her powerset for the benefit of the readers--

PANEL THREE: And then, from the outside, we see the two men, still phased and surrounded by that crackling aura, pass through the wall and out into the open air. They're horrified, naturally.

PANEL FOUR: Enigma grabs hold of the Secret Emperor. The one eye in the middle of her face glowing--she looks menacing.

> **ENIGMA:** Those were the last of your men. The rest are gone.

> **ENIGMA:** I have phased them. They will float, like ghosts, light as clouds. No-one dies.

> **ENIGMA:** But now it is just you. You, I am not so careful over.

> **ENIGMA:** Switch it off.

PANEL FIVE:

Close on the Secret Emperor's face--under the mask, his eyes are wide and mad.

> **SECRET EMPEROR:** Switch it off?

> **SECRET EMPEROR:** This is vengeance! Boiling magma vengeance on your Hollywood! Your lies and agendas! Your lattes!

> **SECRET EMPEROR:** What makes you think we built an off-switch?!

PAGE THIRTEEN: FOUR PANELS.

PANEL ONE: A bunch of little drones fly out of the volcano--the "flying legions" we mentioned earlier, ejected from hatchways, or maybe bursting out of the top, covered in magma. They're going after the jets--maybe firing lasers of some kind, maybe just as a swarm. It's a lot of small things coming out of a big thing, which I know is tough to do in a panel, so feel free to pick whichever way of showing that is easiest and we can have Roberto narrate over this and the next panel.

PANEL TWO: Smallish panel. Roberto, in Mission Control, calling for help on his radio. He's going to do some lifting here in terms of explaining what we're seeing in Panel One.

> ROBERTO: It's ejected anti-aircraft drones! They're going after the jets!

> ROBERTO: Sam--Doreen--

PANEL THREE: Swooping down from above--Cannonball and Squirrel Girl. Cannonball's holding Squirrel Girl by the arms, flying her towards the foe--Squirrel Girl's barking orders to a small army of flying squirrels wearing tiny jet packs. (I'm so sorry. There are more talking-head pages to come, which should hopefully be easier.) Maybe Cannonball's got a little stubble going? It'll look good in his talking-head page.

So a flying squirrel, with a teeny-tiny little jetpack on its back and maybe an adorable little helmet.

> ROBERTO: (crackly, no tail) --we need air support!

> CANNONBALL: On it!

> CANNONBALL: (small) Nigh-invulnerable, and I'm a glorified taxi service--

> SQUIRREL GIRL: Oh, hush! I'm working on the flying thing, okay?

> SQUIRREL GIRL: Flying squirrels--attack!

PANEL FOUR:

Smallish panel. This is another flashforward/to-camera panel, this time with Doreen, in her Squirrel Girl costume, smiling and giving a thumbs up to the camera. She really likes dual citizenship!

SQUIRREL GIRL: I'm a dual
citizen!

SQUIRREL GIRL: Powers of
American *and* powers of Canadian! Also
powers of squirrel and girl! And powers
of comp-sci student!

SQUIRREL GIRL: That's a lot
of powers!

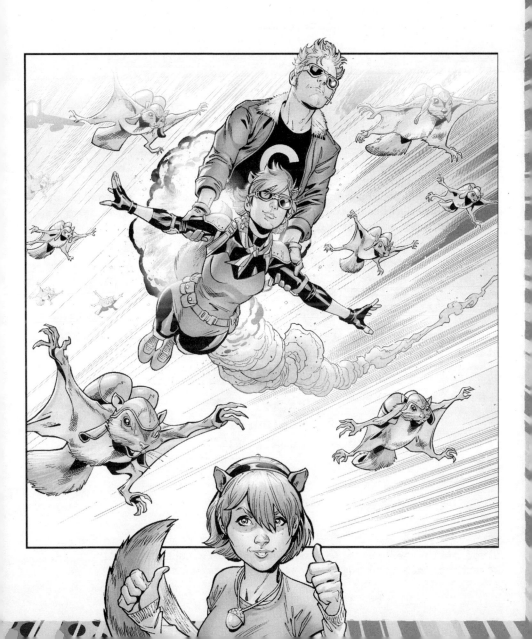

PAGE FOURTEEN: FIVE PANELS.

PANEL ONE: Squirrels versus drones! The squirrels are latching onto the drones, tearing at any wiring or sensitive parts, grabbing their laser barrels and making them shoot each other, generally causing havoc!

> **ROBERTO: (crackly, no tail)** We're keeping the drones busy--let's try to keep squirrel casualties to a minimum, guys--

> **ROBERTO: (crackly, no tail)** Iron Patriot--status report!

PANEL TWO: Close on Iron Patriot--sparks coming off the suit! She's pushing it to the limit!

> **IRON PATRIOT:** I'm holding back a literal mountain, Roberto! The field can't take much more--it's overloading!

> **IRON PATRIOT:** And if it goes--so does LA!

PANEL THREE: On the carrier--the General, nervous, stares at one bare forearm. (We can fold this into the next panel if we need the room--I'm just thinking in terms of a re-establishing shot.)

> **IRON PATRIOT: (crackly, no tail)** General--we need you!

> **GENERAL: (small)** Come on... gat-danged safety lock...

PANEL FOUR: We get a close look at the general's forearm as he stares at it--there's a glowing display shining through the skin, like a glowing red tattoo. A circle, as big as a watch face--the 'button'--and next to it, the words:

<div align="center">

"SAFETY LOCK
00:00:01
REMAINING"

</div>

This is the countdown to when the General can Hulk-out again. It's nearly up.

> **GENERAL: (small)** Nearly...

PANEL FIVE:

Close on the General's forearm--the "Safety Lock 00:00:01 Remaining" has been replaced with a single word:

SMASH

The red glowing "button" is still there.
It's always there.

SFX: (small) Bing!

GENERAL: Finally.

PAGE FIFTEEN: SIX PANEL GRID.

PANEL ONE: And--flashback/flashforward to the interview section,
talking to the reader. This time it's General Maverick's turn. He
gets a whole page. Make sure to leave a lot of room for dialogue in
these panels, 'cos this is the main exposition bit. The General is
sitting down, calmly talking to the reader. Laying out the story
so far. Maybe he's got a cup of coffee if you want to give him a
physical prop.

> **GENERAL:** Okay. The story so far.

> **GENERAL:** You have A.I.M.--crazy
> super-science folks, generally evil, work
> for the bad guys.

> **GENERAL:** They go corporate--bad
> move. Roberto Da Costa, billionaire
> mutant, buys them out.

PANEL TWO: The General keeps telling the story. Looking
disgruntled--he doesn't like Roberto.

> **GENERAL:** He sends the evil guys to
> jail, keeps the ones who just love mad
> science--and makes them mad-science for
> the goodies.

> **GENERAL:** The U.S. doesn't like it. I
> don't like it. S.H.I.E.L.D. doesn't like
> it. I don't like S.H.I.E.L.D. either.

> **GENERAL:** Cue shenanigans.

PANEL THREE: General doing a "what now?" face. Still in
storyteller mode.

> **GENERAL:** When the dust settles...
> the U.S. needs a strong S.H.I.E.L.D., but
> S.H.I.E.L.D. looks weak--and A.I.M. just
> saved the President.

GENERAL: What now?

PANEL FOUR: General Maverick points a thumb at himself--"with *me* on hand"--giving a tight smile.

GENERAL: Answer: A.I.M. starts mad-sciencing for S.H.I.E.L.D.--Q Branch meets Mission: Impossible. "American Intelligence Mechanics."

GENERAL: Best of both worlds. Hi-fi spy-fi, the craziest jobs for the craziest unit.

GENERAL: With me on hand to look out for Uncle Sugar.

PANEL FIVE: The General changes to a new topic--leaning back. He's smiling now--happy about this bit.

GENERAL: Meanwhile. S.H.I.E.L.D. have this thing called the Hulk Plug-In.

GENERAL: Genetic enhancement--makes you what they call a "Bannerman", a weak-sauce version of a Hulk.

GENERAL: Nice toy.

PANEL SIX: The General leans forward, a big nasty grin on his face. He's the one perfect recipient of the Hulk Plug-in, and he loves it.

> **GENERAL:** A.I.M. get hold of it. Iron out some bugs. Look around for the one perfect genetic profile to plug it into.
>
> **GENERAL:** And so, for one hour in every forty--the hour of power--
>
> **GENERAL:** --one deeply fortunate individual gets to go Full Hulk.

PAGE SIXTEEN: FOUR PANELS.

PANEL ONE: Flashforward/to-camera panel--the General holds up his forearm. We can see the glowing tattoo--the button, and **SAFETY LOCK 37:10:09 REMAINING.** So this is quite soon after a Hulk-out.

(I'm thinking the tattoo is visible when the General wills it--maybe the "button" is always visible, that could be done at the color stage, but it's much easier art-wise if he only sees the countdown when he wants to.)

> **GENERAL:** And that is why I love America.
>
> **GENERAL:** It's the land of opportunity.

PANEL TWO: Back to the present, on the aircraft carrier--the General, irritated at having to wait so long, pushes the "button". Like tapping an iWatch.

> **SFX: (small)** Breep!

PANEL THREE:

Big panel! The General HULKS OUT! Immediately becoming the Red Hulk, mustache and all! Eyes glowing a fiery red, howling with primal fury! (He can speak, but he likes to growl.)

> **RED HULK:** Rrraaarrgh!

PANEL FOUR: And the Red Hulk LEAPS off the deck of the aircraft carrier! Making a beeline for the Volcano!

PAGE SEVENTEEN: FOUR PANELS.

PANEL ONE: The Red Hulk roaring--one fist pulled back--speed lines all around him, he's dropping like a bomb--

PANEL TWO: On board the Volcano base--Enigma grabs hold of the Secret Emperor and phases him. It's the only way either of them are going to survive.

PANEL THREE: Big panel--the Red Hulk SLAMS right through the Volcano base! Like firing a bullet through it. Smashing it open, lava spilling everywhere into the ocean, the mechanical bits he plows through absolutely destroyed. No way this thing is ever going to be a threat again.

PANEL FOUR: A shot of Cannonball and Squirrel Girl--Cannonball's still holding Squirrel Girl--looking awed and dumbfounded.

> **SQUIRREL GIRL:** ...Wow.
>
> **CANNONBALL:** Oh, yeah.
>
> **CANNONBALL:** Makes you wonder what he's gonna do for the other 59 minutes.

PAGE EIGHTEEN: SIX PANELS. It's another to-camera talky bit! But the last.

PANEL ONE: It's Cannonball's turn to talk to the camera. He's wearing a leather jacket and a LILA CHENEY TOUR t-shirt. Maybe he's got a little stubble going, as I said. He's talking frankly to the camera, about a hard life--again, leave room for dialogue.

> **CANNONBALL:** I was born in Cameron County, in Kentucky. Eldest of a big family.
>
> **CANNONBALL:** My daddy worked in a mine to keep food on our table, and that's what killed him. Black lung, from coal dust.
>
> **CANNONBALL:** I was sixteen.

PANEL TWO: Cannonball looks down, remembering the memory. Those were bad days for him, but they're life for a whole lot of people, probably including some readers. Sam's a point of contact with an America that's rarely seen or represented.

> **CANNONBALL:** And that was my American dream. Right there, my path.

> **CANNONBALL:** There were mouths to feed, and I had to step up into my daddy's shoes and feed 'em.

> **CANNONBALL:** I woulda died down that mine. I mean it--it collapsed, the first day.

PANEL THREE: Sam looks up again. Serious, thinking about his second chance.

> **CANNONBALL:** 'Cept I was a mutant, so I lived through it.

> **CANNONBALL:** An' my whole life changed.

> **CANNONBALL:** That's when I met a man name of Professor Charles Xavier.

PANEL FOUR: Cannonball talks sincerely to us. This is an ideal he's believed strongly in for years--Professor X's dream of unity is his ideology.

> **CANNONBALL:** The Prof had an American dream of his own.

> **CANNONBALL:** A dream of people. All kinds, all creeds, all the different ways people can be. All walks of life.

> **CANNONBALL:** All with our own battles to fight every day, that no-one else knows or cares about.

PANEL FIVE: Cannonball looks down again. Sad. It hurts him to see America divided. We're not playing this for laughs.

> **CANNONBALL:** And all part of one thing.

> **CANNONBALL:** The Professor's dead now, and part of me wonders what he'd make of these times. When we're as divided as we are.

> **CANNONBALL:** When everything's "us" and "them". Blue and red. City and country.

PANEL SIX: Cannonball raises his head. Steadfast. Determined. He fights for all people, all humanity. He's an Avenger.

> **CANNONBALL:** Maybe he'd say that when we treat folks like they ain't human, we kill what's human in ourselves.

> **CANNONBALL:** We're fifty states, but we're one country. With all our differences, all the things that make us ourselves. We're one planet.

> **CANNONBALL:** He'd say there ain't no "them".

PAGE NINETEEN:

PANEL ONE: Cannonball looks straight at the camera. Dead serious, but maybe the ghost of a smile. I'd like to do something with the color here--move from flashback/flashforward colors to present-day colors, to show that all these to-camera PR pieces have been happening after the main action.

> **CANNONBALL:** It's just us. All of us, good and bad. All of us together.

> **CANNONBALL:** And...

> **CANNONBALL:** ...ah guess ah'm in the U.S.Avengers.

PANEL TWO: And we're in the present day! The wood-paneled room we've been in is a kind of admin office on board the U.S.Avengers' flying HQ (which we'll get to next ish. We'll lampshade that with a caption.) Pull out--Cannonball's finished his segment, and the camera people are giving the thumbs up--a couple of guys in light blue A.I.M. jumpsuits (admin division) with a camera, a small-scale operation. Roberto, standing off to the side, is smiling, gently mocking Sam--Sam smiles back.

> **CAMERAMAN:** And... cut.

> **ROBERTO:** "We're one planet?" Don't you commute in from the Shi'ar homeworld?

> **CANNONBALL:** Didn't seem the right time to mention it.

> **CANNONBALL:** 'Sides, ain't like I surrendered my passport.

PANEL THREE: Sam and Roberto take a couple of steps away from the camera people, talking amongst themselves. Sam's wondering if all the flags are the right move—-Roberto thinks he means the PR pieces they've been doing.

> **CANNONBALL:** ...you think this'll work?

> **ROBERTO:** These to-camera pieces, you mean? They're being sent as internal memos.

> **ROBERTO:** Hopefully, they can convince the S.H.I.E.L.D. skeptics that A.I.M. have changed. That we're just folks who want to help.

PANEL FOUR: Close on Sam and Roberto. Sam asking a serious question—-is it too much? Roberto answering with a half-smile. Joking, but sincere.

> **CANNONBALL:** I mean the whole bit. All the flags, all the hoo-rah...

> **ROBERTO:** Well, the PR people tell me it'll help our image. Probably.

> **ROBERTO:** But I wasn't lying earlier, Sam.

PANEL FIVE: Close on Roberto, giving Sam a sincere, heartfelt answer—-as suddenly there's a bright flash off-panel.

> ROBERTO: <u>This</u> is my country
> now. And for all that, yes, it's hated
> me, it's feared me, it's <u>hurt</u> me--

> ROBERTO: --I <u>still</u> want to
> work for...

> SFX: Va-kroom

PAGE TWENTY:

PANEL ONE: Roberto and Sam turn in the direction of the flash--
Sam astonished, Roberto realizing something's happened behind him.
The camera people are staring in astonishment--we can see little
crackles of energy coming from off-panel, from what we're about to
see.

> ROBERTO: ... the... future
> of...

> CAP 20XX: (off-panel) <u>Roberto</u>
> <u>Da Costa!</u>

PANEL TWO: BIG panel--nearly a splash. Roberto turns... to see
CAPTAIN AMERICA 20XX has materialized in the middle of the office.
Time-travel energy still crackling off her. A shield on one arm,
the other pointing at Roberto in an "Uncle Sam needs YOU!" fashion.
This is the literal future of America, calling on Roberto to work
for her. It's an order.

> ROBERTO: (small) ...the future of
> America.

> CAP 20XX: <u>This is Captain</u>
> <u>America calling!</u>

PANEL THREE: Close on Roberto--exchanging a look with Sam.
Roberto's acknowledging the coincidence of Cap 20XX suddenly
appearing on cue like that. Sam doesn't entirely believe Roberto
didn't plan it.

> ROBERTO: ...

> ROBERTO: You know I didn't
> plan that, right?

... *TO BE CONTINUED.*
Next issue--we find out what Cap wants!

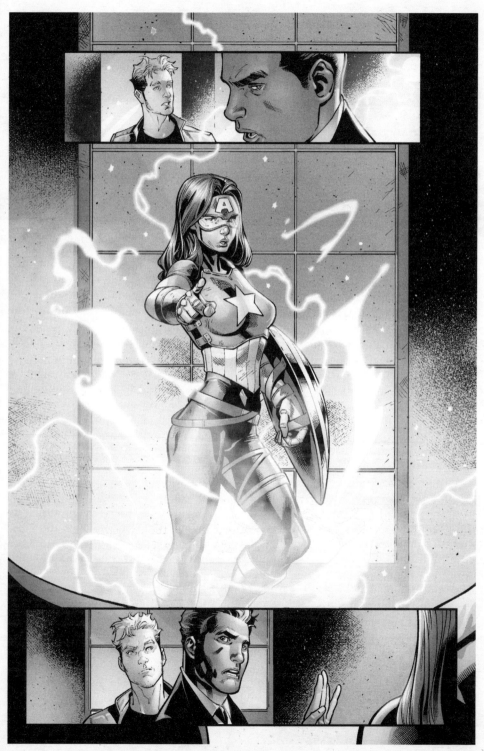

SECRET WARS (2015)
BY JONATHAN HICKMAN

AN INTRODUCTION BY **TOM BREVOORT**
IN CONVERSATION WITH **ANDREW SUMNER**

ecret Wars (2015) is probably the most ambitious event series that Marvel Comics has ever done, as it brought to a finale not only the ongoing storylines that Jonathan Hickman had been featuring in his *Avengers* and *New Avengers* runs, but literally everything else that Marvel was publishing throughout the Marvel Universe and the (then-creatively separate) Ultimate Universe up to that point. *Secret Wars* sets up a new beginning point for everything that would come, moving forward in one united Marvel Universe.

Secret Wars has a complicated genesis, because the original idea for it was one that Jonathan had while we were working on *The Fantastic Four*. And it was literally that he wanted to do a book called *Secret Wars*, which would be a secondary title that we would launch, involving a plot that wasn't ultimately the plot of *Secret Wars* as it came to be (but that did become the plot of the *Avengers* titles leading up to *Secret Wars*), involving parallel Earths being drawn together with incursion points and our protagonists being faced with this kill-or-be-killed situation, again and again and again, narratively designed to put them under pressure and to see what would happen—whether they would crack and how they would deal with these extreme events.

Those initial plans changed, although Jonathan did end up writing a Fantastic Four story that was theoretically there to set up that version of the *Secret Wars* book. But we ended up building *Secret Wars* in a different way because, on the other side of the *Avengers vs X-Men* event we did [that Jonathan, as well as four other writers, were a part of], we decided that we wanted to switch up all the key creative assignments across the Marvel line at that point. And that's the point at which Brian Michael Bendis stopped writing the *Avengers* titles and migrated over to write *X-Men* instead. Jonathan came on to *Avengers*, and Jonathan's take for doing *Avengers* was, "I'll do the *Secret Wars* stuff here, within

the two ongoing *Avengers* books: *Avengers* and *New Avengers*. *Avengers* will be more universal, featuring the public-facing and positive group, and *New Avengers* will be the clandestine and secret group that's actually dealing with these situations that are building towards a key event. And eventually we'll roll everything together into a massive event that can be *Secret Wars*." He pitched this to all of us at one of our retreats. And, as is typical for Jonathan, he would say things like, "And then, in issue 45..." and everybody would go, "You're out of your mind!" But my point is, Jonathan had all the main strokes of his narrative worked out well ahead of time. So, after that retreat, we knew for a good two years, maybe longer, that we were going to be doing *Secret Wars*.

Secret Wars is a big, all-encompassing Marvel Universe event series, the most lasting consequence of which is that it's the point at which the Ultimate Universe ceases to exist as an entity. For close to fifteen years before that, the Ultimate Universe had existed as a more accessible alternative to the main Marvel Comics universe, where (theoretically) newer, younger readers could come to Marvel's characters without all of that long-standing history and continuity baggage being attached to them, with their storylines being recast slightly more from a 21st-century perspective rather than a 20th-century perspective.

But, after fifteen years or so, anything starts to get old if it's been there for long enough. Having now done so many stories, the Ultimate Universe had just as much baggage as the core Marvel Universe. So, the decision was made that we would use *Secret Wars* to bring it all to an end and to migrate all of the best ideas, set pieces, and characters into the core Marvel Universe. For all that the *Secret Wars* we published started out as an Avengers story and ended up growing out of *Avengers* and *New Avengers*, you can really see its actual roots as a Fantastic Four story, because Doctor Doom and Reed Richards and Sue and all the Fantastic Four characters are so central to the actual *Secret Wars* narrative. At heart, Jonathan's story is a Fantastic Four idea more than anything else.

We've got the script for issue #1 here, and issue #1 was actually not

the first script that Jonathan wrote. Jonathan wrote the script for issue #2 first. The reason we did that is that, at the end of issue #1 pretty much everything is destroyed, the entire Marvel Universe is destroyed, and nothing is left. And issue #2 is all about Battleworld, this patchwork hodgepodge Earth—technically not even really an Earth, but a planet that Doctor Doom has been able to put together by salvaging the last bits, the last crumbs of all destroyed universes. And so it's a world that's made up of variants of all the various Marvel characters and bits and pieces that relate to many storylines of the past. It's a complicated place, and it's a place that we wanted to have a significant effect on all of our books. *Secret Wars* is, I think, the only Marvel event during my tenure here where editorial and creative buy-in was mandatory, by which I mean typically, when we're doing a big crossover event, we'll speak to the individual editors and creators and say, "Hey, we're doing this story that involves this, here's the buy-in, if you want to tie in, if you want to be a part of this and contribute to it, you can." And in certain instances we may strong-arm our people a little bit. For example, if it's Civil War and Captain America and Iron Man are the two key players, it kind of makes sense for there to be Captain America and Iron Man tie-ins. But even then, more often than not it's a choice rather than an ultimatum. But because of the way *Secret Wars* was laid out, the way we were going to wipe out both of our ongoing universes, literally every book in the entire Marvel line was compelled to play along: wherever you are, whatever story you're in the middle of, once we hit (I think it was May of that year), it stops. And for months, something else will fill that publishing slot that hopefully is relevant to what you're doing. And then you'll be able to pick up again, more or less unmolested (hopefully), on the other side, when we're finished in September, October, November—whenever it ended up being.

So, Jonathan wrote issue #2 first so that people could understand, "What is Battleworld? How does it work? What are its political and economic structures? Who lives where? What characters do we need in central roles?" That way, everybody else could come up with things

that they wanted to do, and fill out the rest of that environment, and do stories that were meaningful to them. Additionally, *Secret Wars* was supposed to be eight issues. And once we got into it at a certain point, we found that there was more to do than could be done in the space that we had allowed. So, what would have been *Secret Wars* issue #8 Jonathan expanded and broke into #8 and #9, both of which are scripts that we're presenting here. At some point there was a single-issue version of these two books that was trying to achieve all this narrative in a single script. And it was too tight, it didn't work. So, at the eleventh hour, we added a ninth issue. And that caused a lot of consternation, because it meant that the last issue of *Secret Wars* came out after all of the titles that were actually launching off the back of it and all the books that were returning! That was unfortunate, and there was a lot of 'sturm und drang' about it at the time, but now it's all in the rear-view mirror, nobody cares. Seven years later, it's clearly the right move to have made, even though a lot of people were unhappy about us doing that at the time—now everyone understands that the story works well, it's a great piece of work, and people really respond to it.

AVENGERS

SECRET WARS
ISSUE #1
2015

"The End Times"

By Jonathan Hickman

Art by Esad Ribic
and Ive Svorcina

PAGE 1--(5 PANELS)

NOTE: Okay, first issue, Esad. We're about two weeks behind schedule, but I think we can make up some of it on this issue. The opening and close are VERY SPARSE, and I'm going to try and keep the page count down. Just keep in mind that the issues following this one are all 20 pages, so if we hustle through this you should be in much better shape.

We're only giving you the first three pages because the issue has to be vetted by all the editors, BUT IF YOU NEED PAGES...YELL, I can get you more immediately.

Panel 1--All Black.

CAPTION
We know so much more than we understand.

Panel 2-- All Black.

CAPTION
It's been theorized that the white light you see when you die is the supercharged electric whimper of a desperate and dying brain. Synaptic death.

But it's not.

Panel 3--

A medium shot of DOCTOR DOOM, DOCTOR STRANGE, and MOLECULE MAN. It's DARK--they are in a black void. (Obviously, Doom should be out front...as he's the god we're alluding to here).

CAPTION
That brilliant, blinding light is god...

Panel 4--A brilliant light flashes.

It catches them by surprise. (This is super high contrast.)

CAPTION
And he has been with us all along.

Panel 5--On Doom.

Holding his hand up, shielding his eyes from the blinding light.

NO DIALOGUE

PAGE 2--(1 PANEL)

Panel 1--FULL PAGE.

A giant tear in space lets light come pouring out.

We see the three of them (DOOM, STRANGE, MOLECULE MAN) standing on a rectangular platform (with some kind of high-tech machinery underneath it--this is a DOOM-built time travel device). They are small in the frame against the giant fissure.

NOTE: Esad, this should be your version of the Beyonder's intro in *Secret Wars*. I'm sending you what Deo did in an issue of *AVENGERS* leading up to this (and the original page from the original *Secret Wars*), but obviously, don't feel like you need to be slavish. Do it your own way. As your way is best.

NO DIALOGUE

PAGE 3--(3 PANELS)

Panel 1--

A full shot of all three of them floating on the platform.

NO DIALOGUE

Panel 2--

On the white fissure--a voice radiating from the brilliant light. It says...

> **BEYOND**
>
> We are Beyond.
>
> Dreamers. Destroyers. All of reality our whim.
>
> (tail)
>
> Who dares stand before us?

Panel 3--On Doom.

Defiant.

> **DOOM**
>
> I.
>
> Doom.

TITLE PAGE:
EVERYTHING DIES.

MARVEL COMICS PRESENTS:
SECRET WARS

PAGE 4--(3 PANELS)

NOTE: Esad, almost all of the ULTIMATE stuff I'm referring to are
things that you've drawn before in our *Ultimates* run. So just use
that as reference. The only tricky part is how THE CITY has taken
over part of Manhattan, but you can just lay the dome over part of
it and that will look cool.

Panel 1--

Establishing shot of ULTIMATE MANHATTAN. Just like our Manhattan
except extending off the end of the island is the giant DOME of
the CITY (again, from our *Ultimates*). It shouldn't just sit in the
water, though--it should overlap the end of Manhattan and some of
the skyscrapers should be sticking up out of it.

This should be pretty wide, so we might see some of the
Helicarriers from the next panel, but maybe not.

<div align="center">

CAPTION
</div>

> Manhattan.

> Earth 1610.

Panel 2--The Triskelion.

Base of the Ultimates. Command center of S.H.I.E.L.D. Helicarriers
float around it. On high alert...as it's wartime.

NOTE: This should be both the cool futuristic HELICARRIERS you
designed in *Ultimates*, as well as a few of the old decommissioned
ones (the ones that look like floating aircraft carriers).

<div align="center">

CAPTION
</div>

> The Triskelion.

> Home of this Earth's S.H.I.E.L.D.

Panel 3--On Ultimate Nick Fury.

Sitting in a command chair. Ultimate Hawkeye beside him.
S.H.I.E.L.D. agents swarming around. He's talking to a screen
displaying the face of Ultimate REED RICHARDS (THE MAKER).

FURY

You tell me the world is ending, I wonder
if you think I'm blind. You tell me it's
ending today...

Well, then...I wanna know how long we got left?

PAGE 5--(5 PANELS)

Panel 1--On the MAKER.

We're inside the City (the DOME). The Giant City-face behind him. A
Hologram of NICK FURY'S face before him (this is the other side of
the conversation).

CAPTION

The City.

Home of the Cabal and the Children of
Tomorrow.

MAKER

Everything dies, General. In fact, much
of what could be defined as existence
already has--now all that remains is our
reality...and theirs.

What follows--this...final incursion
between Earths--will begin very soon. In
minutes, perhaps. How long will it last?
That, General Fury, depends on no small
number of variables...

(tail)

And how good you are at eliminating them.

FURY

So this is it? We destroy their world and
ours lives.

You're sure this is the last one?

Panel 2--Close on the Maker.

He tilts his head to the side.

MAKER

This City has many machines. One of
which scours all of space and time.
Observing... Recording...Witnessing the
collapse of our once infinite multiverse.

(tail)

Am I sure this is all there is left? More
than any other thing.

Panel 3--Back in the command deck.

Fury facing the giant face of Reed Richards.

> **MAKER**
> So go, General Fury...
>
> Save your world one last time. Save us
> all.

Panel 4--

Hawkeye turns to Fury as the screen blips off.

> **SFX**
> Be-doop!

> **HAWKEYE**
> Can we trust him?

> **FURY**
> Reed Richards is a thousand-year-old,
> megalomaniacal boy genius who wiped out
> most of Europe on a whim, Hawkeye.
>
> No. We most certainly cannot.

> **HAWKEYE**
> Then what the hell are we doing, Nick?

Panel 5--

On Fury, cutting his eyes over at us.

> **FURY**
> Because it's also worth pointing out that
> he's not wrong, and my job--our job--is
> protecting the world.
>
> So if this comes down to them trying
> to kill us, or us killing them. Well,
> Clint...

> *(tail)*
> That ain't no choice at all.

PAGE 6--(4 PANELS)

Panel 1--BIGGER PANEL.

Wide on the Helicarriers angling up from the Triskelion. Headed towards us.

> **CAPTION**
> Send everything...
>
> Everything we got.

Panel 2--On Ultimate Reed.

The Giant face of the city reports...

> **CITY**
> The Triskelion has launched all their ships, Maker.

> **MAKER**
> Good.
>
> They'll attack preemptively, the other Earth will respond, and while they play...we will be hard at work on the things that actually matter.
>
> What's our current estimated time of completion, City?

> **CITY**
> Undetermined. When they first started, the incursions between worlds lasted eight hours, but compression of space-time now puts my best guess at under an hour.

Panel 3--On Reed and the CITY.

Reed is turning to us as someone speaks to him.

> **THANOS**
> I have to wonder...Why lie to them?

> **MAKER**
> Hmmm?

> **THANOS**
> We've run every simulation there is. We've reached the early death

of everything. There is no saving
anything...so why lie?

MAKER
We show them one hand, and hide our real
objective in the other.

I lied because we need just a little more
time...I dress the lie up in a story of
hope because if they have that, then
they'll believe they have a chance...

Panel 4--On Thanos.

Flanked by TERRAX and the BLACK SWAN. He smiles a tight smile.

MAKER
They'll fight a little harder...and won't
that be fun?

THANOS
You humans and your theatrics...it's
unseemly. There is no honor is running
from a death...

A people should know when their time is up.

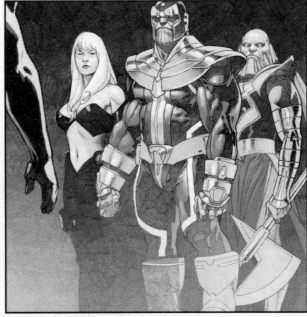

PAGE 7--(1 PANEL)

Panel 1--The incursion begins.

FROM the MARVEL UNIVERSE EARTH. Looking up at the other Earth hanging in the sky. Helicarriers crashing towards us--the HEROES of Earth rising up to meet them.

NOTE: Esad, a version of this shot has been done for the FCBD teaser, but we need to see your version (one page, not two...we don't have the real estate, plus a single page will make the angle more severe and cooler anyway). The only thing you need to make sure of is that we don't see Reed Richards stretching at the bottom of the page.

And, of course, make this much cooler and do it your way. Don't feel beholden at all.

CAPTION

Manhattan.

Earth 616.

The Incursion point between both worlds.

CAPTION

We told the truth.

We informed the various world leaders what we had learned that morning, and then we watched as they told their nations.

It was the Chancellor in Germany, the Prime Minister in Britain and Japan, it was the royal family in Riyadh...and here it was the President.

The language they used--their message-- was almost all the same.

Remain calm. The World is ending and we--those in power--are doing everything we can to find some solution to this terrible problem. But no one believed them...

How could they?

PAGE 8--(5 PANELS)

Panel 1--

People, down on the street, looking up terrified. SOMEONE STEPS UP THROUGH the crowd to the FRONT--It's SPIDER-MAN, he looks up. EYES WIDE.

CAPTION
They were just men, and the people
believed in something more.

SPIDER-MAN
Ooookay, everyone get off the streets.
Get some place safe...

I'll take care of this...

(small)
Uh, maybe.

Panel 2--

Establishing shot of the Baxter Building. Other buildings around it are blowing up, but it has a small force field deflecting anything that isn't a direct attack.

THE THING
(from inside the building)

Looks like the situation's gone from bad
to worse...

Are we ready to go?

Panel 3--

Inside the main lab--WE SEE the completed LIFE RAFT. All of the FUTURE FOUNDATION KIDS along with JOHNNY and BEN are loading supplies into it (for the trip to who-knows-where, but someone's gotta make it through this thing).

HUMAN TORCH
All the supplies are prepped and we're
almost done packing.

But looking over the lab specs, are we
sure we need this many foodpacks?

Panel 4--On REED, BLACK PANTHER, and SUSAN.

Reed and Panther are standing over a command center. Preparing the RAFT for launch. Reed is turning back to say something to SUSAN. Susan has on a headset, in communication with someone.

> **REED**
> When we realized mankind was doomed, we built the life raft with the hopes of restarting the human race.
>
> Hydroponics is a pretty solid medium-range solution, Johnny...
>
> But that's not going to matter if our entire specially chosen science team starves in the first month.

> **BLACK PANTHER**
> Speaking of...
>
> What's the ETA on our valuable cargo, Susan?

Panel 5--

On SUSAN, touching the headset with her hand.

> **SUSAN**
> They're due any minute, T'Challa...but that was before the rain started...

> *(tail)*
> Let me check in.

PAGE 9--(5 PANELS)

Panel 1--

On a SCIENCE TRANSPORT SHIP moving between various skyscrapers headed towards the BAXTER BUILDING (NOTE: We can't see the Baxter Building here). Inside are all the various experts in biology, chemistry, engineering, *etc.* that would be necessary if you needed to RESTART human civilization after an end times event (such as what's going on right now).

> **RADIO**
> Courier One, this is the Baxter Building calling for a status update.

(tail)
Black Widow? Spider-Woman? Are you
reading me?

Panel 2--

Inside the SCIENCE TRANSPORT SHIP. Piloting it are BLACK WIDOW and
SPIDER-WOMAN...Behind them we can see the holding area where all
the scientists are strapped in.

> **BLACK WIDOW**
> We hear you, Susan. Our transport is five
> minutes out...
>
> We're having to take a longer, less-
> explosive route.

> **SUSAN**
> *(radio)*
> How did the exfiltration go?

Panel 3--

In the holding area of the SHIP. We should see BEAST and AMADEUS
CHO strapped in alongside the other scientists. Cho is putting his
hand on Beast's shoulder trying to comfort him--Beast has tears
running down his face (he's just spent the last two hours pulling
families apart because they don't have room for everyone). Everyone
is taking it hard.

> **BLACK WIDOW**
> *(off panel)*
> We just spent an hour literally pulling
> families apart.
>
> So it went exactly as expected, and no
> one is taking it well.
>
> Two of the scientists even changed their
> minds and decided to stay. Here, I'm
> sending you the final passenger list now.

Panel 4--

Susan turns back to Reed and Panther. Tells them everything is GOOD
to GO. The scientists are on the way.

SUSAN

Natasha says five minutes. And we lost
Doctors May and Zhang. They stayed
behind.

REED

Chemistry and physics. They were
redundancies.

We're okay.

(tail)

Let's start the countdown to launch.
T'Challa, can you...

BLACK PANTHER

Yes.

Panel 5--On Panther and Reed.

Strapping in EDEN FESI--MANIFOLD--into the circular portion of THE
BRIDGE. The Bridge is a device that Reed created that can allow
the user to scan potential futures--We'll get you ref for this,
but MANIFOLD should be positioned inside the circle, kind of like
the Vitruvian man. It's basically been converted into some kind of
control harness.

NOTE: Manifold is who will gather all the remaining heroes that end
up on the raft (CYCLOPS, CAPTAIN MARVEL, STAR-LORD, ETC.).

BLACK PANTHER

Two scenarios, Manifold, you get that.
One, everything goes as planned. We
launch with our resurrection team, you
teleport on board, and we're off.

Two...everything goes wrong...

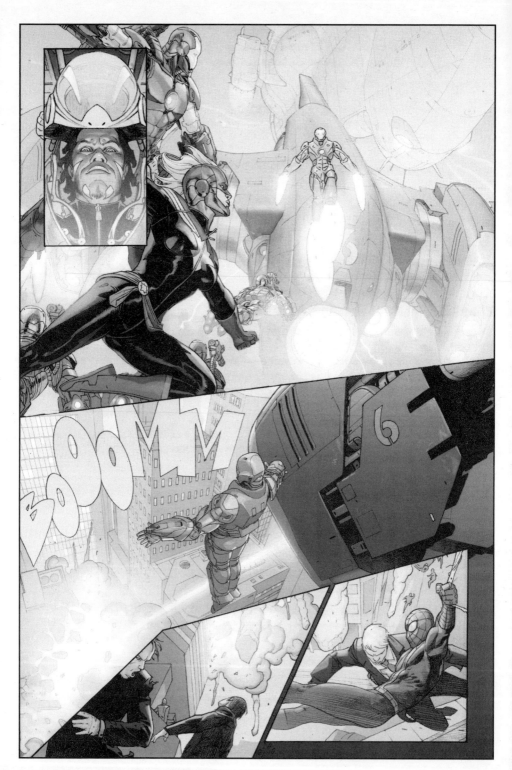

PAGE 10--(5 PANELS)

Panel 1--

On Eden Fesi (MANIFOLD) as they attach some headgear to him.

Serious. "I'll get it done."

MANIFOLD
And then I save the day.

(tail)
Okay, I'm ready...turn this thing on.

Panel 2--

Ultimate IRON MAN hovering down--a bunch of Helicarriers around and behind him--he's directing the attack on the '616' Universe. In the extreme foreground, we see CAPTAIN MARVEL (Carol Danvers) and multiple WAR MACHINES flying towards him.

ULTIMATE IRON MAN
Fury, this is Stark...

We are meeting heavy opposition. No large-scale response to our fleet, but we are heavily outnumbered on the metahuman front.

(tail)
You want to dispel some of that tactical acumen you're famous for?

FURY
(radio)
There's no second chances or prolonged conflict here, Mister Stark. Overwhelming force is what's called for.

Just win, baby.

Panel 3--

Behind ULTIMATE IRON MAN, the crazy, giant IRON MAN DESTROYER UNIT from the end of Hitch and Millar's *Ultimates* descends (we'll get you ref). It BLASTS AWAY with its super huge laser cannons. They disintegrate one or two war machines, but the blasts are bigger than that we watch as they...

ULTIMATE IRON MAN
Understood.

(tail)
Initializing Iron Man Six...

SFX
BBOOOOOMMMM!

Panel 4--LOOKING UP.

In the background, we see a building blasted into bits. Debris falling to the ground--a bunch of people running away, but one stands paralyzed...

PEOPLE
Look out!

PEOPLE
Run!

PEOPLE
Oh, god...

Panel 5--

Until Spider-Man swings in and snatches them from being crushed by falling debris.

SPIDER-MAN
You can breathe.

I got you.

PAGE 11--(5 PANELS)

Panel 1--

In the foreground, we see LUKE CAGE lifting up some debris so IRON FIST can rescue some people trapped. Behind them, in the sky, we see the GUARDIANS of THE GALAXY's ships hovering over a building getting ready to land.

POWER MAN
Danny?

IRON FIST
Almost done. Last one...

> (tail)
>
> Come on. That's it.

Panel 2--

The Guardians getting out of the ship. Have you seen the movie, Esad? If you have, then ROCKET should be fastening some kind of superweapon onto DRAX's chest for him to fire. Star-Lord should be pointing off to the giant IRON MAN DESTROYER in the sky.

> **STAR-LORD**
>
> See that big robot thing in the sky... that's the one you want to focus on.

> **ROCKET**
>
> What? Where? Oh, you mean the massive, tacky yellow and gold thing that basically says, "Hello. I was built by a giant tool, please shoot me out of the sky."

> (tail)
>
> No. Problem.

Panel 3--

THOR (this is lady Thor) and STORM in the sky--both of them using their powers to summon lightning...

> **STORM**
>
> Thor! With me...

> **THOR**
>
> Aye. If this is the end, let us summon a storm for the ages.

> (tail)
>
> STRIKE!

Panel 4--

And together they BLAST a Helicarrier with lightning--it cracks open.

> **SFX**
>
> KRAK-A-THOOOOOM!!!

Panel 5--

Captain America (this is FALCON-CAP, Esad) and ICE MAN on top of the AVENGERS tower. They are looking down at TWO SENTINELS flying through the city...

CAPTAIN AMERICA
Ice Man, look!

Sentinels! Are they friend or foe?

ICE MAN
Who knows, Captain. It's the Nation...

PAGE 12--(5 PANELS)

Panel 1--

CLOSER on the TWO SENTINELS landing in the city. In between them they are carrying a container (inside the container is a PHOENIX EGG that Cyclops is going to crack open to become the new Phoenix)--Cyclops is crouched on top of the container. Obviously, people are running away from them.

CAPTION
There's no telling what Cyclops has planned.

SENTINEL
Landfall, Professor. Package intact.

Your orders.

CYCLOPS
I need just a little time.

Keep everyone away for as long as you can.

Panel 2--

The Inhumans arrive landing on a HELICARRIER--(you can pick who you want with him), but BLACK BOLT screams as he lands--destroying a bunch of jet fighters.

CAPTION
Fury! We're taking heavy losses...

Helicarriers are going offline.

Panel 3--

ULTIMATE IRON MAN (who is grappling with CAPTAIN MARVEL) looks back as the giant IRON MAN DESTROYER explodes in the sky.

<div align="center">

FURY
(radio)
Hold as long as you can, Stark.

ULTIMATE IRON MAN
I don't think that--

SFX

</div>

BA-BOOOOOM!

Panel 4--

ROCKET and GROOT laughing and pointing (at the big explosion the Iron Man Destroyer made) as DRAX reloads the superweapon.

> **ROCKET**
> Ha! Ha! Ha!
>
> There goes a billion dollars' worth of red and gold crap.

> **GROOT**
> I am Groot.

> **ROCKET**
> I do remember when comic books were only a dollar.
>
> A dollar's worth of crap!

Panel 5--

CAPTAIN MARVEL fighting with Ultimate Iron Man in midair. She rips a chunk of his armor off.

> **CAPTAIN MARVEL**
> See that, hero...
>
> Time to radio in with some more bad news. Maybe call for backup.

PAGE 13--(5 PANELS)

Panel 1--On the roof of a skyscraper.

HULK. SHE-HULK. COLOSSUS. POD. And NIGHTCRAWLER. POD is pointing off up into the sky (at the other Earth--tracking that the ships are coming from the Triskelion), She-Hulk, standing beside her, is using a high-tech telescope/binoculars of some kind.

> **POD**
> Magnify section 187.09 By 902.87. See it?

> **SHE-HULK**
> Uh-huh. That's where they're coming from. But it'll be like hitting a penny with a marble from a mile away...

You sure you can do that, Colossus?

COLOSSUS
Trust me, comrade...

Panel 2--

COLOSSUS throwing Hulk towards us. A 'fastball special' like when Colossus used to throw Wolverine.

COLOSSUS
I've had lots of practice.

Panel 3--

On General Fury and Hawkeye in the Command Center. They are talking to ULTIMATE TONY STARK on the display. TONY STARK IS SCREAMING.

ULTIMATE IRON MAN
Nick, I lost the Six and we're down eighty percent of the carriers.

We're done, Fury! DONE!

FURY
I hear you, Stark--I'm going to cal--

Panel 4--WIDE on the TRISKELION.

We see something crashing through it -

- like a meteor. (It's the HULK).

SFX
BA-BBOOOOOOM!

Panel 5--On FURY and HAWKEYE.

The building shaking like it's coming apart.

HAWKEYE
What the hell?

PAGE 14--(4 PANELS)

Panel 1--

On the HULK digging himself out of the wreckage--HE SMILES--as two more meteors smash through the building behind him.

NO DIALOGUE

Panel 2--BIG PANEL.

Hulk looking up at the still-standing Triskelion but with big smoking holes in it. Behind him, SHE-HULK is helping POD out of the rubble, while NIGHTCRAWLER is teleporting him and COLOSSUS onto the scene.

SHE-HULK
I say, let's go for a ride... Whoa, baby. It's a rollercoaster.

(tail)
I can't believe that thing is still standing.

HULK
For now.

Panel 3--

Inside the Triskelion command center. Everything is wrecked, people are injured. Hawkeye is pulling cables from some machine and connecting them to another. Fury has a bloody nose.

> **HAWKEYE**
> We've lost communication with the
> Incursion force.

> **FURY**
> Patch me through to the City, Hawkeye.
> Any time you shave off of your very best
> would be greatly appr--

> **HAWKEYE**
> Got 'em.

Panel 4--

The screen flickers to life. THE MAKER and the CITY FACE behind
him.

> **MAKER**
> General. How goes the war?

> **FURY**
> Oh, pretty damn fantastic as you might be
> able to infer...
>
> We've failed to secure the Incursion site
> on the other Earth. You're going to have
> to do that as well before you detonate
> it.
>
> As much as I hate to admit it...

PAGE 15--(5 PANELS)

Panel 1--

The HULK, SHE-HULK, COLOSSUS and POD are all straining--LIFTING the
base section of the TRISKELION.

> **CAPTION**
> We're done.

Panel 2--FURY.

Screaming into the monitor at the MAKER. "We're going down--it's up
to you and the CITY now."

FURY

Darkest moments of a dark life, and I swear, I never once thought I'd go out like this.

Make sure you finish the job, MAKER!

MAKER

'Finish' implies that your task was uncompleted, General.

Panel 3--

On HULK straining, screaming, extending his arms up--like he's dead-lifting the whole damn building.

CAPTION

It implies a failure of action or understanding of purpose--Let me assure you...

This was always how it was going to end.

Panel 4--WIDE.

We see the Triskelion crumbling/collapsing. In the foreground, silhouetted, we see several people watching this from a distance.

CAPTION

You bought us no little bit of time...

And that was remarkable for one whose time had long passed.

Panel 5--

We see ULTIMATE Cloak and Dagger, Kitty Pride, Jean Grey and Jimmy Hudson looking on, completely shocked.

CAPTION

Let me show you what I'll build on your ruins.

PAGE 16--(4 PANELS)

Panel 1--

Amongst the wreckage of the collapsed Triskelion. SHE-HULK, HULK, COLOSSUS and POD in the background, all looking off into the distance. IN THE FOREGROUND, NIGHTCRAWLER is pointing at something. "MY GOD...what's that?"

> **NIGHTCRAWLER**
> Mein Gott!
>
> What is that?

Panel 2--BIG PANEL.

On the DOME. The top of it pulling apart / flowering open.

> **NO DIALOGUE**

Panel 3--

A hologram of the Maker, deep inside the DOME, speaking with MAXIMUS and NAMOR. CORVUS and PROXIMA MIDNIGHT are in the background, messing with their Raft.

NOTE: What they are working on here is THEIR VERSION OF THE LIFE RAFT (what you've already drawn in issue 2). We need to show them working on it, but don't give away what it is. We want to hold onto that end of issue #2 reveal as hard as we can.

> **MAKER**
> The diversion has run its course. Is the
> build completed?

> **PROXIMA**
> Your specially bred engineers erected a
> temporal bubble to buy themselves time...
> but they are not finished.

> **NAMOR**
> It seems your fast is not fast enough,
> Richards. It seems you continue to
> disappoint in two worlds.
>
> Do something.

Panel 4--On the MAKER and the CITY.

Standing face to face. The Maker basically convincing the City that the only course of action it can take is sacrificing itself (and

many of its CHILDREN) to save the day (He knows better and he's lying to it).

> **MAKER**
> City.

> **CITY**
> Yes, Maker.

> **MAKER**
> We cannot have any more interlopers from their Earth...I need more time...
>
> Will you launch the Children into the fray?

PAGE 17--(4 PANELS)

Panel 1--BIG PANEL.

Out of the OPENING of the DOME, all the future ships that THE CHILDREN of the CITY had in *ULTIMATES* come flying out accompanied by a bunch of the flying warriors as well (First swords, second knifes, *etc.*--You have all this ref). They streak off into the sky towards the other EARTH.

> **CAPTION**
> Abandon our sons and daughters one last time.

Panel 2--

We focus on the top of the DOME. We see a small human shape there clinging to/creeping up to the top.

> **NO DIALOGUE**

Panel 3--

We move closer and see that it's ULTIMATE SPIDER-MAN, MILES MORALES.

> **ULTIMATE SPIDER-MAN**
> Huh.

Panel 4--

He peeks inside. And the eyes of his mask go wide at what he sees.

> **ULTIMATE SPIDER-MAN**
> Whoa.

PAGE 18--(4 PANELS)

Panel 1--

The Children descend to 616 EARTH. Just an invading horde of unstoppable future ships and people.

NO DIALOGUE

Panel 2--

We see them SWARM the Inhumans--specifically BLACK BOLT.

One of the CHILDREN clamping something over his mouth, others sticking all kinds of probes in him. Inhumans dying behind them.

NO DIALOGUE

Panel 3--

Ice Man and Captain America on top of the AVENGERS tower. In the background, ICE MAN is shooting off some frozen balls of death. In the foreground, Captain America turns and looks at us like "OH, ███."

> **ICE MAN**
> Who are these guys? What are th--

> **CAPTAIN AMERICA**
> I don't know...

Panel 4--

We see a CHILDREN cruiser has lifted up right in front of the Avengers Tower. It's clearly big enough to destroy the Tower.

> **CAPTAIN AMERICA**
> But we're about to find out.

PAGE 19--(5 PANELS)

Panel 1--And it does.

Absolutely blasting away the entire thing--the top of the Avengers
Tower breaking apart. We see the 'A' flying off.

> **CAPTION**
> To: Lizard@aol.com, Hitthetarget@gmail.
> com, who@geocities.com, *Etc.*
>
> From: wfisk@fiskindustries.com
>
> Re: END OF WORLD.

Panel 2 -

A bunch of bad guys in a bar, drinking to the end of the world. In
the background there's a big screen showing the Avengers Tower being
destroyed and a few of them are toasting it. "Yay! Let it burn!"

NOTE: The bad guys here are people like: BULLSEYE, KINGPIN,
SANDMAN, MYSTERIO, SCORPION, RHINO, PYRO, ABSORBING MAN, ELECTRO.
Use whoever you want.

> **CAPTION**
> Like all of you, I dreamed of a glorious
> end. Me, standing over the vanquished, as
> the world looked up in envy. But it seems
> time, that fickle mistress, has robbed us
> all of such opportunity.
>
> So I say this: If the world is truly
> ending, let it end thusly...
>
> With drink, and joy at the sight of our
> enemies' greatest failure.

Panel 3--

The bad guys in the bar turn towards us (away from the screen).
Someone has said something that has caught their attention.

> **CAPTION**
> Please join me for a most raucous
> celebration at that place where we met
> that time for the thing. I'm buying.
>
> Sincerely,
>
> Wilson Fisk.

PUNISHER

Ahem!

Panel 4--

In the background, silhouetted in the door frame is the PUNISHER. We see his skull logo prominently. In the foreground, bad guys turning to face him.

PUNISHER

Gentlemen. They say...that when you die, you can't take it with you.

Which begs the question:

Panel 5--

Medium shot of the Punisher. He cocks his guns (so he's either holding a shotgun or two pistols, or maybe two machine guns--your call). He smirks. "You don't get to go out like this."

PUNISHER

Exactly what am I gonna do with all these bullets?

PAGE 20--(5 PANELS)

Panel 1--

The SCIENCE CARRIER piloted by SPIDER-WOMAN and BLACK WIDOW approaching the Baxter Building. We can see CHILDREN swarming all over it.

> **BLACK WIDOW**
> *(radio)*
> Baxter Building, this is Courier One.
>
> Bad news...

Panel 2--INSIDE THE SCIENCE CARRIER.

Terrified scientists scream as CHILDREN rip through the hull. Black Widow screaming into her comms.

Beast fighting one of the Children off. Cho is already dead.

> **BLACK WIDOW**
> We're not going to make it.
>
> You're on your ow--

Panel 3--Exterior shot.

We see the Science Ship explode. Children flutter away.

> **SFX**
> Ba-BOOOOOOOM!

Panel 4--

On Susan, turning to Reed. "Oh, God. We've lost the ship."

> **SUSAN**
> Oh no...
>
> Reed! We've lost the Resurrection Team.

> **REED**
> Damn. T'Challa...

Panel 5--

Black Panther turns to Eden Fesi--I'm sorry, but there's no other choice. Fesi tells him to "do it."

BLACK PANTHER
Option two it is, Eden.

I'm sorry. This is going to hurt.

MANIFOLD
Do it.

PAGE 21--(5 PANELS)

Panel 1--

THE BRIDGE POWERS UP! Eden Fesi becomes supercharged. The MANIFOLD ENERGY SIGNATURE appearing--little tendrils of energy shoot out from it (each one going to collect a hero). He almost becomes an outline and we can see his skeleton inside.

MANIFOLD
AARRGGHHHH!

Panel 2--

We're looking up at the Baxter Building--we see the tendrils of energy shoot out.

NO DIALOGUE
Panel 3--

Elsewhere in the city we see the SENTINELS blasting out at CHILDREN. Protecting CYCLOPS and the CARRIER. One of the CHILDREN is tearing a Sentinel's head off. But that's not what catches our EYE.

CYCLOPS has opened the carrier (like the sides of it fell open), and we see a LARGE GLOWING EGG in there.

CYCLOPS
There you are, old friend...

Remember me?

Panel 4--

On CYCLOPS and the EGG. It cracks open.

CYCLOPS
Remember how this feels?

Panel 5--

On CYCLOPS' face--reflected in his 'X' visor we can see a PHOENIX emerging from the EGG.

<div align="center">

CYCLOPS
</div>

> It's love.

PAGE 22--(4 PANELS)

Panel 1--BIG PANEL.

CYCLOPS is now the PHOENIX. He almost unaware that he's melted the Sentinels to slag and vaporized the CHILDREN.

<div align="center">

NO DIALOGUE
</div>

Panel 2--

We see a CHILDREN ship blow up where the GUARDIANS are fighting. Groot is destroyed. Shattered into pieces. Rocket is blasted as well.

<div align="center">

SFX
</div>

> Tha-THOOOOM!

<div align="center">

ROCKET
</div>

> AARGGHH!

Panel 3--

One of the Guardians. Gamora kneeling over Rocket's dead body (surrounded by exploded Groot wood). Drax shaking a blade at the sky in anger. But what we really notice is ONE of MANIFOLD's energy tendrils hitting STAR-LORD. He stares at his hands as he starts glowing.

<div align="center">

GAMORA
</div>

> No. Rocket...
>
> Groot...

<div align="center">

STAR-LORD
</div>

> These guys are...wait...
>
> What...

Panel 4--

And then we pull back from the shot and see that STAR-LORD has disappeared and the two remaining living Guardians (Gamora and Drax) are surrounded by CHILDREN and THEIR SHIPS.

STAR-LORD

The...

PAGE 23--(6 PANELS)

Panel 1--STORM and THOR battling CHILDREN.

THOR being hit by the MANIFOLD signature and becoming pure energy.

<div align="center">

THOR

</div>

 The...

Panel 2--

Spider-Man swings through the city. Also getting hit by the MANIFOLD signature and becoming pure energy.

<div align="center">

SPIDER-MAN

</div>

 The...

Panel 3--

CAPTAIN MARVEL still battling with ULTIMATE IRON MAN. She's getting ready to punch him...

<div align="center">

ULTIMATE IRON MAN

</div>

I know this is long shot, but when all
this is done maybe I could take you out.

Show you the town.

<div align="center">

CAPTAIN MARVEL

</div>

Oh, shut...

Panel 4--

But gets hit by the MANIFOLD SIGNATURE and becomes energy.

> **CAPTAIN MARVEL**
> The...

Panel 5--Inside the BAXTER BUILDING.

Everyone getting into the LIFE RAFT. Reed and Black Panther look back at us. IN THE EXTREME FOREGROUND we can see bits of what he's looking at: MANIFOLD still strapped into the machine.

> **REED**
> We're out of time. We're lifting off.
>
> Cut him loose.

> **BLACK PANTHER**
> Can't. I changed the plan, Reed. If we lost the science team, I didn't tell him to find more people capable of doing that job.
>
> I told him to find people who could do a different one.
>
> And that's what he's doing.

Panel 6--On MANIFOLD.

Cutting his eyes over at PANTHER (at us). Again, he's almost pure energy now--we can see his bones through his skin...but we can make out his expression: "GO!"

> **MANIFOLD**
> Go.

PAGE 24--(5 PANELS)

NOTE: The next three shots should all be ONE-POINT perspective, LOOKING DOWN!

Panel 1--

Looking down at the top of the BAXTER BUILDING--IT OPENS and we see the LIFE RAFT fully for the FIRST TIME.

NO DIALOGUE

Panel 2--

Looking down at the Baxter Building again. Same shot, basically, but the LIFE RAFT is closer to us. It's launched.

NO DIALOGUE

Panel 3--

LOOKING DOWN at the DOME back on the Ultimate EARTH. We can see that the Dome has opened wider, and maybe we can see tiny bits of it, but they have a RAFT as well. NOTE: ESAD, again...this needs to be vague. It needs to make sense if people flip back to it after the end of ISSUE 2 (revealing that the Cabal had A LIFE RAFT as well, but we don't want to give it away).

NO DIALOGUE

Panel 4--On the MAKER and THANOS.

It's time to go. The Maker tapping his head with his finger as he walks off.

> **MAKER**
> (tying together all the 'strategy'
> threads).

Panel 5--WIDE on the MANHATTAN.

We see the PHOENIX BIRD rising out of it. CHILDREN ships being eradicated. The LIFE RAFT silhouetted above the Baxter Building.

> **CYCLOPS**
> You can't kill an idea.

PAGE 25--(4 PANELS)

Panel 1--

On MANIFOLD in the harness. Screaming.

> **MANIFOLD**
> AARRGGHHHH!!!

> **CAPTION**
> It always comes back.

Panel 2--On PHOENIX-CYCLOPS.

He gets hits by the MANIFOLD SIGNATURE.

CYCLOPS
Reborn into its new form. Reborn as
the...

Panel 3--

MANIFOLD fades away.

NO DIALOGUE

Panel 4--BIG PANEL.

On board the LIFE RAFT. The assembled refugees appear: CYCLOPS,
STAR-LORD, THOR, SPIDER-MAN, CAPTAIN MARVEL.

NOTE: STAR-LORD should be picking off a piece of wood from his
jacket--A PIECE OF GROOT--this is the toothpick he is chewing on.

CYCLOPS
Same thing...in a different form.

PAGE 26--(4 PANELS)

NOTE: Also, Esad, there will be more people inside the raft than what's listed in these panels, but we'll cover that in the previous pages, so you're okay to just focus on what follows.

Panel 1--BIG PANEL.

Inside the RAFT. In the foreground, REED RICHARDS and BLACK PANTHER are at a command/control panel.

In the background, the INVISIBLE WOMAN, THING, JOHNNY STORM are trying to get the FUTURE FOUNDATION KIDS to go sit in their seats against the wall. (As for the FOUNDATION KIDS, you're fine just showing VAL, FRANKLIN, LEACH and BENTLEY).

NOTE: Reed has a beard.

REED
Everyone strap in! Are we at full power?

BLACK PANTHER
Yes...but the incursion wall is expanding.

Panel 2--

On Just Black Panther and Reed at the control panel.

REED
Are we going to make it?

BLACK PANTHER
Yes. Barely.

Panel 3--

On STAR-LORD and CAPTAIN MARVEL. The ship starts shaking. They look up and around at the ship...is this thing going to hold together?

NOTE: STAR-LORD should have a toothpick in his mouth.

SFX
RRRUUMMMMBLLLLEEE!

CAPTAIN MARVEL
That doesn't sound good.

> **STAR-LORD**
> Should that be happening? Should we be
> shaking like this?

Panel 4--

Back on Reed and Black Panther. Both concerned.

> **REED**
> Where are we?

> **BLACK PANTHER**
> Ninety-two percent. Still in the Raft's
> safety threshold.

> **REED**
> The shield is holding...but we've got to
> get clear of this before--

PAGE 27--(2 PANELS)

Panel 1--BIG PANEL.

Arcs of lightning/energy have been sparking between the two worlds
as they've gotten closer. ONE of them hits the RAFT in one of the
protruding sections (the pieces sticking out at 12, 3, 6, and 9
o'clock).

The section breaks off.

> **SFX**
> KKRRAKK-A-THOOOM

Panel 2--

In the foreground we see Reed and Panther turn and where Susan,
Ben, Johnny and the kids were there is now a gaping hole in the
RAFT...Except in the distance, maybe 100 feet away, we can see the
others still in the broken-off section.

And maybe this is the exact same panel as PANEL 1 on the previous
page, Esad. So adjust the panel size of THIS PAGE'S panel 1 if you
need to make it work.

> **REED**
> Oh, no...

PAGE 28--(5 PANELS)

NOTE: From this point on, the background of these panels should be WHITE...like they're floating in nothingness (as they basically are).

Panel 1--WIDE.

The severed piece floating away from the raft.

NO DIALOGUE

Panel 2--SAME SHOT.

-- MAYBE the piece has moved a bit farther away--but suddenly it has one of the Invisible Woman's force bubbles around it.

NO DIALOGUE

Panel 3--

We're looking into the broken-off piece. The kids are all hugging either each other or Ben. Johnny stands in front of them, partially flamed on--BUT SUSAN, like a rock, stands there with her hands out...straining to keep the broken-off piece together.

NO DIALOGUE

Panel 4--On Reed and Black Panther.

Standing in the hole that's broken off. Reed has one of his hands stretched out--like he's going to reach out and PULL THEM BACK-- but it's blocked by the FORCE SHIELD around the raft, so his hand squishes up against it.

NOTE: Maybe Captain Marvel and Star-Lord have come up behind them.

> **REED**
> That's it, Susan...
>
> *(tail)*
> T'Challa, I need you to drop the shield--
> the forces at play out there...they have
> to be taking everything she's got to keep
> them in one piece--but I can pull them
> back in.
>
> **BLACK PANTHER**
> You'd only have, maybe, five-six seconds
> before the entire raft is compromised,
> Reed...

Panel 5--CLOSE on Reed and T'Challa.

Reed snaps his head around, as serious as we've ever seen him.

> **BLACK PANTHER**
> Can you do--
>
> **REED**
> Yes!

PAGE 29--(5 PANELS)

Panel 1--Wide on the room.

Panther moving back to the control panel. Reed still standing at the breach...Captain Marvel and Star-Lord have been joined by lady Thor.

BLACK PANTHER
Okay...It's going to take a full cycle to
power down the shield...I can instantly
slam it back into place, but, Reed...If
hull integrity goes below 90 percent, I
have to turn it back on no matter what,
understand? We'll lose the entire raft if
I don't.

REED
I understand.

Do it.

BLACK PANTHER
Okay. In 5...

Panel 2--Close on Reed.

Ready. Hoping...

CAPTION
4...

REED
Hold on, Susan...

Panel 3--On Susan and the others.

Her hands still stretched out. We can see how much she's straining.
If you want, do the thing where her nose is bleeding out of one
nostril. And we can see by this panel, Esad...she is holding.

CAPTION
3...

CAPTION
Hold on.

Panel 4--

And then we see a crack in her shield. She glances at it. If you're
wider here, do Johnny and the others (but really, we want to play
with Susan's expressions here).

CAPTION
2...

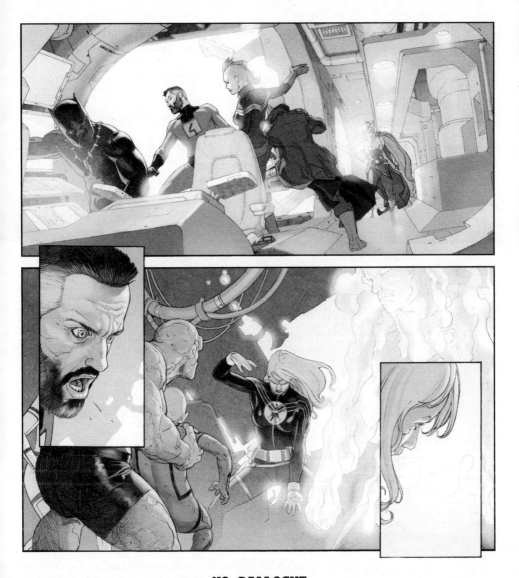

NO DIALOGUE

<u>**Panel 5--CLOSE on Susan.**</u>

The crack spreads...but we don't even notice that, because her
face...my god, the look on her face, it says..."I'm sorry." Tears
welling up in her eyes.

CAPTION

1...

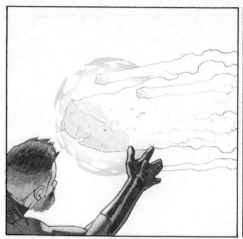
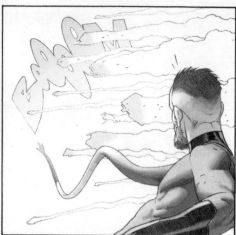

NO DIALOGUE

PAGE 30--(5 PANELS)

Panel 1--Wide.

On the bubble section and raft. The bubble shatters.

CAPTION

Go!

Panel 2--Same shot.

The broken-off section of the ship disintegrates.

We see Reed's arms extending out to grab it...but nothing...

NO DIALOGUE

Panel 3--BIG PANEL.

We're looking into the raft from outside through the hole. REED is screaming out, his hands extended--he's just watched his entire family die right in front of him, so he's mad with grief. CAPTAIN MARVEL, LADY THOR and STAR-LORD are trying to hold him and pull him back in.

REED

NNOOOOOOOOO!

CAPTAIN MARVEL

They're gone. The section just splintered into...oh, god...

(tail)

Get the shield back up, T'Challa!

Panel 4--WE PULL BACK.

The RAFT drifting away. Reed's hands still stretched out a bit, he's still reaching out...

CAPTION

GET THE SHIELD UP!

Panel 5--

The RAFT drifts further away. The shield is invisible, Esad...but we see just a bit of it where it activates and cuts off the tips of the fingers of one of Reed's hands.

NO DIALOGUE

PAGE 31--(5 PANELS)

NOTE: We're fading to white during all this, Esad. So while the drawings should be your normal tight stuff, the PALETTE should be completely grayscale and then eventually completely white. I think it'll be okay to leave the worlds as just big balls and not try to color them 'Earth' colors.

Panel 1--

The RAFT now far in the distance...it's fading away (into white), moving out of phase with these two collapsing universes. All that's left behind are the little nubs of Reed's fingertips.

NO DIALOGUE

Panel 2--

We pull wider. We see the two hemispheres of two worlds getting ready to touch.

NO DIALOGUE

Panel 3--

The two worlds touch. Huge chunks of Earth peel off and float. Like if you rubbed two huge (but soft) rocks together and pieces are just grinding off.

NO DIALOGUE

Panel 4--

Now they fully collapse into each other. Huge chunks floating.

NO DIALOGUE

Panel 5--

Then everything goes white.

NO DIALOGUE

PAGE 32--(5 PANELS)

Panel 1--White.

Panel 2--White.

Panel 3--CLOSE ON the FACE OF DOOM.

(Also colored completely white--and, I think, we're going for just the mask here, Esad. No eyes, no cloak). Subtle. Iconic.

Panel 4--White.

Panel 5--Black.

PAGE 33--(1 PANEL)

Panel 1--All black.

PAGE 34--(1 PANEL)

Panel 1--All black.

AVENGERS

SECRET WARS
ISSUE #8
2015

"Under Siege"

By Jonathan Hickman

Art by Esad Ribic
and Ive Svorcina

PAGE 1--(2 PANELS)

Panel 1--BIG PANEL.

The battle where we left off last issue. Rabid Hulks tearing
through the fighting armies (Inferno demons, Mister Sinisters,
Thors, etc.) on the battlefield before Castle Doom. Please make
sure we see Spider-Man and Ultimate Spider-Man fighting amongst the
craziness.

CAPTION

Thirty klicks out.

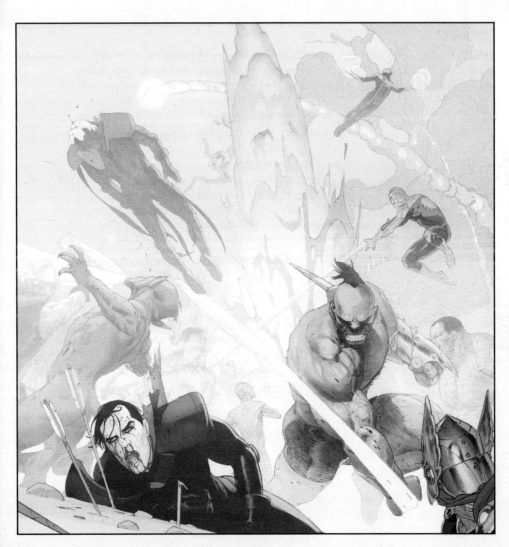

Panel 2--

The cool-looking ship of REED, MAKER and STAR-LORD races over the battle towards Castle Doom. Say around 30 miles out--the castle in the distance. In the SUPER EXTREME foreground we can see the rocky shapes that are one of BEN GRIMM's legs (make this subtle, Esad, we should only figure this out after he shows up in a few pages).

<div align="center">

STAR-LORD
(from ship)
We're hitting the warzone...

</div>

PAGE 2--(4 PANELS)

Panel 1--

Inside the ship we see STAR-LORD piloting (TOOTHPICK IN MOUTH)--Reed and the Maker are his passengers. Star-Lord smiling and cocky. REED RICHARDS is holding a tracking device and is looking down at it.

<div align="center">

STAR-LORD
So I need a final destination lock. Now.

REED
Readings confirm what Spider-Man said--
and they've remained constant to this very
minute... Our target is Castle Doom. Please
get us there in one piece, Mister Quill.

STAR-LORD
Oh...trust me, old man. I don't get shot down.

</div>

Panel 2--

Outside the ship carrying Star-Lord and the Reeds. A HULK has jumped on it and is tearing bits of it off. We can see them looking up at the Hulk through the cockpit.

<div align="center">

HULK
RARRRRR!

STAR-LORD
What the--

REED
It seems there's a Hulk on your ship,
Mister Quill. I suggest you get it off.

</div>

(tail)

Quickly!

Panel 3--WIDE.

The ship carrying Star-Lord and the Reeds does a corkscrew to send the Hulk flying off.

STAR-LORD

Lost our aft engines...

Panel 4--Inside the cockpit.

Star-Lord is now straining to keep the ship in the air. No longer confident. The Reeds look on.

STAR-LORD

Remember that thing I said about getting us there in one piece?

(tail)

Well...I was wrong.

PAGE 3--(6 PANELS)

Panel 1--The Maestro smiling.

Looking over at Castle Doom from the top of his Helicarrier.

> **MAESTRO**
> Can you see me from your castle, Doom?
> For I am here. And I have brought the
> entire green north to your lands.

Panel 2--

Now the Maestro looking back our way. Shock on his face.

> **MAESTRO**
> I have waited for this day long enough,
> and when I am done with the armies below
> I am coming for you, god... I am--

Panel 3--WIDE.

The Maestro standing on the deck of the Helicarrier in the
foreground, in the background the GIANT FACE/HEAD of Godzilla-sized
BEN GRIMM.

> **MAESTRO**
> What is this?

> **THING**
> Well, pal, clearly Imma giant orange guy,
> on his way to settle old scores...

Panel 4--

BEN GRIMM grabs the HELICARRIER in both hands like a toy.

> **THING**
> And you look like somethin' in my way.

Panel 5--On the battlefield.

Standing over a defeated Apocalypse, Jane THOR looking up in the
sky at something (at BEN). In the background, Captain Marvel (who
is/was battling with a HULK) looks up as well. We can also see
Sinister's head on the ground. A shadow falling over them.

> **THOR**
> Look! It's coming down!

CAPTAIN MARVEL
RUN!

Panel 6--On Sinister's head.

A sad face.

BARON SINISTER
How embarrassing.

PAGE 4--(5 PANELS)

Panel 1--BIG PANEL.

He smashes it into the ground. Pulverizing it.

SFX
CRRASSSHHH!

Panel 2--On the balcony.

On Susan, her hand over her mouth. Doom standing behind her, glancing over at her.

SUSAN
Oh, Ben. What are you doing?

Panel 3--WIDER.

On Doom and the entire family on the balcony. An EXPLOSION rocks the castle.

SFX
BA-BOOOOOM!

BLACK SWAN
The rebels have reached the castle!

Panel 4--

In the foreground, Doom watches Black Swan turning to leave (moving towards the background).

> ### DOOM
> No. We would know if the lower levels
> had been breached. It must have been
> something else. Black Swan, would you...

> ### BLACK SWAN
> Of course, my lord. I'll be right back.

Panel 5--

In the background, Susan turning to Doom (what are you going to do). In the foreground, Val is looking at us (at Franklin leaving [which we don't know yet]).

> ### SUSAN
> What about Ben, Victor? What we you going
> to do about--

> ### VAL
> Too late, mom. Look!

PAGE 5--(4 PANELS)

Panel 1--

On TERRAX, emerging from the battle. He's looking up at the sky in wonder.

> **TERRAX**
> This chaotic world has been a wilderness... But I have found my way here! Now! I see the promise of returning to who I REALLY am.

Panel 2--

From behind, we see him fall to his knees. His arms/hands raised before him. Offering his ax up to the sky. Total surrender.

> **TERRAX**
> Hear me, World Eater! It is I, Terrax the Enlightened...your servant. On another world I was a herald of Galactus! Now I will be yo--

Panel 3--

Same shot, except one of Galactus' boots coming down. Crushing him.

> **SFX**
> SMUSH!

Panel 4--HUGE PANEL.

Galactus facing off against Giant Ben Grimm.

> **FRANKLIN**
> Hey dummy.

> **(tail)**
> I hope you liked getting your butt kicked.

PAGE 6--(5 PANELS)

Panel 1--An exterior shot of CASTLE DOOM.

We see smoke coming out of a hole in the castle.

NO DIALOGUE

Panel 2--BIG PANEL.

We see the crashed ship that Star-Lord was piloting. The three of them have climbed out of the ship. Star-Lord is looking at the wreckage, scratching his head. Reed Richards and the Maker are looking at the tracking device Reed is holding.

MAKER
Well, at least we aren't dead. Yet.

STAR-LORD
Any port in the storm, pal.

(tail)
But I have no idea how I'm going to get this thing back in the air.

REED

Got a signal lock.

Panel 3--

Reed and the Maker are walking off, following where the tracker is leading them. The Maker turns back to Star-Lord (who is staying with the ship).

REED

It's this way. Come on.

MAKER

Stay here. Fix that.

Panel 4--On Star-Lord.

Taking the toothpick out of his mouth. Waving them off.

STAR-LORD

Oh, sure. You guys go right ahead...

Panel 5--Star-Lord.

All alone with his broken ship.

STAR-LORD

When you get back, the ship'll be fixed and ready to fly.

(tail)

I'll be right here waiting.

(tail-small)

All alone in the creepy-ass castle.

PAGE 7--(5 PANELS)

Panel 1--

BEN GRIMM and GALACTUS slugging it out.

FRANKLIN

Ready to give?

THING

You wish, squirt. Time for bed.

Panel 2--

BEN GRIMM punches Galactus and sends him reeling. Franklin holding on for dear life.

SFX
THOOOM!

FRANKLIN
WHOOOAA!

Panel 3--On Susan and Doom.

They watch as their son battles.

SUSAN
This is a nightmare.

Panel 4--On Susan turning to Doom.

"Go help him."

SUSAN
What are you waiting for, Victor!

(tail)
Put an end to this!

DOOM
I will...but not just yet.

(small)
Ben was the shield...and if the shield
has fallen...

Panel 5--

In the foreground, Galactus rising...Franklin yelling from his head. In the background, Ben Grimm thumbing behind him and saying...

FRANKLIN
Nice punch, but it's gonna take more than
that--more than just you--to knock me
out. I'm tougher than that.

THING
Got bad news for you, sport... There's a
whole lot more than just me comin'.

PAGE 8--(4 PANELS)

Panel 1--On the battlefield.

Everyone stops fighting and looks in our direction.

SFX

ZWWWOOOOOO!

Panel 2--

On the horizon we see something coming towards the battle.

SFX

ZWWWOOOOOO!

Panel 3--HUGE PANEL.

Thanos and the Annihilation horde. Super-massive bugs flying. Huge centipede-like monster crawling. All of these controlled/piloted by Annihilation DRONES. In the center, THANOS rides on the back of one of the monsters. One of the Drones is blowing a giant horn.

SFX

ZWWWOOOOOO!

Panel 4--Same shot as panel 2.

Except DOOM is teleporting away.

NO DIALOGUE

PAGE 9--(5 PANELS)

Panel 1--BIG PANEL.

In the foreground. Galactus' face (GALACTUS' eyes are glowing) with Franklin riding him. Franklin pointing to the background. We see column of LIGHT appearing in the Annihilation horde. Small little bugs go flying. Blasted to bits.

FRANKLIN
Well, you've done it now.

(tail)
Do you see that, God is here--my father-- and he's definitely not happy.

Panel 2--

Galactus blasts BEN GRIMM with his eye beams. A huge chunk of rock goes flying off.

FRANKLIN
And neither am I!

THING
AARGHHHH!

Panel 3--

BEN GRIMM holds up his hand. As if to say "Stop. Wait."

THING
Stop! Wait!

Panel 4--

Close on Ben Grimm's face. Curious.

THING
You said he's your father...

(tail)
You mean Doom?

Panel 5--On Franklin.

Still waiting to fight.

FRANKLIN
Yeah.

PAGE 10--(5 PANELS)

Panel 1--Ben drops his hands.

"I ain't gonna fight you."

THING
So that makes you Suzie's kid?

Panel 2--On Franklin.

Yelling at us from the head of Galactus. Galactus' eyes crackling with energy.

FRANKLIN
Yeah. That's me.

(tail)
Franklin von Doom. Now come on!

Panel 3--On Ben's face again.

Sad.

THING
(small)

Well, this just ain't gonna have a happy ending, is it?

(tail-regular)
I know we're supposed ta fight some more, but I ain't gonna... Don't seem right now.

Panel 4--Closer on Ben's face.

Super sad.

THING
You... You do whatcha gotta do, kiddo.

Panel 5--HUGE PANEL.

Galactus blasts Ben Grimm to rubble.

SFX
ZZAAAKKKKK!

PAGE 11--(6 PANELS)

Panel 1--On Susan and Val in the Castle.

Val surprised. Susan turns away. Tears in her eyes at what Franklin has done.

> **SUSAN**
> Oh, Franklin...what have you done?

Panel 2--On Susan and Val.

Val in the foreground, staring out at the battle. Susan behind her, turns (a little angry) in reaction to what she said.

> **VAL**
> Man...this is some show.

> **SUSAN**
> What?

> **VAL**
> It's some show. The spectacle of it.

Panel 3--On Susan and Val.

Val turning back to Susan. Sincerity in her little girl eyes.

> **SUSAN**
> Val, what are you--

> **VAL**
> Do you trust me, mom?

> **SUSAN**
> Yes.

Panel 4--On Val.

Not sure if she should tell her mom this. A little scared.

> **VAL**
> Do you love me more than anything? No
> matter what?

Panel 5--On Susan.

Her heart breaking a little.

SUSAN

You're my daughter, Valeria. Of course I do.

Panel 6--They leave the throne room.

Val motioning for Susan to follow her.

VAL

Come with me...

PAGE 12--(5 PANELS)

Panel 1--

Star-Lord is working on his broken ship. Trying to fix it.

CAPTION

I need to show you something.

Panel 2--Someone calls out.

He turns towards us.

BLACK SWAN
(off panel)

What do you think you are doing?

Panel 3--BIG PANEL.

We see BLACK SWAN approaching Star-Lord. She does not look happy.

STAR-LORD

Well, right now I'm fixing my ship so that when my pals take care of this Doom person we can get out of here.

(tail)

What are you doing?

BLACK SWAN

Serving my god.

(tail)

Destroying those who stand against him.

Panel 4--Star-Lord stands up.

Like a gunfighter. Toothpick in mouth.

STAR-LORD
Oh, I get it. You think if you say scary
things I'm the type of guy who takes it
to heart. Well, listen up, lady...

Panel 5--

Star-Lord puts one hand on his pistol and motions with the other
one "Just stop right there...I don't want to have to be the bad guy
here."

STAR-LORD
I am a bad man who does bad things.
I don't necessarily like it--and I
certainly don't relish it--but I just
can't help my nature.

(tail)

So why don't you go on back to wherever
you came from, before this turns into one
of those 'I told you so' kinda things.
Okay?

PAGE 13--(6 PANELS)

Panel 1--

Star-Lord crashing through a wall into the THRONE ROOM. (Swan blasting him with her eyebeams). Bricks go flying.

SFX

CRRASSSHHH!

STAR-LORD

ARRGHHH!

Panel 2--

In the foreground, Star-Lord crawling towards us (towards the World Tree throne of DOOM...he's almost there). In the background, Black Swan stalks after him.

STAR-LORD

Spleen. My spleen.

Panel 3--On the Swan.

Not happy with the day's events. Eyes burning with energy.

BLACK SWAN

I'm sure it hurts. For pain is the next-to-last step of the great collapse. We all have an extinction cycle...This is yours. I am a Black Swan, and THIS is my nature.

Panel 4--

On Star-Lord picking up his TOOTHPICK (which is Groot). Make it clear he's picking up the toothpick.

STAR-LORD

Where...where'd you go?

(tail)

Ah. There you are.

Panel 5--

In the foreground, he turns back towards her--holding the toothpick in one hand (so we can see it). He's backed up to the Throne of Doom (the World Tree). In the background, she stands over him.

STAR-LORD
Okay. Last chance. If you stop right there--if you stop right now--I promise I won't use this.

BLACK SWAN
One final empty threat? What a fool you are. You're bleeding on God's throne, little man. Time to die.

Panel 6--
Close on Star-Lord--a bloody nose, but a smirk.

STAR-LORD
Well...just remember...I told you so...

PAGE 14--(5 PANELS)

Panel 1--On Star-Lord.
He holds the toothpick out to us. Super-foreshortened in the foreground. We see Groot's curled-up face and arms at the end of the toothpick.

STAR-LORD
Say hello to my little friend.

Panel 2--
He slams the toothpick into the WORLD TREE.

SFX
SLAM!

Panel 3--
We see Groot begin to sprout rapidly and vines start wrapping around the roots of the World Tree.

NO DIALOGUE
Panel 4--On Star-Lord and the Swan.
He's smirking. She's shocked.

BLACK SWAN
What have you done... What is that?

STAR-LORD

Wait for it.

Panel 5--

Still inside the Throne Room, we see the World Tree sprout giant hands and arms.

GROOT

I...

I...

PAGE 15--(3 PANEL)

Panel 1--HUGE PANEL.

The WORLD TREE--now GROOT--pulls itself free of CASTLE DOOM. Huge chunk of the castle crumbling. This is not just a giant Groot, Esad. This is giant ████ magic super tree Groot. Make it cool.

GROOT
I.

AM.

GROOT!

CAPTION
The World Tree.

Panel 2--

Galactus, in the middle of the giant battle, turns back towards the castle upon hearing GROOT ROAR!

NO DIALOGUE
Panel 3--Close on Franklin riding Galactus.

"Uh-oh"

FRANKLIN
Oh, boy...

(tail)
Now this looks like trouble.

PAGE 16--(4 PANELS)

Panel 1--

On Val and Susan entering the garden, where the statues of Strange and The Molecule Man are. They are exiting an arched doorway. The castle is rattling. Bricks falling. In the background, we can see Groot the World Tree, Susan is looking back up at him.

> **SUSAN**
> A battle is raging as far as the eye can see, and now the World Tree is walking away from the castle. I don't understand what this is, Val, but are you sure this is what we--

> **VAL**
> Look, mom. What I'm saying is that I think we've been lied to. For a very long time. And it's much...well, it'll all make sense when you see it.

Panel 2--Close on Val and Susan.

Val's eyes go wide (as she's looking out at us). Susan is still looking at Val.

> **SUSAN**
> See what?

> **VAL**
> What Dad's been hid-- Oh.

Panel 3--HUGE PANEL.

Wide on the garden. In the foreground, Susan and Val are stepping into the garden. In the background we see Reed and Maker. The Maker is getting ready to enter the secret place beneath the Molecule Man statue. Reed has stopped and is looking back at them. There should be some distance between the Reeds and Susan and Val--they are not standing CLOSE to each other.

> **REED**
> Valeria. I suppose I shouldn't be surprised.

Panel 4--CLOSE On Reed.

Chin up, trying not to get emotional.

<div align="center">

REED

</div>

Hello, Susan.

PAGE 17--(5 PANELS)

Panel 1--

Doom in the midst of all the Annihilation bugs. They are all trying to attack him and he simply has his hand raised and the bugs are flying apart. In the background, Thanos riding on his giant bug.

NO DIALOGUE

Panel 2--

Thanos screams out for all of his bug soldiers to stop as he jumps down from the back of the bug.

> **THANOS**
> ENOUGH!

Panel 3--

He lands in front of Doom--knees bent, crouching a bit--not his FULL HEIGHT.

> **DOOM**
> Thanos.

Panel 4--

Thanos stands up to his full height. Looks DOWN at DOOM. Towering over him.

> **THANOS**
> Doom.

Panel 5--

On both of them--facing off. We see Annihilus peeking out from behind Thanos. He's become Thanos' 'servant'.

> **DOOM**
> You have brought down the wall--pierced
> the shield I so carefully and costly
> built--for what?

> **(tail)**
> This?

PAGE 18--(7 PANELS)

Panel 1--On Doom.

He waves his hand "A gift. If not..." Then what's the ▮▮▮▮ point?

DOOM
You wish to be Baron of the horde?

(tail)
I will permit you to keep the horde if you
can find your faith. A gift. If not...

Panel 2--On Thanos.

THANOS
You offer me a gift. Me? I was a god once as
well. The Infinity Gauntlet gave me that power.

Panel 3--Closer.

THANOS
And when I was god, I did not use those powers
as a mortal would...as you have...saving what
you can. No, I wielded them as a god should.
In judgement of all living things.

Panel 4--Closer.

THANOS
You are a weak god. A pretender.

Panel 5--Thanos at his most ominous.

THANOS
It is you who should bow before me.

Panel 6--Doom.

Looking off to the side. Cutting his eyes back at us (at Thanos).

DOOM
Do you have an Infinity Gauntlet now?

Panel 7--On Thanos.

Snarling.

THANOS
I do not...yet I remain Thanos. The great
tyrant. And for you that will be enough.

PAGE 19--(5 PANELS)

Panel 1--

Thanos looks down and Doom has put his hand in (INSIDE) Thanos' chest.

> **THANOS**
> Hurk!

Panel 2--BIG PANEL.

Doom holding Thanos' skeleton off to the side. He's pulled it whole out of Thanos' body. The remaining Thanos stuff splats to the ground in front of Annihilus.

> **DOOM**
> That appears...untrue.

Panel 3--

Doom plucks the skull of Thanos off and drops the skeleton. Annihilus looking up at him.

> **DOOM**
> Annihilus...

> **ANNIHILUS**
> Ssssss.

> **DOOM**
> I am owed penance for this indulgence.

Panel 4--On Annihilus

> **ANNIHILUS**
> Yesssss, God. Yesssss. Whatever you
> wissssh.

Panel 5--Doom.

Crushing the skull. Looking down at us (at Annihilus).

> **DOOM**
> There are heretics attacking my castle...

PAGE 20--(4 PANELS)

Panel 1--HUGE PANEL.

Giant fight of everyone. Demons. Hulks. Thors. Captain Marvel. Annihilus Bugs. In the background, Groot fighting Galactus.

CAPTION

I want you to devour them for me.

Panel 2--A blinding light.

NO DIALOGUE

Panel 3--On Captain Marvel.

Shock on her face.

CAPTAIN MARVEL

What now?

Panel 4--

The SIEGE COURAGEOUS appears in the middle of the battlefield.

NO DIALOGUE

PAGE 21--(5 PANELS)

Panel 1--On Doom.

DOOM

No.

Panel 2--

ZOMBIES pouring out of the Siege Courageous.

NO DIALOGUE

Panel 3--Zombies eating Hulks.

NO DIALOGUE

Panel 4--

Zombies trying to eat Doom, but he's destroying them.

NO DIALOGUE

Panel 5--Closer on Doom.

He turns as someone calls out his name.

BLACK PANTHER

Victor!

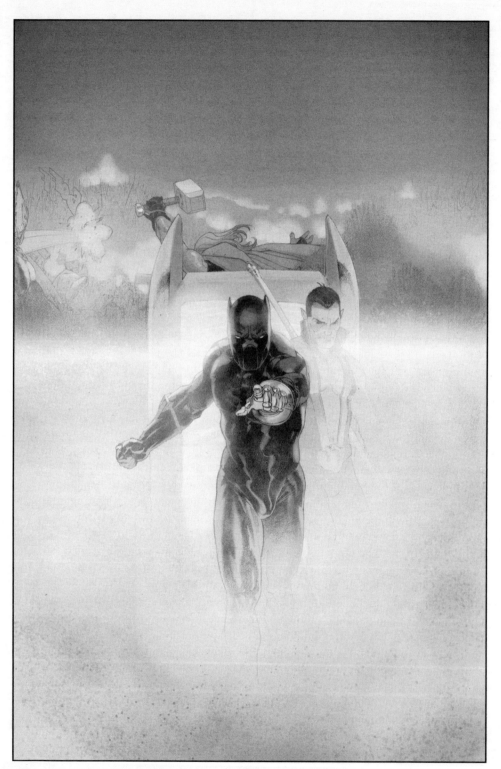

PAGE 22--(1 PANEL)

Panel 1--

Black Panther and Namor coming out of the Siege Courageous.

Black Panther pointing at Doom with the Infinity Gauntlet.

<div align="center">

BLACK PANTHER
It's time for this to end.

</div>

AVENGERS

SECRET WARS
ISSUE #9
2015

"Beyond"

By Jonathan Hickman

Art by Esad Ribic
and Ive Svorcina

PAGE 1--(6 PANELS)

NOTE: Esad, anytime we pull back during this DOOM-BLACK PANTHER fight, remember that there's a massive battle going.

Panel 1--Close on a Zombie screaming.

In the middle of the giant battle.

> **CAPTION**
> I see it now...

Panel 2--On Doom.

We're where we left him. In the middle of the battle: Zombies, Bugs, Hulks, etc...He's facing Panther and Namor, who have just stepped out of the Siege Courageous.

> **DOOM**
> All this structured chaos, it reeks of machination.

> **(tail)**
> You orchestrated this, didn't you?

Panel 3--

On Black Panther and Namor (holding his spear) in front of the Siege Courageous.

> **BLACK PANTHER**
> I had some help.

> **(tail)**
> This has to end, Victor.

Panel 4--Wider on Doom.

He spreads his hands.

> **DOOM**
> You know better than most the decisions kings must make. Imagine the ones a god must be burdened with. I know you both understand.

(tail)

That has value. You could join me. I
would raise a new Atlantis. I'll remake
Wakanda.

I can give you back everything you've
lost.

Panel 5--On Panther.

He holds up his hand with the Infinity Gauntlet, his palm open (so
he can make a fist on the next page).

BLACK PANTHER

I don't think you can, Victor. That would
take a certain something you just don't
have in you.

(tail)

You're not defective. Just limited.

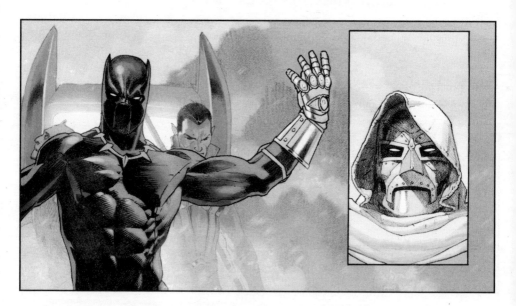

Panel 6--CLOSER on Doom.

DOOM

And you're not? Not now because you have
a gauntlet? This your plan? To take it
for yourself? T'Challa, the fallen king
of Wakanda, reborn as a god.

PAGE 2--(5 PANELS)

Panel 1--On Namor.

A smirk.

> **NAMOR**
> Actually... I always assumed everyone
> would prefer it be me.

Panel 2--SUPER CLOSE on DOOM.

> **DOOM**
> I think not.

Panel 3--

Same shot as PANEL 5 on PAGE 1. Except now he closes his fist.

> **BLACK PANTHER**
> I figured as much. Goodbye, Victor.

Panel 4--

Doctor Doom becomes completely crystal/glass.

> **NO DIALOGUE**

Panel 5--Namor throws his trident.

> **NO DIALOGUE**

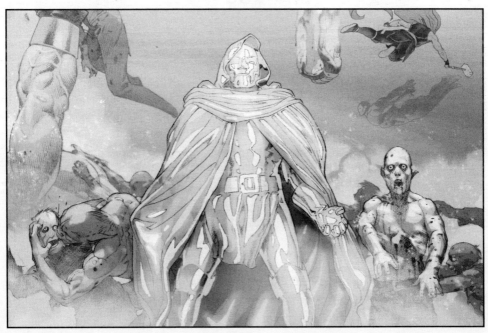

PAGE 3--(4 PANELS)

Panel 1--

Doctor Doom shatters into a million pieces.

NO DIALOGUE

Panel 2--

Namor and Panther stand over all the shattered bits.

NAMOR
It can't be that easy.

BLACK PANTHER
It won't be.

Panel 3--

The shards of glass begin to re-assemble.

NO DIALOGUE

Panel 4--

A distorted/█████-up Doctor Doom made of broken pieces of glass rumbles to its feet.

DOOM
That. Hurt.

PAGE 4--(4 PANELS)

Panel 1--BIG PANEL.

The shattered-glass Doom blasts Panther and Namor.

Panther uses the power of the Infinity Gauntlet to barely shield himself in time, but Namor is closer and is burnt to a crisp.

SFX
ZZZAKKKKKKK!

Panel 2--

On Black Panther, in the foreground. Turning away from the smoking remains of Namor to look at us. WE CAN SEE THAT one of the GEMS on the Gauntlet is broken and bleeding off energy.

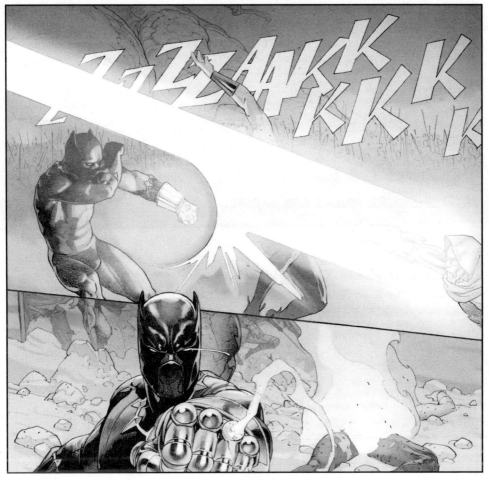

DOOM
(off panel)
But after pain comes clarity, T'Challa.

(tail)
I see you now.

Panel 3--On Doom.

The pieces of glass falling off to reveal a perfectly healthy Doom.

DOOM
You are more than just a mortal man...

(tail)
Let us finish this as gods.

Panel 4--WIDE.

On the battle. Everyone stops fighting as we see a massive column of light erupting from the battlefield where Doom and Panther begin their battle. In the foreground, Groot and Galactus/Franklin turning to look.

CAPTION
On the Earth. In the sky. And the heavens above.

PAGE 5--(6 PANELS)

Panel 1--On Susan. In the garden.

SUSAN
YOU!

Panel 2--Susan and Val on one side.

Reed near the Molecule Man statue on the other. Reed is hopeful here. Does she remember him?

SUSAN
I remember you.

REED
From what I understood, you didn't know who I was. I...never was. Are you saying you know me, Susan?

Panel 3--On Susan and Val.

Susan looking at us. Val looking up at her mom.

SUSAN
Yes. I saw you in the hologram of the battle. You were fighting Thors. You're from that ship. Those who murdered Stephen Strange.

VAL
Actually, mom, that's not what happened.

Panel 4--On Reed.

Disappointed. Eyes down. Looking away.

REED
Of course...you know me from a picture...

(tail)
Like Valeria said...that's not what
happened. It was Doom.

Panel 5--On Susan.

Doubtful. Not trusting him.

SUSAN
You mean God.

Panel 6--

Same shot of Reed as two panels ago. Except now he looks up. A
little angry.

REED
I mean Victor.

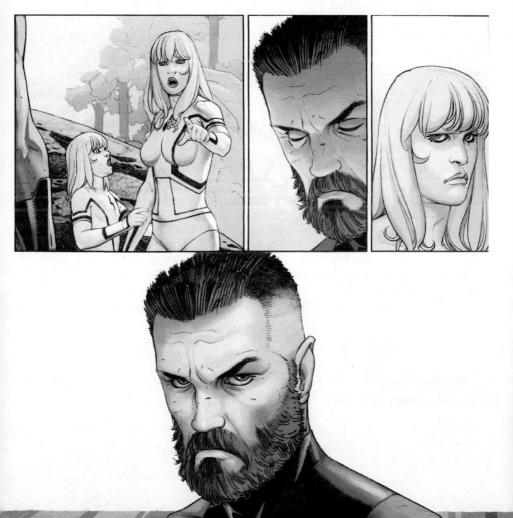

PAGE 6--(4 PANELS)

Panel 1--BIG PANEL.

GODS FIGHTING GODS. ESAD, this is the first of four BIG PANELS (half a page) showing the fight between DOOM and PANTHER. I don't care in what order you do these--I'm going to suggest one, but you should do whichever one works for the specific page you're doing. Okay?

1. A GIGANTIC DOOM fighting A GIGANTIC PANTHER. Each one has a glowing exo-skeleton of armor.

2. A trippy, hallucinogenic battle of the minds where they are twisting around each other in a psychedelic environment.

3. Fighting in the SUN. Both of them on fire but not feeling the flames. In the background, the HUMAN TORCH looks over at them.

4. LEAVE THIS ONE FOURTH...explained later in the script.

CAPTION
And however well-intentioned all of this is, I mean to put things back the way they are supposed to be and end this charade of a world.

Panel 2--Wide.

Back on Reed in the garden. Talking to Susan.

REED
This is not the life we are supposed to have. Not Val. Not me. And certainly not you, Susan.

Panel 3--On Susan.

Head tilted.

SUSAN
Who...are you?

Panel 4--On Reed.

Chin up. Heart breaking.

REED
I'm the one who fixes things. No matter what.

PAGE 7--(5 PANELS)

Panel 1--BIG PANEL.

Doom and Panther. GODS FIGHTING GODS panel number two.

NO DIALOGUE

Panel 2--

Reed and the Maker walking down into the WHITE PLACE where the Molecule Man lives.

> **MOLECULE MAN**
> (off panel)
>
> Find the quietest place in the world--
> call it here, call it now--and if you
> close your eyes and listen you can hear
> the screaming.

Panel 3--On the Molecule Man.

Turning towards us.

> **MOLECULE MAN**
> Did you bring me something to eat, Reeds?

Panel 4--On Reed.

Scratching his head. Looking around at the white space.

> **REED**
> (small)
> I knew it, but I wasn't really prepared
> for it...
>
> (tail)
> I'm sorry, Owen. I don't have anything.
> How are you feeling?

Panel 5--On the Molecule Man.

> **MOLECULE MAN**
> I'm starving.

PAGE 8--(5 PANELS)

Panel 1--On Reed and the Maker.

REED

I'm sure. An infinite number of missing mouths not being fed will do that. But I think I can help.

MAKER

So this is the battery? The repository for all of Doom's power?

REED

Yes.

Panel 2--On the Maker and Molecule Man.

The Maker is taking out a secret techy device.

MOLECULE MAN

Hello. Hello. Hello.

MAKER

Hello yourself. If you don't mind, please excuse us for a moment.

MOLECULE MAN

Okay.

Panel 3--On the Maker and Reed.

The Maker holding up the device.

MAKER

Reed.

REED

Yes, what is...

MAKER

I've been saving this...

Panel 4--the Maker ZAPS Reed with the device.

Creating a bubble around the two of them.

SFX

ZZZNNNNNNNNN!

Panel 5--BIG PANEL.

Doom and Panther. GODS FIGHTING GODS panel number three.

CAPTION

You have no idea how hard it was to construct a device capable of creating a proper temporal bubble out of available materials on this retrograde world.

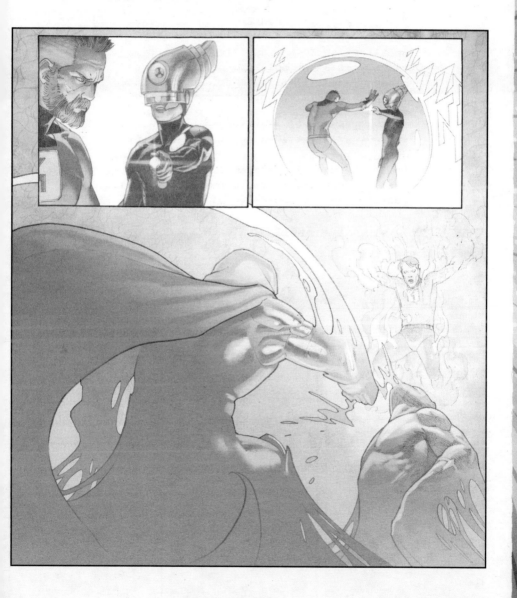

PAGE 9--(7 PANELS)

Panels 1-4--

Okay, this should take up the other half of the page...four panels side by side with no gutter. THE MAKER should be walking beside Reed in each panel, while Reed is stumbling and DEVOLVING into an ape version of himself.

> **MAKER**
> But I did it. I overcame, like we always do. The interesting thing about a temporal bubble is that it's not like normal time travel. It's not point-to-point. It's a closed temporal environment, so theoretically one should only be able to move forward in time. To evolve. However, you and I know differently, don't we? Someone can holistically visit the past. It just hurts. I suppose I could apologize about the betrayal. But I saw you almost start crying up there with a woman who isn't your wife, and I just cannot tolerate that kind of weakness.

Panel 5--Close on the Maker.

Sneering.

> **MAKER**
> Really, Reed. Who's interested in a weepy god?

Panel 6--

Same shot except the Molecule Man pops up behind him. BOO!

MOLECULE MAN
Me.

Panel 7--

The Molecule Man watches as Maker turns into like 30 horizontal slices.

MAKER
HURK!

PAGE 10--(5 PANELS)

Panel 1--

The Molecule Man bends down to talk to re-evolving Reed. The slices of the Maker flop into a pile behind them.

MOLECULE MAN
He'll be here soon.

Panel 2--BIG PANEL.

Doom and Panther. GODS FIGHTING GODS panel number FOUR. Black Panther is swinging at Doom with his gauntlet hand. But Doom catches it. NOTE: Both of them are beat up. Clothes torn, *etc*.

NOTE: BLACK PANTHER's mask is torn off. We can see his face.

CAPTION
Then we'll see what's what.

Panel 3--

Close on Doom's hand that has caught Panther's (with the Gauntlet). He crushes Panther's hand. We don't have to show it, but the gems shatter. All but one.

SFX
CRRUUNCHH!

BLACK PANTHER
AARGHHHH!

Panel 4--Doom standing over the Panther.

Still holding his hand.

> **DOOM**
> It's over...and what have you gained?
> Nothing.

Panel 5--He smashes Panther.

Still holding onto the hand.

> **DOOM**
> Yes. You tested me... Reduced me to
> this--wanton physical violence...but I
> remain Doom. And you something beneath
> me...

PAGE 11--(5 PANELS)

Panel 1--ON DOOM.

Getting ready to smash Panther again, but stops, because he notices
something.

> **DOOM**
> A lesser. A fool who doesn't know that
> he's beaten. A smiling fool who...who...

(tail)
Why are you smiling at me, T'Challa?

Panel 2--On Panther.

Beaten. Battered. Looking up at us, but managing a smirk.

BLACK PANTHER
B...because you're going to...to lose.
All this...structured chaos... It...it...
reeks of machination...

(tail)
D...doesn't it?

Panel 3--On DOOM's eyes.

WIDE.

DOOM
This is all a distraction.

Panel 4--

DOOM teleports away, leaving Panther to collapse to his knees.

NO DIALOGUE
Panel 5--DOOM teleporting into the garden.

NO DIALOGUE

PAGE 12--(6 PANELS)

Panel 1--He looks back at us.

He's surprised.

> **DOOM**
> ...

Panel 2--

He sees Val and Susan standing there. He reaches out for them.

> **DOOM**
> Susan. Valeria... What are you--

Panel 3--On Susan and Val.

Looking at him. Their expressions unreadable.

> **SUSAN**
> Is it true, Victor? Is all of it true?

Panel 4--On Doom.

Resigned. He looks away from them. Unable to meet their eyes.

> **NO DIALOGUE**

Panel 5--

Same as panel 2, except he pulls back his hand. He knows the well has been poisoned.

> **NO DIALOGUE**

Panel 6--

Doom turns and goes into the place beneath the Molecule Man statue.

> **DOOM**
> **(small)**
> I'm sorry.

PAGE 13--(6 PANELS)

Panel 1--Doom.

Walking down the stairs to us. NOT HAPPY.

DOOM
You had to meddle, didn't you?

(tail)
Of course you did. You're a meddler.

Panel 2--

In the foreground, a silhouette of Doom coming down the stairs to the WHITE SPACE. In the background, an almost completely re-evolved Reed is getting to his knees--a bit of monkey drool falling from his bottom lip. The Molecule Man is beside him. Head tilted.

DOOM
You have some great plan, I expect. What is it this time, Reed? A new idea? A fresh take on our very old problem? Have you built another great machine?

REED
No. Nothing like that. I just came to convince Owen that, perhaps, there's a better solution to all this than you.

Panel 3--On Doom.

Not playing around.

DOOM
A better solution...

(tail)
(MORE)

DOOM (cont'd)
Like what? For years you have been distracted with all the modern concerns afforded to you and your kind. Ethics, and order, and society...when all that mattered was survival. I saved millions. Owen saved millions.

Panel 4--On Reed.

Now back to normal. Staggering to his feet. He wipes his chin/ mouth. Teeth bared.

DOOM

You said it yourself...all you could save
was your friends. You couldn't even save
your family.

Panel 5--On Reed.

REED

How dare you.

Panel 6--On Doom.

He snaps his fingers.

DOOM

Haven't you been paying attention, Reed?
I dare quite a bit.

(tail)

I dared to choose between living and
dying for millions...and I'll choose for
you as well.

SFX

SNAP!

PAGE 14--(5 PANELS)

NOTE: Esad, two really dynamic pages of these guys fighting.

Panel 1--On both of them.

Reed looking down at himself. Touching his chest. "Am I still here?" Doom looking at his fingers.

> **DOOM**
> What is this?

Panel 2--On Doom and Molecule Man.

Doom looking over at him.

> **MOLECULE MAN**
> Did you bring me something to eat, Victor?

> **DOOM**
> No.

> **MOLECULE MAN**
> Then that makes the two of you equal, doesn't it?

Panel 3--REED LEAPS for Doom.

Tackling him.

> **CAPTION**
> Fair's fair? Right?

> **REED**
> RRRAAAAAR!

Panel 4--

DOOM blasts Reed with energy from his hand, but all it does is cause Reed's body to stretch and expand where the blast was.

> **DOOM**
> You dare put your hands on me?

Panel 5--

Reed stretching all over the place, wrapping around Doom.

<div align="center">

REED
</div>

Haven't you been paying attention, Victor?
I dare quite a bit. Things aren't so easy
when you're not omnipotent, are they?

PAGE 15--(5 PANELS)

Panel 1--

DOOM stretching his arms apart--showing his strength.

<div align="center">

DOOM
</div>

RRAAAAR!

<div align="center">

(tail)
</div>

You think any of this has been easy?

Panel 2--Doom smashing at Reed.

<div align="center">

DOOM
</div>

You think power makes impossible choices
more palatable? I have always had power,
Reed. NOTHING has ever been EASY.

Panel 3--

But Reed just wraps Doom tighter. Now,
facing one another.

<div align="center">

REED
</div>

You know what's not easy...being erased
because you wanted to indulge yourself.
You made yourself god and the first thing
you did was replace me.

Panel 4--

Doom getting a hand free and punching the ██████ out of Reed.
But Reed holds. Still facing each other.

<div align="center">

DOOM
</div>

The first thing I offered was salvation.

Panel 5--CLOSER.

REED stretching a bit more. Bringing his face right up to DOOM's--
they snarl at each other.

REED
YOU STOLE MY FAMILY.

PAGE 16--(150 PANELS)

Panels 1-150--Okay Esad, on your live area of 10x15 we want
a column or row every inch. So 10 panels by 15 panels is 150
panels. This is just ONE BIG SHOT of DOOM'S FACE and REED'S FACE
interlaced. So 75 panels of REED and 75 panels of Doom. Let me know
if this is confusing, I can draw it out for you.

NOTE: Tom, we'll just remove some of the panels and stick words in
them instead of doing actual captions.

DOOM

You're wrong. They chose me. If you wish
to believe that they only did so in the
absence of you, very well... But they
chose. SHE chose. She believed. All that
I have done...all of this, and you still
give me no credit. Can't you accept that
I have done good things here?

REED

I have accepted that, Victor. But you
could have done more. You closed your
hands around everything that was left
and called it YOURS. You're so afraid of
losing the things you love that you've
held them too tight. And don't you see?
A tree is just a seed in its realized
state, Victor.

DOOM

This is what caused the fall of man,
Reed. Abandoning the good, because you
desire the perfect. I understand now--I
know what this is. The same thing it's
always been between you and I...

PAGE 17--(5 PANELS)

Panel 1--DOOM getting the upper hand on Reed.

Slamming his torso to the ground. Reed still all wrapped around Doom.

> **DOOM**
> You think you are better than I am.

Panel 2--On Reed.

A moment of sincerity in the middle of a huge fight.

> **REED**
> No, Victor. You're wrong.

> **(tail)**
> I've always believed you could be better.

Panel 3--On both of them.

Victor grabbing Reed by the face and throat.

> **DOOM**
> No. Now. This moment.

Panel 4--Energy burning off of Doom's hands.

Reed's skin begins to bubble.

> **DOOM**
> If you had this power, you think you
> could have solved it all--solved
> everything... You think you could have
> done so...much...better...

Panel 5--CLOSE on Victor.

Screaming at us (at Reed).

> **DOOM**
> Don't you?

> **(tail)**
> DON'T YOU!?!

PAGE 18--(5 PANELS)

Panel 1--On Reed.

Looking right at us as Victor is burning him. This is all in the eyes, Esad. Reed is saying the one thing Victor knows--

"You can win, but you'll never beat me."

<div align="center">

REED
</div>

Yes. (tail)

And we both know it.

Panel 2--ON DOOM.

Enraged. Snarling through his mask.

<div align="center">

DOOM
</div>

Yes.

Panel 3--Doom.

Burning Reed to death.

<div align="center">

REED
</div>

AAAIIEEEEEEEEE!

Panel 4--On the Molecule Man.

Glancing at us.

<div align="center">

MOLECULE MAN
</div>

Okay then. So be it.

Panel 5--On Doom.

Turning. Surprised as everything is GOING WHITE!

<div align="center">

DOOM
</div>

Wait. No...

PAGE 19--(2 PANELS)

Panel 1--We see CASTLE DOOM.

Explode in WHITE BLINDING LIGHT.

SFX
BA-BA-DOOOOOOOOOOOOM!

Panel 2--WIDE from SPACE.

We see BATTLEWORLD begin to come apart.

NO DIALOGUE

PAGE 20--(6 PANELS)

Panel 1--ON THE BATTLEFIELD.

The explosion of CASTLE DOOM. Tearing through the armies fighting.

NO DIALOGUE
Panel 2--On Black Panther.

On his knees. The white blast of light approaching him.

NO DIALOGUE
Panel 3--On him kneeling.

In the background, the wave of white energy screaming towards him--destroying the armies. We see him picking something off of his ruined Infinity Gauntlet hand.

NO DIALOGUE

Panel 4--CLOSE.

We see the last non-shattered infinity gem resting in his palm--THE GREEN ONE.

NO DIALOGUE
Panel 5--He clenches his fist around it.

A little trickle of Kirby crackle as he uses the gem.

NO DIALOGUE
Panel 6--Everything goes WHITE.

NO DIALOGUE

PAGE 21--(5 PANELS)

NOTE: OKAY. This is a straight rip on *NEW AVENGERS* #1. The sequencing is different, and you need to put your spin on these, but please make sure that the sequence is recognizable.

Panel 1--WHITE.

NO DIALOGUE

Panel 2--

Same shot as panel 5 from the previous page. Black Panther's clenched fist. Still a white background.

NO DIALOGUE

Panel 3--

Same as panel 4 from the previous page, EXCEPT when he opens his hand the gem is dust and starts to float away. ALSO, the background here is the GREEN of the jungles of Wakanda.

> ### N'KONO
> #### (off panel)
> It's the Sundiata Code. A hidden cipher within the region's oral history.

Panel 4--On Black Panther.

He turns and looks at us. He's now WHOLE.

AND he HEARS SOMEONE TALKING.

> ### CAPTION
> Wakanda.

> ### N'KONO
> #### (off panel)
> It's a theory about tradition. Of exactly how Wakandan excellence has been passed down through the generations. Passed down through blood. Ah. I see...

> ### (tail)
> Blood.

NOTE: *Three Wakandan teenagers going through a rite of passage. We'll get you ref.*

N'Kono--Male. Eighteen. He should be wearing power gloves and a mic/earpiece thing.

T'Dori--Female. Eighteen. She should have this cool headpiece with a visor that slides down allowing her to see 'more.' It should be up when we first see her.

Kimo--Male. Sixteen. He should be a weaponeer. Carrying a high-tech spear of some sort.

Panel 5--N'Kono holding a knife.

Holds his hand out over the obelisk as he's already cut it. A drop of blood hits the obelisk.

> ### N'KONO
> So we remember where we came from...

PAGE 22--(4 PANELS)

Panel 1--

They step back as the ground around the obelisk pulls apart.

> **N'KONO**
> On the way to where we're going.

> **SFX**
> FSSHHTT!

Panel 2--BIG PANEL.

They stand at the edge of a rounded technology pit six feet across. The obelisk stands in the center. A large sphere hovers above it-- representing a sun. Then extending outward in circular orbits is a solar system of planets (NOT OURS). Steve, we'll probably have the colorist hold this stuff like it's a hologram, so please make sure you draw the circular orbits of each planet.

> **KIMO**
> Huh! Stellar cartography--A map of our solar system.

> **T'DORI**
> Count, Kimo...twelve planets. It's not ours.

Panel 3--The kids look back at us.

Someone speaks to them. They drop to their knees.

BLACK PANTHER
(off panel)
But it is where you are going.

N'KONO
My king!

Panel 4--

T'Challa, the Black Panther emerges from the Jungle. We cannot tell where the shadows cast by giant foliage end and he begins.

BLACK PANTHER
YES.

Congratulations, MAKERS. On your feet--
Stand tall. For you are the finest of
your generation.

PAGE 23--(5 PANELS)

Panel 1--

T'Challa touching one of his hands to his heart and putting his other hand on N'Kono's shoulder--N'Kono should be overwhelmed by what T'Challa is saying. The others, in the background, look on, smiling broadly.

BLACK PANTHER
Kimo, T'Dori...very, very well done.

(tail)
N'Kono, your father's grandfather was
T'Konda--the Black Panther of his time.
He was called 'The Wall' and now his
spirit, like all other previous Panthers,
lives within me.

(tail)
I feel his pride when I look at you.

Panel 2--

On all four, the pit behind Black Panther. T'Challa telling them how important they are. He talks with his hands (emphasis on the words 'OUT THERE' if it helps). The kids are totally enraptured.

BLACK PANTHER
Pride. Pride, and not shame, which is
what we feel for the world out there.
Great societies are crumbling around us,
and the old men who run them are out of
ideas.

(tail)
So all eyes turn to you, our children--To
build us something better.

Panel 3--

On T'Challa, he turns to the pit and focuses on a single planet.
The hologram swells. He talks about a single planet that rests
above his hand.

BLACK PANTHER
This is M23-671A. An M-class planet
circling an orange dwarf 241 light years
away.

(tail)
The West has abandoned space, and
the East crawls when it could run...
as a result, Wakanda now possesses the
preeminent space program on the planet...
But we must do more, go farther...to
somewhere no human has ever been.

(tail)
Your prize, MAKERS...are the stars
themselves.

Panel 4--

Now all the kids are looking down at the hologram of the planet.
T'Dori and N'Kono are staring into the hologram--excited, giddy.
Something catches Kimo's attention...he glances off, away in
another direction.

T'DORI
The stars...oh wow...

N'KONO
I know. You dream a thing, and the idea
that it could become real... Amazing.

KIMO
Hey...Do you guys feel that...like little
micro tremors?

Panel 5--Now Black Panther on the alert.

T'Dori's visor snapping down. She cocks her head sideways. Curious.
The kids at the ready. Something's coming.

T'DORI
Hrmph. I'm not seeing anything.

BLACK PANTHER
Turn around.

PAGE 24--(4 PANELS)

Panel 1--BIG PANEL.

In the foreground, all of them looking up. In the background, the shining city of Wakanda. And lifting off into the sky...a ROCKET.

SFX

RUMMBLLLLLEEEE!

Panel 2--On the kids.

Looking up.

KIMO

What is it?

T'DORI

It's a rocket, Kimo.

N'KONO

But what's it for? Is it ours?

Panel 3--On the Black Panther.

(Talking about Captain Marvel stuff)

BLACK PANTHER

No. Your journey begins later. But this is where it begins...

(tail)

Earth command, to support local system travel. We will drag mankind to the stars on the back of Wakandan science. Step by step...

Panel 4--On all four looking up at the sky.

BLACK PANTHER
And this is our first one.

(tail)
Our Alpha Flight.

TITLE PAGE: EIGHT MONTHS LATER.

PAGE 25--(5 PANELS)

NOTE: A flashback to issue 6 where both Spider-Men met with Molecule Man.

Panel 1--WHITE.

NO DIALOGUE

Panel 2--

We're back in the white space where the Molecule Man was kept. He turns to us and says...

MOLECULE MAN
Hey, little spider person...

Before you go, I want to tell you something.

Panel 3--Ultimate Spider-Man turns back to us.

Regular Spider-Man is behind him.

ULTIMATE SPIDER-MAN
Uh, okay... What?

Panel 4--On Molecule Man.

He smiles a dumb, innocent smile.

MOLECULE MAN
Thanks for the burger...

Panel 5--

Same shot, but everything is fading to white.

MOLECULE MAN

I owe you one.

PAGE 26--(6 PANELS)

Panel 1--

Ultimate Spider-Man standing on the roof of a New York high-rise. He has his mask off. He's looking out over the city. His city.

CAPTION
New York City.

Panel 2--

Someone calls out to him, he glances back.

SPIDER-MAN
What did you tell your mom you'd be doing?

Panel 3--

We're looking at Miles, he's looking down at his mask. We can see that Spider-Man (also no mask) is walking up from behind him.

ULTIMATE SPIDER-MAN
Studying with a friend.

SPIDER-MAN
So not a total lie. More of a half-truth.

ULTIMATE SPIDER-MAN
Something like that.

Panel 4--Now they're standing beside each other.

SPIDER-MAN
You eat a snack?

ULTIMATE SPIDER-MAN
Uh-huh.

Panel 5--

Same shot as panel 4, but Miles is putting on his mask.

SPIDER-MAN
You do your homework?

ULTIMATE SPIDER-MAN
Yeah.

Panel 6--

Close on Peter, pulling on his mask. But before he pulls it down to cover his face, he looks over at us and smiles.

> **SPIDER-MAN**
> You wanna go beat up some bad guys?

PAGE 27--(2 PANELS)

Panel 1--On Ultimate Spider-Man. Mask on.

> **ULTIMATE SPIDER-MAN**
> Oh, hell yes.

Panel 2--HUGE PANEL.

On the two of them swinging through Manhattan. Awesome shot, Esad.

> **NO DIALOGUE**

PAGE 28--(5 PANELS)

Panel 1--White.

Panel 2--On Molecule Man's smiling face.

> **CAPTION**
> Explain it to me again.

Panel 3--On Val and Susan.

We're tight here. But we can tell that we are in an alien environment.

> **VAL**
> Okay, Mom... Do you want the complicated version or the super-complicated one?

Panel 4--On both of them again.

> Val rolling her eyes.

> **SUSAN**
> I'd prefer the one that makes sense. Can you do that, dear?

> **VAL**
> Sigh. I can try. So...

Panel 5--HUGE PANEL.

We get a good look at the alien terrain. In the foreground, Val and Susan are looking on. In the middle ground, all the students of the Future Foundation (Alex, Dragon Man, Bentley, Onome, Artie, Leech, the Moloids, and the Fish kids) are watching what's happening in the background and recording it all with high-tech equipment. In the background, Reed, Franklin and the Molecule Man are standing side-by-side looking out into the cool space background.

> **CAPTION**
> Owen over there is the key. He's kind of a human repository of unlimited power. And that omnipotent power has to be directed--used--by an individual. In this case...Dad. And that's where it really gets interesting, as Franklin is a universal shaper. A dreamer.

PAGE 29--(6 PANELS)

Panel 1--On Franklin.

He's holding out his hands. A sphere full of galaxies is forming in his hands.

> **CAPTION**
> So he has these ideas...

Panel 2--Back on Susan and Val.

Val gesturing with her hands. Big motion.

> **SUSAN**
> For worlds?

> **VAL**
> For universes, Mom. Whole universes. Then he gives them to Dad.

Panel 3--On Reed.

Taking the sphere and throwing it into the sky--it expands.

> **CAPTION**
> And he, using all that power, spins them off into their own reality.

Panel 4--On Molecule Man.

Splitting in two.

> **CAPTION**
> And they slice off a bit of Owen to go
> with it. Like an anchor. But it also
> serves to make the Molecule Man better.
> Whole.

Panel 5--

The Molecule Man waving goodbye to the Molecule Man as he steps
away into the air--towards the expanding universe.

> **CAPTION**
> Healing him.

Panel 6--Back on Susan and Val.

> **SUSAN**
> Okay.

> **VAL**
> And all that is the start of what we're
> doing. All of this has to be cataloged.
> Recorded. Explored.

PAGE 30--(7 PANELS)

Panel 1--On Susan.

Getting it.

> **SUSAN**
> So we're like Lewis and Clark, except for
> all of reality.

Panel 2--On Val in the foreground.

The Future Foundation kids walking up behind her/towards her.

> **VAL**
> Well, sure, Mom...if Lewis and Clark
> were also creating the land they were
> exploring.

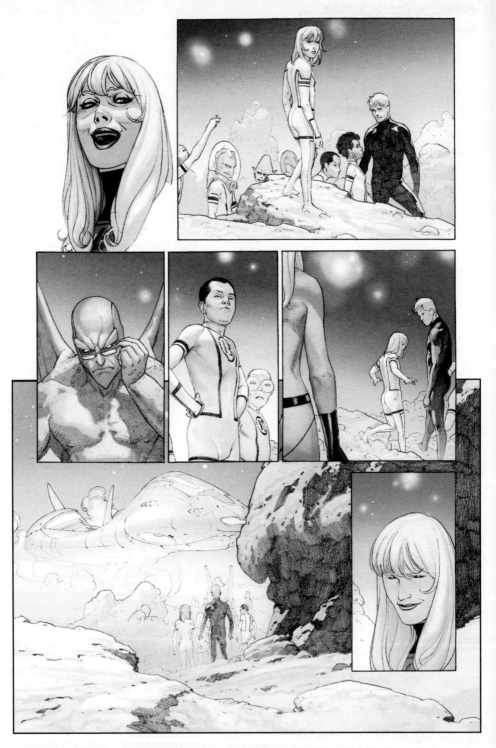

Panel 3--On Dragon-Man.

Adjusting his glasses.

> **DRAGON MAN**
> And were smarter.

Panel 4--On Bentley. Smug.

> **BENTLEY 23**
> And totally better looking.

Panel 5--

On Val, turning to join Alex as the kids are all walking away to learn from what they've just observed.

> **VAL**
> Okay. Gotta work now, Mom.

> **(tail)**
> Did you guys figure out where to start?

Panel 6--

On Alex and Val walking away from Susan.

> **ALEX**
> We kinda have to start with the
> underlying physics of it all, right?

> **(text drifts off)**
> Sure. I mean that makes the most sense.
> But we are recording all the creation
> myths Franklin is spinning out as well,
> so maybe...

Panel 7--

> Susan smiles as she watches the Future
> Foundation kids go off.

> **NO DIALOGUE**

PAGE 31--(5 PANELS)

Panel 1--

She walks over to Reed, Franklin, and Owen. Leech is hanging around...wanting Franklin to go play.

NO DIALOGUE

Panel 2--She takes Reed's hand in hers.

NO DIALOGUE

Panel 3--BIG PANEL.

They look out together, their back to us. Franklin standing beside Reed. The sky is now full of a massive new universe collapsing into a black hole--pinching it into a new reality. Just cool psychedelic star ███.

> **SUSAN**
> This sure is something.

> **REED**
> Sure is.

Panel 4--On Franklin, Looking up at his dad.

> **FRANKLIN**
> Hey, Dad...can I ask you a question?

> **REED**
> Of course.

Panel 5--On Franklin.

A bit sad, and totally sincere.

> **FRANKLIN**
> Are we not super heroes anymore?

PAGE 32--(6 PANELS)

Panel 1--Reed just looks at him.

A bit hurt, but a fatherly smile. **NO DIALOGUE**

Panel 2--Reed squats down to look at Franklin eye-to-eye.

> **REED**
> Well, here's the thing, Franklin.

(tail)

It's doing good that counts, not
necessarily how you do it. And what we're
doing right now matters--it might be the
most important thing ever--and the best
part is I get to do it with all of you.

Panel 3--On Reed.

REED

So, no...no more super heroes for a
while, just science. *(tail)* And no more
Mister Fantastic, just Dad.

Panel 4--On Reed.

Franklin turning to go run off with Leech who's laughing.

REED

That doesn't sound too bad, does it?

FRANKLIN

Nope. *(tail)*

Gonna play now.

Panel 5--On Susan, leaning close to Reed.

Into him.

SUSAN

For not being a super hero that was a
pretty amazing final act.

Panel 6--They look at each other.

Him down at her. Her up at him.

SUSAN

The raft broke and I thought we were
done.

(tail)

And then you saved us.

REED

Well...

PAGE 33--(6 PANELS)

Panel 1--A shot of the Molecule Man, but he's fading into white.

> **CAPTION**
> I had some help.

Panel 2--WHITE.

> **NO DIALOGUE**

Panel 3--Back in the Marvel Universe.

The regular, old CASTLE DOOM in Latveria.

> **CAPTION**
> And they bought me just enough time to
> fix the things I've been wrong about.

Panel 4--We pull closer to Doom on a balcony.

From behind him. (NOTE: He's in his standard green outfit, Esad).

> **CAPTION**
> The difference between living and dying
> is managing fear.

Panel 5--Closer.

He reaches for his face.

> **CAPTION**
> Not being so afraid of losing the things
> you love that you hold them too tight.

Panel 6--Closer (but still behind him).

He pulls off his mask.

> **CAPTION**
> I used to believe in universal
> contraction. Entropy and the end of all
> things.

PAGE 34--(3 PANELS)

Panel 1--On Doom.

Touching his face with the hand that isn't holding his mask. He's beautiful here, Esad. The Molecule Man healed him.

CAPTION

Well, I've changed my mind.

Panel 2--On Doom.

He looks down and to the side. A small smile at what Owen Reece did for him.

CAPTION

I'm letting go, because I believe in
expansion. I believe we endure. Don't you
see...

Panel 3--Wide on Doom on the balcony.

He looks up and out. A huge smile on his face.

CAPTION

Everything lives.

CIVIL WAR (2006) BY MARK MILLAR

AN INTRODUCTION BY **TOM BREVOORT**
IN CONVERSATION WITH **ANDREW SUMNER**

Civil War is a key Marvel event series, one that brought together all the major Marvel players to deal with a story that was metaphorically ripped from the headlines of that day. Civil War spoke to the zeitgeist at that time, while also being a crackerjack super hero adventure that pitted our characters against one another, putting them through a crucible and showing who they were and what they were made of. It's the best remembered, most influential event series that Marvel's done this century—maybe even longer.

The way Civil War came about is that two or three times a year, Marvel hold editorial summits, which are basically big multi-day meetings, where we gather together all the senior editorial staff, and a number of our key creators, mostly writers, to talk about and plan our stories for the next year or eighteen months—even the next two years. In theory, the event that we were planning that year was World War Hulk [ultimately published a year later in 2007], which writer Greg Pak was starting to put together with editor Mark Paniccia.

I came into that meeting, and I remember that I specifically said at the outset, "I just finished [the 2005 event series] House of M and I'm really not doing that again. This is all now Mark P's problem." And so, we started talking about the World War Hulk event and, after about two days, it was pretty clear that it wasn't working. The problem was that we didn't have enough time, there wasn't enough time in our publishing calendar to send the Hulk into space, to have him land on Planet Sakaar and go through the process of becoming a gladiator and then a rebel leader and then a king and then come back with all his forces to fight the other Marvel heroes.

And so, in the evening between the second and third day of the summit, Mark Millar started talking about stuff. Mark was coming over from the UK, so he had a very different viewpoint on what New York was like in 2005,

in the aftermath of 9/11. If you came through any of the major NYC train hubs or the NY airports, there were National Guardsmen there in full riot gear with big, scary-looking automatic weaponry. Mark walked through all this and was rather disquieted by something that, to the rest of us New Yorkers back in that moment, was just background noise. So, Mark came up with the initial core notion of reflecting that situation in the Marvel Universe, with the underlying question of civil liberty versus the need for safety and security told through the prism of a super hero story.

Mark originally pitched his story with Captain America being the pro-registration person and Iron Man being the anti-registration person—and I'm pretty sure that I was the one who said, "No, you've got that wrong, you've got it backwards." Captain America as I understand him is not a, "my country, right or wrong" sort of guy, he's all about individual civil liberties. And he would definitely bristle at the overreach of authority in that situation. Whereas Tony Stark, as a forward-looking futurist, would project in his mind the bad things that might happen, and could see the need for some regulation, some oversight or control. And so that storyline was bounced around that last day in the room between Mark and the rest of us—the whole thing changed. And we made the argument to Greg and Mark Paniccia that, "This is good, if we do this now, you'll have the time to carry the Hulk through that journey to Sakaar, and it will make it far more meaningful when we get to *World War Hulk* the following year."

Then there was a certain point in this conversation where it became horrifyingly apparent that all the characters involved in these story discussions were characters in my world, the Avengers world. And so I had to say, "Ah, I guess I'm going to do this, because I wouldn't want anybody else to do it, it's going to impact all of my books too heavily." And there really was nobody else in a position to do it. So, having graduated from the workload of *House of M*, I went straight into *Civil War* for the next year.

Mark went away and wrote up his initial outline for the series. He and I had worked together on and off for a bunch of years—I edited the first thing that he did for Marvel, *Skrull Kill Krew* [1995], which I commissioned and he co-wrote with Grant Morrison. So, I had a certain familiarity with Mark and his approach.

The best way to describe Mark's writing is that he always takes big swings. Mark writes in all capital letters, he builds things LARGE. And he's very good at deploying that approach in an all-company crossover event like *Civil War* (which he hasn't really done since). He's done stories

that use all our characters, like *Old Man Logan* [2008], but he hasn't really done another core crossover story like this. And he's really good at finding those scenes, those moments that truly highlight characters and create electricity, that inspire interest in the readers. He's great at building each issue around these brilliantly assembled set pieces.

Of the three *Civil War* scripts that we're presenting in this book, the first one is setting the stage, putting everything together. And even though there's a lot of exposition in issue #1, Mark also ends with a brilliantly ridiculous action sequence where Captain America escapes from the S.H.I.E.L.D. Helicarrier by surfing on the back of an F14—which is exactly the sort of over-the-top super hero idea that Mark excels at.

I think the biggest moment in *Civil War* is probably issue #2, when Spider-Man throws in with Iron Man's pro-registration alliance and publicly unmasks. We introduced that plotline because, at this time, planning was already going on for the *Spider-Man: One More Day* storyline [the 2007 series that removed Peter Parker and Mary Jane's marriage from continuity]. And so, knowing that story was in the offing, we all thought that we could actually unmask Spider-Man as part of *Civil War*, and then be able to resolve that plot point as part of *One More Day* [mystical arch-villain Mephisto changes history so that Peter and Mary Jane never married]. That immediately meant that there was a huge and publicly noteworthy event that would happen in *Civil War* issue #2, a very strong driver of interest for the whole series.

There was a lot of push and pull between having that moment happen in *Civil War* and having it happen in the core Spidey book, *Amazing Spider-Man*, but it was a key *Civil War* story moment, so Mark got to do it and it happened in *Civil War*. And *Amazing Spider-Man* handled the moment leading up to it, and all of the personal ramifications that came right after.

We had some delays putting *Civil War* together, because it was a huge undertaking and the later issues started to space out. Seven issues is a weird number; I feel like maybe we started out with six and we expanded it to seven. I think we had figured all of that out by the time we published the first issue (the series has a tagline that says something like, "a Marvel Comics event in seven parts," right from issue #1). I think it may have been the case that there was a version of Mark's final [post-Hulk] outline that only had six issues, and it was too tight. So, we decided, "Okay, we'll do seven." But seven's still a weird number.

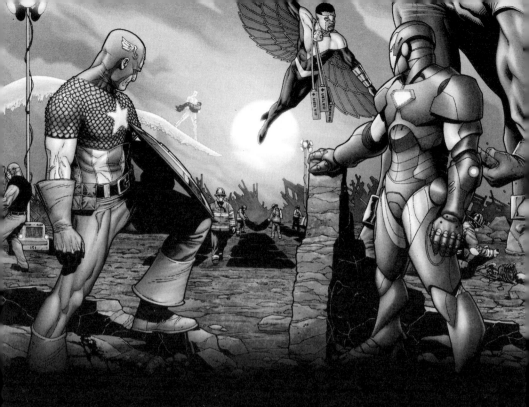

AVENGERS

CIVIL WAR
ISSUE #1
2006

By Mark Millar

Art by Steve McNiven, Dexter Vines,
and Morry Hollowell

PAGE ONE

1/ Open with a shot of one of the producers from the New Warriors comic sitting at the same video-system we've seen them use before. This guy is in contact with the team via radio.

> **CAPTION** : (name of a Marvel TV station)

> **PRODUCER** : Okay, how many super-villains are we TALKING here, Speedball?

2/ Cut to Connecticut and the New Warriors (minus Nova) as they crouch by a bush and spy on a big house where some baddies seem to be holed up. They're watching with binoculars. There's four of them in total; Speedball, Microbe, Namorita and Night-Thrasher. They have a couple of camera guys here too and a make-up girl. As you'll have seen from their regular book, they're reality TV super heroes; the X-Men meets Extreme Makeover as they wander America in a van in search of crime and ratings.

> **CAPTION** : Stamford, Connecticut:

> **SPEEDBALL** : Three. No, wait. I think I see Coldheart in the back yard emptying the trash. That's FOUR of 'em in total and all four are on the FBI WANTED LIST, right?

3/ Cut back to the producers and we get a wider shot of the studio here as they check their files and answer Speedball's question.

> **PRODUCER** : Cobalt Man, Coldheart, Speedfreek, Nitro... Yep, they all broke out of Ryker's three months back and all of them have records as long as your arm.

> **PRODUCER** : Coldheart fought Spider-Man a couple of times and--get this--Speedfreek almost took down THE HULK.

PAGE TWO

1/ Cut back to the New Warriors and Speedball looks a bit irritated at the nervousness of his team-mates as they all crouch behind this tree,

NIGHT-THRASHER : He WHAT?

MICROBE : These guys are totally out of our LEAGUE, man. No WAY we should be going in there.

SPEEDBALL : But think about the RATINGS, Microbe. This could be the best episode of the entire SECOND SEASON.

2/ Pull back and see their loud NEW WARRIORS van parked discreetly down the street and somewhere the super-villains won't see it.

SPEEDBALL : Six months we've been driving around the mid-west looking for goof-balls to fight and the best we've managed so far was a bum with a spray-can and a wooden leg.

SPEEDBALL : This could be the episode that really puts New Warriors on the map, dude. We beat THESE guys and people stop bitching about NOVA leaving the show.

3/ Cut back to Namorita and she's a lot more gung-ho than the others until Speedball points out the big zit on her chin.

NAMORITA : So what's the plan?

SPEEDBALL : The plan is you spend five more minutes in make-up, Namorita. You think people wanna see that great, big ugly ZIT on your chin?

4/ Speedball continues with the plan, but Night-Thrasher interrupts as he looks through the binoculars at us.

SPEEDBALL : Then we--

NIGHT-TRASHER : Uh-oh.

MICROBE : Whassup?

5/ Shot through the binoculars and we see the female Spider-villain Coldheart in her civvies as she stops empty the trash and looks around at us for a second, focusing.

NIGHT-THRASHER : We've been MARKED.

PAGE THREE

1/ Cut to inside the house as Coldheart runs in and yells at the others. They've all been hiding out in here and should be in some combination of their civvies and their super hero costumes. Speedfreek picks up his helmet and prepares to get into costume.

> **COLDHEART** : EVERYONE IN COSTUME!

> **COLDHEART** : IT'S A RAID!

2/ Cut to the New Warriors leaping into action.

> **SPEEDBALL** (huge) : GO!

3/ Cut back inside the house and Speedball jumps through the window and heads straight for Speedfreek while he isn't even partially suited-up.

> **COBALT MAN** : HOLY JEEZ!

PAGE FOUR

1/ Cut to outside the back of the house as Speedball and Speedfreek smash out through the back wall and land on the grass, Speedball in total control of what he's doing here.

> **SPEEDFREEK** : OOF!

> **SPEEDBALL** : I'd HEARD that clothes make the man, Speedfreek...

2/ Pull back for a beautiful big smack and Speedball takes him right out, one of the camera guys running around in the background and trying to get a perfect shot.

> **SPEEDBALL** : ...and in your case it's TOTALLY TRUE!

> **SPEEDFREEK** : UNGH!

> **CAMERA GUY** : Sound was off for a second there, bud. Any chance of that last part again?

3/ Switch angles and Speedball just smacks the poor villain again.

> **SPEEDBALL** (big) : ...and in YOUR case it's TOTALLY TRUE, chuckles!

> **SPEEDFREEK** : UNGH!

PAGE FIVE

1/ Cut to Coldheart, still in her civvies, as she swings her sword around in the garden and both Namorita and Night-Thrasher do what they can to avoid it.

> **COLDHEART** : Wait a minute. I know you guys. You're those idiots from that REALITY SHOW. I'm not getting taken down by GOLDFISH-GIRL and THE BONDAGE QUEEN.

2/ Nasty crack as she gets belted across the face by Namorita.

> **NAMORITA** : Beg to differ, Coldheart.

3/ Another cool shot as she just gets put down by Night-Thrasher.

> **NIGHT-THRASHER** : Could we cut out the
> part where she called me THE BONDAGE QUEEN?

4/ Cut to Microbe standing over Cobalt Man and we see him lying
across the barbecue and rusting up fast with Microbe's little germ
friends crawling over all him.

> **MICROBE** : Oh, yeah. Because
> NIGHT-THRASHER sounds SO much STRAIGHTER.

> **MICROBE** : Got my beasties
> rusting COBALT MAN if anyone wants to track
> down that old CAPTAIN MARVEL villain.

PAGE SIX

1/ Head and shoulders shot of Microbe, his eyes closed as his hair blows to one side. Something has just flown past him at incredible speed.

NO DIALOGUE

2/ Pull back for an elevated shot from behind Namorita and we see her flying across this neighborhood and heading for Nitro (who's running off into the distance).

> **NAMORITA** : ON it.

3/ Big impact shot as Namorita flattens him against a yellow school bus.

NO DIALOGUE

4/ Switch angles so we see the school and the background. A camera guy appears from nowhere and films the whole thing as Namorita grabs Nitro's shirt with one hand and pulls back her other fist. He's still pretty dazed lying here and she looks pretty bad-ass. One of the camera-men is catching the whole thing here and Namorita is really playing this up for TV.

> **NAMORITA** : On your FEET, Nitro. And don't try any of your stupid explosions because that's only going to make me HIT you harder.

> **NITRO** : Namorita, right? Aren't you the Sub-Mariner's COUSIN or something? Well, I'm afraid we're not the bargain basement losers you guys are USED to, baby...

PAGE SEVEN

1/ Close on Nitro and he gives us a little grin, eyes glowing.

> **NITRO** : ...you're playing with the BIG BOYS now.

2/ Pull back for a huge explosion that takes out both Namorita and the bus.

NO DIALOGUE

3/ Cut to the school-yard and the kids all stop playing ball for a moment, looking up as they're bathed in a brilliant white light.

NO DIALOGUE

4/ Pull back for a big shot of the neighborhood and we see this school just getting obliterated (plus a little of the surrounding houses too) in a white-hot light that just eats everything it touches.

NO DIALOGUE

PAGE EIGHT AND NINE

1/ Cut to just a few hours later and a double-page spread where, most prominently, we see Captain America and Iron Man standing in full-figure shots in the ruins of this place. It looks like a Hiroshima picture with burned bones everywhere. The place is in darkness and we see lots of Avengers and X-Men helping out here with the rescue effort, everyone wearing oxygen masks and working with the official rescue workers. Cap and Iron Man are just surveying the quite awesome damage here. I see this as a full figure shots of Iron Man and Cap (one on each page) but you're the boy, Steve McNiven. Your call.

TITLE AND CREDITS

PAGE TEN

1/ Head and shoulders shot of both as they pause for a moment, surveying the damage to the school and a little of the surrounding area. Total horror.

> **IRON MAN** : I'm told they've got a lead on the NITRO situation. Word is he sneaked out of town in the back of a PICK-UP TRUCK.

> **CAPT AMERICA** : Does it MATTER?

> **CAPT AMERICA** : All these CHILDREN, Tony:
> FEMA Chief said there could be EIGHT
> or NINE HUNDRED. All dead for a stupid
> REALITY TV SHOW.

2/ Shot from behind as they walk off to help everyone.

> **IRON MAN** : They should have called
> US, Cap. Speedball KNEW they were out of
> their league.

> **IRON MAN** : Whole country saw the
> tape where they ADMITTED they were only
> chasing ratings.

3/ Cut to Colossus, Marvel Girl and some of the others trying to help out and they're getting a call from some rescue workers near a huge pile of rubble.

> **RESCUE WORKER** : Marvel Girl! Cyclops!
> We need some help over here. Motion
> detectors are picking something up twenty
> feet down, but we haven't got our DIGGERS
> yet.

4/ Cyclops and Rachel stand around this rubble and Rachel prepares to use her powers to move everything to one side.

> **OTHER RESCUER** : Everybody back. Clear a
> little space, huh?

> **CYCLOPS** : Can you handle this on
> your own, Rachel?

PAGE ELEVEN

1/ Cool shot of Rachel using her powers to remove all the rocks.

> **MARVEL GIRL** : I can HANDLE it, Dad.

2/ Overhead shot and we see some people trapped in what must have been a basement, the rescue workers radioing back for medical back-up.

> **RESCUE WORKER** : Six more survivors over by
> the school's north side. Bring blankets
> and a defibrillator.

3/ Amazing shot of a couple of the big Sentinel robots standing in
the middle of all this madness.

> **WOLVERINE** : You GOTTA be kiddin' me.

4/ A little kid looks scared by these awesome machines off-panel
and his mother reassures him everything will be fine. But everyone
looks a little scared.

> **CHILD** : M-Mommy?

> **MOTHER** : It's okay. honey. They
> aren't going to hurt you. The Sentinels
> are only here to keep an eye on the X-Men
> for us. They're the GOOD GUYS.

PAGE TWELVE

1/ Shot of Wolverine on one of the cameras they're looking through.

> **WOLVERINE** : We volunteer to
> help with a FEDERAL EMERGENCY and you're
> STILL following us around?

2/ Cut to one of these pilots inside as he chews on a cigarette and
grins, looking into his little monitor.

> **SENTINEL PILOT** : Just doin' our
> JOBS, Wolverine.

> **SENTINEL PILOT** : Don't mind us.

3/ Cut to all the super heroes helping out and we focus on Black
Goliath and Ms Marvel (War-Bird) as they attend to the wounded or
look for the dead.

> **BLACK GOLIATH** : It won't just be mutants
> they're watching after THIS one, War-
> Bird. This is the one they've been
> WAITING for.

 MS MARVEL : Who? The
politicians?

4/ Switch angles and go a little closer.

 BLACK GOLIATH : Politicians.
Parents groups. You name it, honey: One
more SCREW-UP and they said they'd be
after us with TORCHES and PITCHFORKS.

 MS MARVEL : Well, maybe they're
RIGHT, Goliath. Maybe we DO need some
kind of clamp-down.

5/ Pull back for a wide shot of all the devastation and the super
heroes and rescue workers as little figures doing what they can.

 MS MARVEL : Who the Hell can
justify THIS?

PAGE THIRTEEN

1/ Cut to a television panel and we see a smartly dressed She-Hulk
being interviewed.

 JENNIFER WALT : A ban on super-heroes?
Well, in a world with thousands of super-
villains that's obviously IMPOSSIBLE,
Larry.

 JENNIFER WALT : But training them properly
and making them carry badges? Yes, I'd
say that sounds like a sensible response.

2/ Cut to an interior shot of a church in Connecticut and a big
grand memorial service for all the kids who died in the accident.

 PRIEST : ...and so we ask you,
Lord, for your mercy. Not only for the
souls of the children who perished, but
the super-people who's carelessness
CAUSED this tragedy.

3/ Cut to church exterior as Tony leaves the church with everyone
else and someone calls on him from off.

 OFF-PANEL : Tony Stark?

PAGE FOURTEEN

1/ Shot of this woman just spitting right in Tony's face and Tony's security guy is horrified.

> SECURITY GUY : HOLY--!

2/ Head and shoulders shot of this furious woman as she screams at us, eyes blazing and maintaining a direct eye-contact with the reader.

> ANGRY MOM : YOU MURDERING SON OF A BITCH!

3/ Tony still seems shocked as he reaches for a hankie and the security guy tries to move the woman to one side.

> SECURITY GUY : Ma'am, please. We're gonna have to ask you to leave.

> ANGRY MOM : Leave WHAT? My own son's FUNERAL? STARK'S the one you should be dragging away.

4/ Tony cleans the spits from his face and tries to be reasonable, but this Mum just won't let up. She's screaming and yelling at him here and everyone is looking.

> TONY STARK : Ma'am, I appreciate that you're upset, but the New Warriors' RECKLESSNESS had nothing to do with ME.

> ANGRY MOM : Oh, yeah? And who owns THE AVENGERS? Who's been telling kids for years that they can live outside the law as long as they're wearing TIGHTS?

PAGE FIFTEEN

1/ The Mum's still losing it, screaming at Tony. The security guy sticks a hand on her shoulder to quiet her down.

> **ANGRY MOM** : Cops have to TRAIN and CARRY BADGES, but that's too BORING for TONY STARK.

> **ANGRY MOM** : Nah, JOE BILLIONAIRE here says all you need is some powers and a bad-ass attitude and you can have a place in his private SUPER-GANG.

> **SECURITY GUY** : Ma'am, PLEASE.

2/ The Mum turns around towards Tony again, shouting at him.

> **ANGRY MOM** : You FUND this sickness, Stark. With your dirty billions.

3/ Pull back and we see the Mum storm off through the crowds.

> **ANGRY MOM** : The blood of my little Damien is on your hands right now.

4/ Cut to Jonah Jameson and Peter Parker standing there watching the whole thing and Jonah looks kind of pleased, asking Parker a question as Peter looks up from his camera.

> **JONAH JAMESON** : I hope you're GETTING all this, Parker.

5/ Cut to another TV panel and a commentator discusses the Registration Act with a little banner down below reading: "Is It Time For Super Heroes To Be Registered?"

> **COMMENTATOR** : ...like Speedball, for example. Nobody likes to speak ill of the dead, but here was a boy who, by all accounts, couldn't even name the President of the United States.

> **COMMENTATOR** : Their powers can be as awesome as NUCLEAR WEAPONS, Bill. Shouldn't they sit some kind of TEST before they're allowed to work in our communities?

PAGE SIXTEEN

1/ Cut to an establishing shot of an area of NYC at night and we see lots of people standing around outside a night-club as a streak of orange shoots through the skies towards them. A beautiful girl is standing below, checking her watch.

> **CAPTION** : Things turn ugly:

2/ The streak of orange flames-off and becomes the Johnny Storm and he stands here, looking cool, as the girl looks a little suspicious.

> **JOHNNY STORM** : Hey, baby. Sorry I'm late, but I had to rescue a bunch of cute kids from a burning orphanage on the way over here.

> **GIRLFRIEND** : Is that TRUE, Johnny, or are you just making stuff up again so I don't get MAD at you?

> **JOHNNY STORM** : Well, swap "orphans" for "babes" and "burning building" for "signing autographs" and it's COMPLETELY true, sweetie.

3/ Johnny gives a big hello to the doorman who unhooks a rope and allows him past all the people lining up outside. These people look a bit pissed off.

> **JOHNNY STORM** : CHICO! How's it HANGING, big man?

> **DOOR-MAN** : Paris and Lindsay are waiting upstairs, Johnny. Chicks couldn't BELIEVE it when I said you were dropping by.

> **SOME GIRL** : Hey! How come that loser's getting in when we've been waiting HOURS?

4/ Johnny blows the girl off with a smirk, but the crowd are getting hostile.

> **JOHNNY STORM** : Tell you what, gorgeous: Next time YOU save the world from Doctor Doom you can borrow my FREE PASS, 'kay?

> **ANOTHER GIRL** : What about the next time you blow up a school, jackass?

> **COOL GUY** : Yeah, what about the next time you kill some KIDS?

PAGE SEVENTEEN

1/ Johnny stops, turns around and mouths back off at these people. The girl is looking uncomfortable, realizing the crowd are against them.

> **JOHNNY STORM** : What?

> **SOME FAT GUY** : Man, you got a NERVE swaggering around town after THAT. I was you I'd be ashamed to step outside the door.

2/ Johnny gets agitated and a little angry as the crowd get very hostile.

> **JOHNNY STORM** : Hell are you SHRIEKING about, tubby? I've never even MET the New Warriors. Those guys were C-List TOPS.

> **ANOTHER GUY** : BABY-KILLER!

> **GIRLFRIEND** : Johnny? I don't LIKE this. I want to go home.

3/ Someone smacks Johnny across the back of the head with a beer-bottle.

> **SOUND F/X** : KLEEESH!

4/ Pull back as he's pulled to the ground and everyone starts attacking him while he's unconscious.

> **GIRLFRIEND** : JOHNNY!

> **FINAL GUY** : HOLD HIM DOWN! HOLD HIM DOWN!

5/ Insert panel with a nightline newsreader.

> **TV BALLOON** : Human Torch the latest in a series of attacks on New York's super-community. More at eleven plus the growing pressure on THE PRESIDENT--

> **TV BALLOON** : The people of Stamford ask: What are his PROPOSALS for SUPER HERO REFORM?

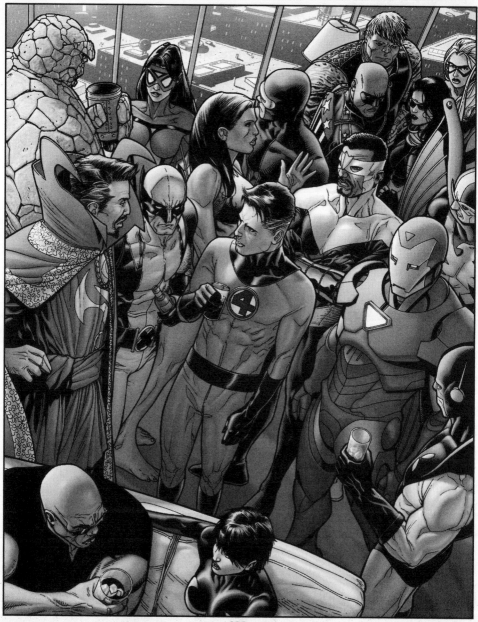

PAGE EIGHTEEN

1/ Okay, turn over for a slim panel down the left hand side of the spread here and an establishing shot of the Baxter Building. The sun is going down and there's lots of long shadows. The place looks very eerie and desolate.

> **CAPTION** : The Baxter
> Building:

2/ Cut to the main picture here and one of those big wide shots that give fanboys like me a multiple orgasm just by glancing at it. Pretty much everyone who'd care about the Registration Act is here in this dark, abandoned place and standing around talking. I remember loving the wedding of Yellowjacket as a kid because it had a great big picture where Buscema carefully worked out who WOULD be standing talking and who'd be kind of annoying the other. I'd like to do that here with the FF (minus Johnny and Reed), Namor, all The Avengers (minus Cap), Cyclops, Wolverine and Marvel Girl from the X-Men (nobody else could get out) and pretty much all the other Marvel heroes from The Defenders to Young Avengers. Tom will be able to advise as regards DD's status come May. Hulk, I think, will be off-world and Spidey will be here in a couple of pages, though not here in this initial spread. But make it as many big name guys as possible because a spread with a bunch of nobodies isn't very exciting and we're already missing so many big players like Thor, Hawkeye, etc. I really want this series to put all those guys back on the map.

> **DR STRANGE** : They wish to make us PAID
> FEDERAL EMPLOYEES?

> **REED RICHARDS** : According to my friends
> in Washington, but it's still to be
> confirmed. Word is they want to give us
> pension plans and annual vacation time.

> **THE WASP** : This is ridiculous. What
> are they trying to do? Turn us into CIVIL
> SERVANTS?

> **POWER-MAN** : Looks to me like they're
> trying to close us down, Wasp.

PAGE NINETEEN

1/ Luke Cage snorts, but Iron Man is also supportive. The Young Avengers are all grouped together and seem a little nervous about speaking out here. Reed isn't quite sure who they are.

> **IRON MAN** : Or make us more LEGITIMATE. Why SHOULDN'T we be better trained and publicly accountable?

> **PATRIOT** : Somebody said we should go on STRIKE if they mess with us like this. Does anybody think that's a good idea?

> **REED RICHARDS** : No, ah... It's PATRIOT, right? No, I don't think anyone here could seriously advocate a super hero strike, son.

2/ Close on Iron Man standing here with Yellowjacket and Reed Richards. They've formed a little nucleus in support of this idea. Cyclops asks a question.

> **CYCLOPS** : So what's the general consensus?

> **IRON MAN** : As far as I'M concerned, Stamford was a wake-up call. What alcoholics refer to as a MOMENT OF CLARITY.

> **IRON MAN** : If they want us all to start working for S.H.I.E.L.D. I say it's definitely worth CONSIDERING.

3/ The Falcon just seems aghast, but Yellowjacket is becoming a little irritated that the guys aren't just lying down and doing as they're told.

> **THE FALCON** : I can't believe I'm HEARING this. The masks are a TRADITION. We can't just let them strip away our RIGHTS.

YELLOWJACKET : Are you kidding? We're lucky people have tolerated this for as long as they have, Sam. Why SHOULD we be allowed to hide behind these things?

4/ Wolverine, who's been watching from the background, snarls. The Thing stands close-by and there's a clear animosity between the two.

WOLVERINE : Because the world ain't so NICE outside your ivory tower, bub.

THE THING : TELL me about it, stumpy. You think Johnny would have ended up in hospital last night if morons like you wasn't out there givin' us a BAD NAME?

PAGE TWENTY

1/ Cool shot of Spidey sliding down a web. Black Cat looks up with a smile on her face, clearly pleased to see him.

> **SPIDER-MAN** : Who knows? But if we're forced to hand over our secret IDS I think a whole lot of people might just hang up their TIGHTS.

> **BLACK CAT** : Spider-Man!

2/ Turn over for a big panel where we get a great shot of Spider-Man sticking to a wall and talking to Sue.

> **SUE RICHARDS** : To be honest, we've been public right from the start and it's really not such a big deal.

> **SPIDER-MAN** : Yeah, well... Not until that day I come home and find my wife impaled on an OCTOPUS ARM and the woman who raised me begging for her LIFE.

3/ Nighthawk asks a question and we see Daredevil sitting at a table and looking moody as he faces away from the others. Imagine the blackboard-scratching scene in Jaws with Robert Shaw. He's sitting here and twisting a coin around his fingers.

> **NIGHTHAWK** : Uh, does anybody else think we're being a little PARANOID here? After all, these proposals are still just IDLE SPECULATION, right?

> **DAREDEVIL** : No, this has been building steam for a LONG TIME, Nighthawk. Stamford's just the straw that broke the camel's back.

4/ Close on Daredevil grinning as he plays with this coin. Although this is Iron Fist in disguise, he should still have that creepy DD grin.

> **DAREDEVIL** : This is the END of the way we do BUSINESS.

PAGE TWENTY-ONE

1/ Cut to an establishing shot of the S.H.I.E.L.D. Helicarrier.

 CAPTION : S.H.I.E.L.D. Helicarrier,

 SUB-CAPTION : Six miles above New York:

2/ Cut to interior and we're in a big wide open space where Captain America stands, shield in hand, as he faces Commander Maria Hill across a room. There should be a couple of high-ranking guys with her here and, of course, a couple of S.H.I.E.L.D. guards too. There's a distance between Cap and Maria at first to illustrate their relationship.

 MARIA HILL : Captain.

 CAPT AMERICA : Commander Hill.

3/ Maria smirks a little as she reads something on a bigger, cooler S.H.I.E.L.D. version of a Blackberry.

 MARIA HILL : I'm told that forty-three of your friends are meeting in The Baxter Building right now to discuss how the super-people should respond to The President's big idea.

 MARIA HILL : You think they'll go for it?

4/ Cap remains disdainful and Maria snaps a little.

 CAPT AMERICA : I don't think that's for me to judge.

 MARIA HILL : C'mon, Rogers. Cut the crap. We're never going to be tight like you and Nick Fury, but I'm still the Acting Head of S.H.I.E.L.D..

 MARIA HILL : Respect the badge if nothing else.

PAGE TWENTY-TWO

1/ Close on Cap, moody and eyes narrowed.

> **CAPT AMERICA** : I think these proposals will split us down the middle.

> **CAPT AMERICA** : I think you're going to have us at WAR with one another.

2/ The other S.H.I.E.L.D. guys are bitching as they all quiz Cap.

> **FIRST GUY** : What's the MATTER with these guys? How can anyone argue with super heroes being PROPERLY TRAINED an PAID for a living?

> **OTHER GUY** : How many rebels do you estimate here, Captain?

> **CAPT AMERICA** : A lot.

> **MARIA HILL** : Any majors?

3/ Cap answers clearly, but is suspicious of the line of questioning.

> **CAPT AMERICA** : A few, but mostly the heroes who work close to the streets like Daredevil and Luke Cage.

> **MARIA HILL** : So nobody you can't handle, huh?

4/ Close on Cap, eyes narrowed and quietly angry-looking.

> **CAPT AMERICA** : Excuse me?

5/ Close on Maria, sneering a little.

> **MARIA HILL** : You heard.

PAGE TWENTY-THREE

1/ Maria consults her little machine again and the others all look at Cap. We can see that he's becoming increasingly uncomfortable here.

MARIA HILL : This goes to a vote in
two weeks time and could be law in as
little as a month. But we can't go into
it half-cocked.

MARIA HILL : We're already developing
an anti-superhuman response unit here,
but we need to make sure The Avengers are
on-side and that you're out there leading
The Avengers.

CAPT AMERICA : Forget about it.

2/ Cap and Maria face off.

CAPT AMERICA : You're asking me to
arrest people who risk their lives for
this country every day of the week.

MARIA HILL : No, I'm asking you to obey
the will of the American people, Captain.

3/ Cap is really getting angry here.

CAPT AMERICA : Don't play POLITICS with
ME, lady. Super heroes need to stay ABOVE
that stuff or Washington starts telling
us who the SUPER-VILLAINS are.

4/ Pull back and a wide shot as we see panels around her big office
open up and specially-trained S.H.I.E.L.D. agents standing here
with weapons. Cap is completely surrounded. IMPORTANT NOTE: These
guys are trained in anti-superhuman warfare and known as Cape-
Killers. Chaykin will be designing them even as we speak to have
Tom forward any visuals prepared.

MARIA HILL : I thought super-villains
were people who broke THE LAW, Captain
Rogers.

SOUND F/X : CHIK-CHAK

PAGE TWENTY-FOUR

1/ Cap doesn't look fazed as these guys surround him with an arsenal of weapons. Maria tries to reason with him here.

> **CAPT AMERICA** : Is this the hit-squad you've been training to take down heroes?

> **MARIA HILL** : Nobody wants a war, Captain. We're just sick and tired of living in The Wild West.

2/ The argument continues, the weapons trained on Cap the whole time as the other S.H.I.E.L.D. people try to talk him into this.

> **CAPT AMERICA** : Masked heroes have been a part of this country for as long as anyone can remember.

> **MARIA HILL** : So's SMALLPOX. Now calm down and let's be REASONABLE, huh? Nobody's saying you can't do your JOB anymore...

> **OTHER GUY** : You just have to conform to the same rules and regulations as EVERYBODY ELSE.

3/ Cap barks an order at the guys and Maria overrules him.

> **CAPT AMERICA** : Put your weapons DOWN, boys.

> **MARIA HILL** : STAND YOUR GROUND, gentlemen. Captain America is NOT in charge here.

4/ Cap is getting louder and angrier and Maria gives the order to a take-down if necessary. The whole thing is getting out of control.

> **CAPT AMERICA** : Put your weapons DOWN or I will NOT be responsible for WHAT COMES NEXT...

> **MARIA HILL** : TRANQUILIZERS ON, gentlemen! ONE FALSE MOVE and you have my permission to TAKE HIM DOWN!

5/ Cap fumes.

 CAPT AMERICA : This is INSANE. Completely
 INSANE.

 CAPT AMERICA : Damn you to Hell for
 this, Hill...

PAGE TWENTY-FIVE

1/ Maria looks equally irritated.

 MARIA HILL : Damn you to Hell for
 MAKING me do it...

2/ Pull back for a big picture as Cap just cuts loose and takes
these guys down, several of them suddenly panicked into action and
responding as Maria barks an order.

 MARIA HILL : TRANQUILIZERS! NOW!

3/ Cap uses one of the guys he's just knocked out as a shield, letting his back pick up the twenty tranquilizer bullets that have just been fired at him.

NO DIALOGUE

PAGE TWENTY-SIX

1/ Dropping this guy, Cap spins around and chucks his shield towards us with the other hand.

NO DIALOGUE

2/ Cool impact shot as this shield slices through various weapons perfectly and takes out a couple of the other S.H.I.E.L.D. people too.

> **CAPE-KILLER ONE** : UNH!

3/ Cut back to Cap moving like an animal through these guys, just kicking their asses Kirby-style as the few remaining S.H.I.E.L.D. guys bunch together and get ready to shoot again.

> **CAPE-KILLER TWO** : TAKE HIM DOWN! TAKE HIM DOWN!

4/ Switch angles and we see Captain America running towards these terrified soldiers and raising his arm to catch his shield without

missing a beat. The shield is coming in from off-panel at an angle.
He's done this a million times and knows what he's doing.

 CAPT AMERICA : Don't even THINK
 about it, boy...

PAGE TWENTY-SEVEN

1/ Pull back for a big picture of Cap holding his shield before his
face and charging through these soldiers like he's playing American
football. This should look like a modern spin on all the classic
Kirby Cap action. Make this really, really brutal.

 NO DIALOGUE

2/ Cut back to Maria as she lies on the floor and yells into her
radio for back-up.

 MARIA HILL : MARIA HILL TO ALL UNITS:
 STOP CAPTAIN AMERICA! I REPEAT: STOP
 CAPTAIN AMERICA!

3/ Cut to the other side of these big glass windows and Cap smashes
through them, using his shield as a buffer, and looking so in
control that it's scary. We're hundreds of feet in the air here and
get to play around with the scale a little on the next page.

 NO DIALOGUE

MARVEL'S AVENGERS—SCRIPT TO PAGE

PAGE TWENTY-EIGHT

1/ Cut to the S.H.I.E.L.D. guards stationed around at various levels as they open fire with their machine guns.

 SOUND F/X : BRAKA BRAKA

 SOUND F/X : BRAKA BRAKA

 SOUND F/X : BRAKA BRAKA

2/ Okay, here's a wildly ambitious shot that's going to take up most of the page where we have a strobe image of Captain America spinning around, seen as a multiple image, as he drops several hundred feet and deflecting bullets every step of the way with his shield. Good luck, mate. You'll need it! But the good news is that this page goes down in history if you manage to pull this off.

 SOUND F/X : PTANG TANG

 SOUND F/X : TANG TANG TANG

3/ Cut to a few hundred feet below and one of the S.H.I.E.L.D. jets coming in to land, the pilot completely unaware of everything that's going on above him. Ground team waiting for him are in a panic.

 RADIO BALLOON : War-Hawk One, you are clear to land. OVER.

 RADIO BALLOON : Roger that, base-command, but what's the situation with the GROUND-TEAM down there?

PAGE TWENTY-NINE

1/ Close on the cock-pit as Cap's shield shattering down through the glass, embedding itself in the steel as Cap stops his fall very suddenly here.

 SOUND F/X : SHADDUNKK!

 PILOT : HOLY MOTHER OF JEEZUS!

2/ Switch angles and a big image of Cap grimacing as he squats here on the front of the jet holding onto his shield as it sits twelve inches deep inside the metal front.

> **CAPT AMERICA** : Keep flying--
>
> **CAPT AMERICA** : --and watch your MOUTH!

3/ Cut to the huge runway on the OTHER side of the Helicarrier and we see all these guys trying to pull the big doors over in time. We're looking through a big open door here and there's total panic all around.

> **GROUND-TEAM** : CLOSE THE DOORS! CLOSE
> THE DOORS! Somebody give me a HAND with
> this thing, huh?
>
> **OTHER GUY** : LOOK OUT!

PAGE THIRTY

1/ Pull back for what's almost a full-page picture and the most spectacular shot of the jet turning sideways with Cap clearly on the side here as it exits the Helicarrier. This is our money-shot and Cap looks like he's wind-surfing from this angle. This should be a picture the readers take to their graves.

NO DIALOGUE

2/ Pull back for a wide shot of it shooting away from the Helicarrier and disappearing off through the clouds.

NO DIALOGUE

PAGE THIRTY-ONE

1/ Cut back to Maria as she's helped to get feet and looks seething mad. We can see the soldiers looking nervous and she's wiping some blood from her nose.

> **MARIA HILL** : IDIOT.

> **MARIA HILL** : We were trying to SAVE LIVES here, Rogers.

2/ Cut to Dr Strange's apartment and we see him sitting back and supping tea in a big Indian chair, his room filled with the most amazing curiosities. Wong stands before him before calmly, his head slightly bowed as he mentions the huge figure of The Watcher standing gazing at them from the corner.

CAPTION:
The Sanctum Sanctorum, Greenwich Village:

> **DR STRANGE** : I fear the super heroes are on the brink of a Civil War here, Wong, and the devastation will be TERRIBLE.

> **DR STRANGE** : Tony Stark seems ESPECIALLY affected by this Stamford Incident and is on the cusp of making a most GRAVE MISCALCULATION.

> **WONG** : Ah.

> **WONG** : You are aware there is an ENTITY in this room with us, master?

3/ Close on the Doctor as he sips his tea and replies almost casually, quite used to these things. He doesn't even look up.

> **DR STRANGE** : His name is THE WATCHER, my friend, and he only appears to record moments of GREAT CHANGE and ENORMOUS UPHEAVAL.

4/ Close on The Watcher, uplit by the candles in this room, as he gazes down emotionless.

> **OFF-PANEL** : His presence now does not BODE WELL.

PAGE THIRTY-TWO

1/ Cut to an establishing shot of Washington and hundreds of families camped outside the White House (like Cindy Sheehan) protesting for a change in the law.

> **CAPTION** : WASHINGTON DC:

2/ TV panel where somebody comments on this situation.

> **TV BALLOON** : No, the fact that Congress has responded so SWIFTLY just proves what an effective political operator Muriel Sharpe has BECOME.

> **TV BALLOON** : She and the OTHER Stamford Reformists have really TAPPED INTO America's quiet discomfort with SUPERHUMAN MISBEHAVIOR here...

3/ Cut to Miriam sitting here among the people with a sign saying "JUSTICE FOR DAMIEN" as she holds a framed photograph of her son, sad eyes looking out at us. "GUNS ARE LICENSED: WHY NOT POWERS?" banner, etc, behind her too.

NO DIALOGUE

4/ Cut to interior and The President (standing) is holding a very tense Cabinet meeting where he's just heard the bad news.

> **SECY OF DEFENSE** : ...and then he landed the jet in a FOOTBALL FIELD before taking the pilot for a HAMBURGER AND FRIES.

> **SECY OF STATE** : Ain't that just like Captain America? Making sure a two billion dollar WAR-PLANE don't get damaged no matter HOW much trouble he's in?

> **THE PRESIDENT** : I'm glad you think this is FUNNY, Mister Secretary. Because I was under the impression that the registration plan was CONTROVERSIAL ENOUGH.

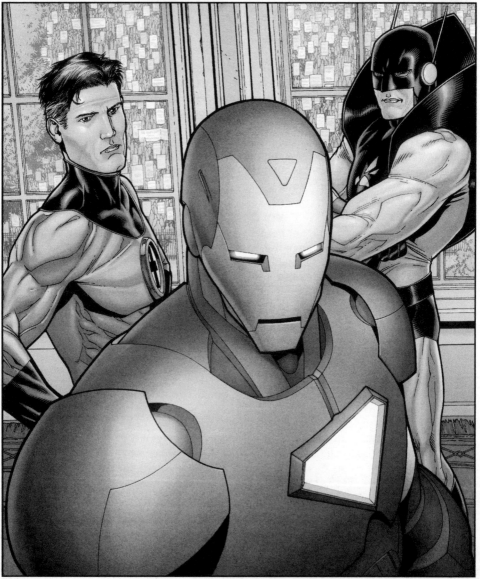

PAGE THIRTY-THREE

1/ Shot from behind Tony Stark as he sits at the other side of the table. The President is still upset.

> **THE PRESIDENT** : Cap going underground means every super hero who disagreed with us now has a figurehead. He'll give civic disobedience ENORMOUS CREDIBILITY.

> **TONY STARK** : Then we give the OTHERS a figurehead of their OWN, sir.

> **VICE-PRESIDENT** : What are you suggesting, Mister Stark?

2/ End the issue with a big image of Tony sitting here flanked by Mister Fantastic and Yellowjacket sitting on either side of him.

> **TONY STARK** : I'm saying we PUSH AHEAD and do what needs to be DONE here.

> **TONY STARK** : Leave CAPTAIN AMERICA to US.

TO BE CONTINUED

AVENGERS

CIVIL WAR
ISSUE #6
2006

By Mark Millar

Art by Steve McNiven, Dexter Vines,
and Morry Hollowell

PAGE ONE

1/ Open the issue with the usual recap page filling everyone in on the non-stop excitement that is Marvel Civil War.

PAGE TWO

1/ Cut to a full-page splash out in the desert where S.H.I.E.L.D. and Hank Pym are testing some of the New Initiative heroes. These are the new Champions we see here and, as I've mentioned before, my idea for these guys is that they're super hero updates of Greek Gods. That DOESN'T mean beards and sandals. It means super-cool, super-sleek renditions where they're all shiny costumes and designed more like Travis Charest's redesigned WildCATS. Hercules, their strong guy, is in his full, buttoned-up costume here and is holding a tank over his head. Maria Hill and Hank Pym (wearing lab-coat) stands here with clipboards and looks at him.

> **CAPTION** : S.H.I.E.L.D. BASE, ARIZONA:
>
> **MARIA HILL** : Can we still call him Hercules when there's ALREADY a Hercules out there?
>
> **HANK PYM** : Fortunately, Greek Gods aren't especially LITIGIOUS, Commander Hill. Besides, all those Goliaths over the years never bothered ME.

PAGE THREE

1/ Switch angles as we focus on Pym and Hill, Pym raising a hand to stop her for a second. This should be very subtle and casual.

> **MARIA HILL** : The Avengers in New York and The Champions in California give The Initiative a nice sense of balance, Doctor Pym.
>
> **MARIA HILL** : And making Hermes a former track-star was a stroke of genius. Was that you or Reed Richards?
>
> **HANK PYM** : Actually, that was Tony Stark, Ma'am. He also came up with the idea of making Aphrodite a FORMER SUPER-MODEL.

> **HANK PYM** : Stand clear of the track, please...

2/ Pull back and we see a Flash-style blur shooting down a track and off into the hills in the distance here, things blown back.

NO DIALOGUE

3/ Close on Pym and Maria again, Pym especially casual.

> **MARIA HILL** : What kind of speed is Hermes hitting now?

> **HANK PYM** : Mach One if he hasn't eaten, but we'll have him at Mach Three by the time we go public.

4/ Maria checks her clipboard again as we pull right back and see them both walking through these groups of scientists around individual heroes getting tested.

> **MARIA HILL** : The Champions in CALIFORNIA, those Mormon heroes in UTAH and the Spaceknights heading for CHICAGO.

> **MARIA HILL** : But who did we have for IOWA again? Are you sending the FORCE WORKS people over there?

> **HANK PYM** : Pending BACKGROUND CHECKS and the local authorities giving their ABSOLUTE APPROVAL.

5/ Close on Hank Pym and he seems very earnest as he pops a pill.

> **HANK PYM** : The public need super-people they can COUNT on.

> **HANK PYM** : We do this RIGHT or NOT AT ALL.

PAGE FOUR

1/ Cut to a S.H.I.E.L.D. officer appearing and calling Pym away.

> **S.H.I.E.L.D. AGENT** : Problem with POSEIDON, Doctor Pym. I think one of the guys fed him the wrong stuff and he's turned a funny color. Could you come take a look?

HANK PYM : No problem. Would you excuse me for a moment, Commander?

2/ S.H.I.E.L.D. officer gives a little nod and smile to a grumpy-looking Commander Hill and we should almost see a little glint in his eye. Obviously, something isn't quite right here, but Hill doesn't know what the problem is.

S.H.I.E.L.D. AGENT : Ma'am.

3/ Cut to the Baxter Building and Reed Richards is wearing goggles and blue FF overalls as he works with a team of scientists on this cyborg Thor. He's speaking via ear-piece to Tony Stark.

CAPTION : THE BAXTER BUILDING:

RADIO BALLOON : Reed, it's Tony. How's the cyborg's reprogramming coming along? Have you found out what the PROBLEM was?

REED RICHARDS : Mm. A little late for BILL FOSTER, but there's a blocker in now stopping anything like that happening when we use him in THE BIG PUSH.

REED RICHARDS : What's the situation on the ground? I've been in surgery THIRTY-SIX HOURS STRAIGHT.

4/ Cut to Iron Man sitting on the roof of a city and looking really cool and casual as he looks out across perfect streets, cars and people down below. It's night-time and there should be a flag fluttering here. Really get a good sense of the heroic.

> **IRON MAN** : Just like you PREDICTED, chum. Exactly like you plotted on your CURVE. Crime figures haven't been this good since EISENHOWER was in office.

> **IRON MAN** : Can you imagine how boring it's going to be once the NEW HEROES are up and running TOO?

> **RADIO BALLOON** : Boring's GOOD, Tony. Boring means little kids aren't getting BUILDINGS pushed on top of them.

PAGE FIVE

1/ Cut back to Reed, but the focus is upwards and towards and air-vent we can see on the wall.

> **RADIO BALLOON** : How did your call with The President go?

> **REED RICHARDS** : I just read him the riot act and told him I wouldn't play a part in our big finale unless I had an absolute guarantee that Sue and Johnny wouldn't face ARREST.

> **RADIO BALLOON** : What did he say?

> **REED RICHARDS** : He said he'd give us TWELVE immunities, but everyone else would be open to PROSECUTION.

2/ Cut back to Iron Man in close-up.

> **IRON MAN** : Leave the rest to me.

> **IRON MAN** : I'm seeing him for dinner anyway.

3/ Cut back to the Baxter Building and the other side of the air-vent where we see The Punisher wearing special gadgets across his body that cancel out his presence on cameras, etc. We can see that

he's hundreds of feet up here, strapped with a couple of weapons and avoiding these sci-fi floating orbs that are based on immune-function T-cells. They're big and shiny and if they detect Punisher here they will attack.

> **CAPTION** : THE BAXTER BUILDING:
>
> **THE PUNISHER** : Punisher to Captain America: Just passed level thirty-eight and none of their alarms have registered.
>
> **THE PUNISHER** : Only two more storeys and were IN there, Cap.
>
> **RADIO BALLOON** : CAREFUL, Castle. You even BRUSH AGAINST one of those things and the whole system attacks you as an invading organism.
>
> **RADIO BALLOON** : Sue said Reed based their security on the HUMAN IMMUNE PROCESS this month.

4/ Cut to Punisher climbing up through another area, head down and moving quickly as he avoids all these T-cells floating around him.

> **THE PUNISHER** : Relax. Nothing can read me while I'm wearing the DAMPERS. I'm invisible to all cameras and trip-beams.
>
> **RADIO BALLOON** : Where the Hell did you lay your hands on this kind of hardware ANYWAY?
>
> **THE PUNISHER** : Let's just say Tony Stark's WAREHOUSE MANAGER should invest in BIGGER LOCKS.

PAGE SIX

1/ Cool boot shot of Punisher kicking an air-vent cover.

NO DIALOGUE

2/ Cut to Cap (who's back in costume again) and we have a wide shot of his computer area and we can see everything Punisher is doing up on a big TV screen as Cap guides him around.

 CAPTION: CAPTAIN AMERICA'S SECRET HQ:

 RADIO BALLOON : Okay, I'm in their DATA-HOUSE.

 CAPT AMERICA : Good. Now I need everything you can find on this Number 42 complex: This big super-prison where they're holding our guys in The Negative Zone.

 CAPT AMERICA : I need the SIZE, how much space we'll have to MOVE around and how many ACCESS POINTS they've built. Think you can handle that without shooting somebody in the HEAD?

3/ Close on Punisher's white gloved fingers as he taps away on this keyboard.

 THE PUNISHER : Hilarious.

4/ Pull back and he looks a little worried.

 THE PUNISHER : Uh-Oh.

 RADIO BALLOON : What's up?

 THE PUNISHER : This compound's got more protection than anything I ever saw. We're gonna need a lot more than your team of GRUNTS to spring these guys.

5/ Cut back to Cap in his den and we see all the other super-people on various monitors around him suggesting Cage is seeing Wolvie, Sue is seeing Namor, etc, etc. Cap looks cool, totally in control and uplit from the monitors in this dark room.

 CAPT AMERICA : I'm ON it, Castle.

 CAPT AMERICA : Just keep TYPING.

PAGE SEVEN

1/ Cut to an amazing, atmospheric picture of Invisible Woman standing in Namor's palace at the bottom of the ocean and wearing the appropriate gear with her FF costume. Really think about how this place would look, almost no light and lots of coral, OTT furniture. Perhaps the whole place is dimly-lit by fish in ornate bowls. Whatever, I'd like it to look dark and more imaginative than we've ever seen Atlantis look. Think King of Siam for Namor's personality as he sits wearing a regal robe and trunks on his throne, one leg cocked over the side. There are guards in the background, but they say nothing.

> CAPTION : ATLANTIS:

> INVISIB WOMAN : Thank you for seeing me at such short notice, Namor. I know your court prefers to follow ROYAL PROTOCOLS, but we haven't got much TIME.

> INVISIB WOMAN : The rebel team's raid is planned for tonight and everyone else has turned us down. Having you on-side could be the difference between WINNING and LOSING.

2/ Close on smirking Namor as he strokes his chin.

> NAMOR : Your Majesty.

3/ Pull back and Susan seems surprised. Namor is playing games.

> INVISIB WOMAN : What?

> NAMOR : I believe that's the correct term when you're addressing a foreign DIGNITARY, Mrs Richards.

4/ Close on Susan, frustrated.

> INVISIB WOMAN : Don't play games, Namor. This is the gravest crisis we've ever faced. They've issued us with a SUPER HERO DRAFT and they're IMPRISONING people who don't comply.

> INVISIB WOMAN : Can you believe they're actually releasing SUPER-VILLAINS to bring us in?

PAGE EIGHT

1/ Pull back and we switch angles as Namor stands up. He really doesn't care at all here and has a playful expression on his face.

>**NAMOR** : You talk like it MATTERS, Susan. Power struggles on your little mound are as meaningless to me as the tides are to YOU.

>**NAMOR** : The death of my cousin Namorita was all that mattered in this debacle and her assailant has been dealt with PRIVATELY.

2/ Susan pleads with him.

>**INVISIB WOMAN** : But Cap's one of your oldest FRIENDS. You've known him longer than ANYONE.

3/ Close on Namor as he walks down a few steps towards us, his face tightening as he gets a little angry.

>**NAMOR** : And where is this friend NOW? Trying to make deals with THE X-MEN or STEPHEN STRANGE while he sends you here with your PUPPY-DOG EYES?

>**NAMOR** : Tell this NEW MASTER of yours I have no interest in helping a man who would take advantage of our UNIQUE RELATIONSHIP.

4/ Pull back and Namor stands before her here, his body language a little too close.

>**INVISIB WOMAN** : What are you TALKING about? We don't HAVE a relationship.

>**NAMOR** : I can feel your HEART-BEAT through the water, Mrs Richards...

5/ Focus on them as he smiles a little touching the glass on her helmet.

>**NAMOR** : ... and it tells a very different story from the LIES upon your LIPS.

PAGE NINE

1/ Cut to Cap's hideout as everyone assembling for a big meeting. Cap, Falcon and some of the others are walking along the corridor like they're the Reservoir Dogs and we see all the others waiting for them in here.

 CAPTION : THE SECRET AVENGERS:

 CAPT AMERICA : So what kind of NUMBERS
 are we looking at, Falcon?

 THE FALCON : Namor says no, Wolverine
 won't break ranks with the X-Men and
 Doctor Strange is still out of REACH,
 Cap.

 THE FALCON : That said, Black Panther
 was very upset about the whole BILL FOSTER
 thing and gave me his assurance both he
 and his wife would HAVE OUR BACKS.

2/ Focus on a couple of the guys in the background here, Spidey and Cage.

> **LUKE CAGE** : How you doing, Spider-Man? Feeling BETTER?

> **SPIDER-MAN** : Not too shabby, Cage. Still a little woozy from the Jack O'Lantern gas-bomb, but I've gotta say I'm PSYCHED being back in my old costume.

3/ Cage puts an arm around Spidey, very brotherly. The Punisher, who looks very out of place, just rolls his eyes.

> **LUKE CAGE** : It gives me a GOOD FEELING, man. Like things are finally getting back to normal. Know what I'm saying?

> **THE PUNISHER** : Jeezus. You two wanna get a room?

PAGE TEN

1/ Everyone gathers around the big table here and we see a three-dimensional projection of this prison appearing for everyone to see.

> **SPIDER-MAN** : Ooh! What's up, honey? You JEALOUS?

> **CAPT AMERICA** : Down to business: The Punisher got us all the plans on their Negative Zone prison and the layout of the place can be found in this three-dimensional schematic.

> **CAPT AMERICA** : Ostensibly, it's for high-risk super-villains, but as you know rebel super heroes are being held here too.

2/ The Falcon takes over and we see the image change to the entrance at Ryker's Island. The Punisher stole Reed's 3D blueprints.

> **THE FALCON** : Stark, Pym and Richards are planning puppet heroes in every state and fifty portals leading directly from their local pens into this huge collective super-prison.

THE FALCON : So far, only two of these doorways have been finished and we've obtained the CODES for the one on Ryker's Island.

3/ Close on Cap, very earnest.

CAPT AMERICA : But we need to move fast. Our intel suggests they're planning a huge assault with S.H.I.E.L.D. and the Thunderbolts so tonight is our absolute LAST OPPORTUNITY.

CAPT AMERICA : Spider-Man, we know you're not in the best of shape right now so nobody's going to judge you if you sit this one out.

4/ Close on Spidey, eager to make good.

SPIDER-MAN : NOT A CHANCE, Cap. I need to do SOMETHING to make for all the bad moves I've made lately.

SPIDER-MAN : Besides, numbers being what they are I think you're gonna need every extra pair of HANDS.

PAGE ELEVEN

1/ One of the heroes calls on a couple of villains to step from the shadows and the other super heroes are a bit shocked.

DIAMONDBACK : Actually, numbers might be a little better than we ANTICIPATED. Goldbug? Plunderer? You want to come out and tell everyone what we DISCUSSED?

JOHNNY STORM : What?

CAPT AMERICA : What the Hell is GOING ON here, Diamondback?

2/ Shot of the two villains standing here and looking quite reasonable, though a little nervous, as they try to be friendly and explain their idea.

PLUNDERER : You guys ain't the ONLY ones scared we're heading for a police-state, Captain. The super-criminal community's more concerned about Stark's plans than ANYONE.

GOLDBUG : We just came by to let you know we're here if you NEED us, man. Only fair if IRON MAN'S got super-villains on HIS side, right? Whaddaya say?

3/ Really sudden and dramatic panel as both villains are just blown away, bullets tearing through their heads and chests. NOTE: Please don't break this stuff up as the panel beats are funnier this way.

NO DIALOGUE

4/ Switch angles as everyone turns around and looks at The Punisher and he stands here with a blank expression and two smoking guns.

NO DIALOGUE

5/ Close on Punisher, eyes sideways and he looks a little confused.

THE PUNISHER : What?

PAGE TWELVE

1/ Huge, sensational full-length picture as Cap just gives Punisher the hardest punch anyone has ever drawn. I've got Miller's Batman punching Superman in my head. It has to be that cool and that and twice as tough. No pressure there, eh?

CAPT AMERICA : You filthy piece of TRASH...

PUNISHER : UNGH!

2/ Cap continues to pound Punisher.

PUNISHER : They were BAD guys, Cap. THIEVES AND MURDERERS...

PAGE THIRTEEN

1/ Cap just keeps kicking and punching him here, but Punisher won't fight back.

> **CAPT AMERICA** : SHUT UP!

2/ Cap hits him again, but Punisher still won't fight back.

NO DIALOGUE

3/ Cap gets REALLY brutal.

NO DIALOGUE

4/ Cap relents for a moment, holding Punisher up against a wall and his fist back again, ready to give him another pummeling. Punisher is really bleeding bad here and looks a mess.

> **CAPT AMERICA** : FIGHT, you COWARD!
>
> **THE PUNISHER** : Are you CRAZY?

5/ Close on Punisher, his face bashed to bits as he squints through his eyes towards us.

> **THE PUNISHER** : Not against YOU.

PAGE FOURTEEN

1/ Close, shocked reaction on Cap's face.

NO DIALOGUE

2/ Cap drops him and barks and order. The girl from Nextwave just smirks around to the others, having predicted this last issue.

> **CAPT AMERICA** : GET HIM OUT OF HERE! And throw his guns in the INCINERATOR! I must have been out of my MIND to give that animal a shot on this team!
>
> **NEXTWAVE GIRL** : Well, HE lasted about ten minutes more than I expected.

3/ Close on Spidey and some of the guys, a little freaked out.

> **PATRIOT** : I wonder why he wouldn't hit CAP.
>
> **SPIDER-MAN** : Are you KIDDING me? Cap's probably the reason he went to VIETNAM. Same GUY, different WAR.

4/ Close on Cap as he grimaces around towards him. We should start to feel a little uncomfortable about Cap here and suspect he might not necessarily be right.

 CAPT AMERICA : WRONG.

 CAPT AMERICA : Frank Castle is INSANE.

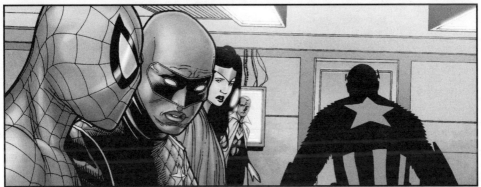

PAGE FIFTEEN

1/ Cut to a Stamford and Tony's built a remembrance garden for the parents on the kids who died in the disaster. This is where the school was and the place has just opened. Lots of Tony's heroes around and Tony stands here holding hands with the Mum of the little kid at the center of all this.

> **CAPTION** : STAMFORD, CONNECTICUT:
>
> **TONY STARK** : I hope you like the gardens we built in the CHILDREN'S HONOR, Miriam.
>
> **MIRIAM SHARPE** : They're BEAUTIFUL, Tony. So nice to have a place where we can come and sit--y'know--whenever we're feeling LONELY and stuff.

2/ Close on the Mum and she looks a bit teary.

> **MIRIAM SHARPE** : I really want to thank you for all this. Not just the money. I mean, all the work you've done to push my BIG IDEA.
>
> **MIRIAM SHARPE** : I HATE how much it's cost you personally. I never would have ASKED if I'd known your lives would get torn apart like this.

3/ Tony reassures here. Reed too.

> **TONY STARK** : We knew what we were TAKING ON, Miriam. There's no shame in making enemies if it means making people SAFER.

4/ Cut to The North Pole at night and we see Dr Strange meditating in the lotus position inside a pentagram in the snow. The scene is only lit by his magic candles and facing him in this big pentagram is The Watcher.

> **CAPTION** : DR STRANGE'S SANCTUARY, THE NORTH POLE:
>
> **THE WATCHER** : How long since you have eaten now, Stephen Strange?

> **DR STRANGE** : Just a little water since the Civil War began, Uatu.

5/ Move in a little closer.

> **THE WATCHER** : Are you not tempted to simply END it? With your great power you could stop this quarrel with a GESTURE or a WHISPER.

> **DR STRANGE** : Precisely why I must remain above the fray.

> **DR STRANGE** : There is no right or wrong in this debate. It is simply a matter of PERSPECTIVE and not my place to influence the evolution of THE SUPERHUMAN ROLE.

PAGE SIXTEEN

1/ Focus on The Watcher here.

> **THE WATCHER** : As a Watcher, I am MORE
> than familiar with such dilemmas.

2/ Pull back and see both figures. Make this as eerie as you can.

> **THE WATCHER** : But tell me: Why are
> you fasting if you favor no side? What
> outcome are you MEDITATING for?

> **DR STRANGE** : Whichever victory is best
> for ALL MANKIND, my friend...

3/ Close on Dr Strange with a solemn expression, his face half-shadowed.

> **DR STRANGE** : ...and spills the least
> amount of blood TONIGHT.

4/ Cut to establishing shot of Ryker's Island prison (or wherever they used in the Front Line and Amazing books).

> **CAPTION** : RYKER'S ISLAND
> PENITENTIARY:

5/ Interior shot and we see the 42 portal leading into the Negative Zone, but nobody's around except some S.H.I.E.L.D. guards.

NO DIALOGUE

PAGE SEVENTEEN

1/ Cut to the complex in the Zone and we see the S.H.I.E.L.D. guards on the other side of the portal all being taken down by invisible opponents.

> **CAPTION** : THE NEGATIVE ZONE:
>
> **S.H.I.E.L.D. GUARD** : AARGH!
>
> **OTHER** : OOF!
>
> **ANOTHER** : URKK!

2/ Switch angles as these guys lie unconscious and Sue makes everyone visible again. Black Panther is here with Storm and has a Wakandan gizmo in his hands he's using to disable the alarm system.

> **CAPT AMERICA** : Thank you, Susan. I think it's safe to make us VISIBLE AGAIN. Panther, what's the situation with prison SECURITY?
>
> **BLACK PANTHER** : Neutralized from top-to-bottom, Captain--though I hate to think how long it would have taken if we hadn't had Mister Fantastic's BLUE-PRINTS.

3/ Close in on Falcon and Panther as they all make their way around in here.

> **THE FALCON** : Thanks again for coming through like this, T'Challa. We know it's in Wakanda's best interests to stay NEUTRAL, but...
>
> **BLACK PANTHER** : Forget about it. Our friend Goliath would still be alive if my wife and I had taken a stand when you FIRST asked us for help.

4/ Spidey calls a halt and everyone seems worried.

> **CAPT AMERICA** : What's wrong?
>
> **SPIDER-MAN** : Spider-sense is going off the SCALE! Seriously, this is DEF CON ONE!

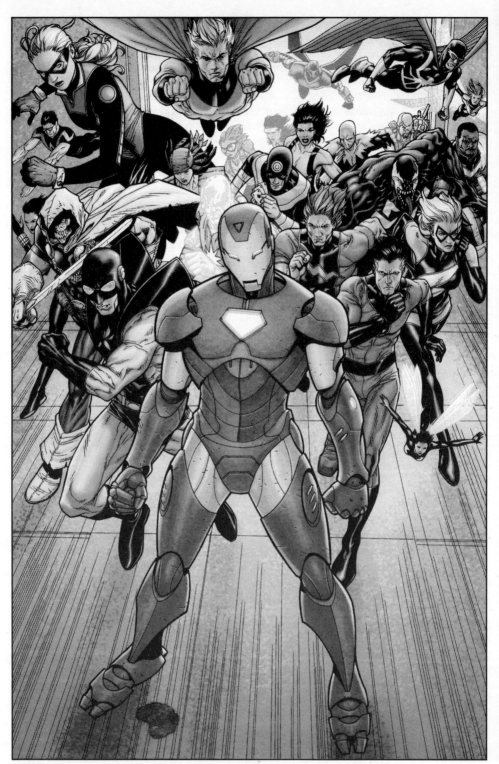

PAGE EIGHTEEN

1/ Turn over for a full page splash where they look up and see Iron Man, Thor, Yellowjacket, Reed Richards and all these guys lined up against them. This should be all the guys we've seen before plus all the B, C and D list guys who would be on their side. I'd like dozens of them just to make this look hopeless for Cap's little dozen or so boys. NOTE: None of the revamps should be here yet or any of the new characters from The Initiative. They aren't ready and they get released next issue in a desperate moment.

> **IRON MAN** : I'm not SURPRISED.

PAGE NINETEEN

1/ Close on Iron Man and he seems very cocky.

> **IRON MAN** : You've just walked into another TRAP, Captain: Earth's mightiest HEROES plus Earth's mightiest VILLAINS,

> **IRON MAN** : We've had a mole on your side for over a week and you're outnumbered TEN-TO-ONE. Would NOW be a good time to talk about a surrender?

2/ Reaction shot from a very calm Captain America as he stands here with his crew. The only person who seems perturbed here is Tigra, but all the others are in on Cap's plan.

> **CAPT AMERICA** : I don't THINK so. If you're talking about TIGRA we knew ALL ABOUT HER, Iron Man.

> **TIGRA** : What?

3/ Pull back as the two teams align themselves behind their leaders, both Cap and Iron Man facing off. Cap's team just seem dwarfed here.

> **CAPT AMERICA** : You're not the ONLY one with a spy in your TEAM.

> **IRON MAN** : Impossible. The only people who knew about TIGRA were MYSELF, HANK and REED.

4/ Yellowjacket comes forward, pulling off his mask to reveal his Hank Pym identity. Iron Man seems shocked. Nobody expected this.

> **YELLOWJACKET** : I'm SORRY, Tony.

> **IRON MAN** : HANK? What are you DOING? You believed in this more than ANY of us...

PAGE TWENTY

1/ Switch angles as Hank morphs into Hulkling and everyone looks shocked. Reed Richards looks especially shocked, realizing the ramifications.

> **HULKLING** : Oh, but I'M not Hank. Doctor Pym's been drugged and unconscious since I knocked him out and replaced him back in ARIZONA this morning.

> **HULKLING** : My name's HULKLING and I'm the SHAPE-CHANGER from The YOUNG AVENGERS.

> **REED RICHARDS** : Oh dear God.

2/ Close on Reed, horrified.

> **REED RICHARDS** : If he could mimic Hank's voice and retinal pattern he's had full authority to do whatever WE can...

3/ Close on Tony, worried as his eyes dart sideways.

> **IRON MAN** : The cells.

4/ Pull back and see shadows looming over everyone. Cap's crew were utterly dwarfed by Tony's side here, but it's been a trap within a trap.

> **CAPT AMERICA** : I believe this EVENS THE ODDS a little...

PAGES TWENTY-ONE AND TWENTY-TWO

1/ Turn over for the most amazing double-page spread in the history of mankind as all these super-people who have been captured since

issue two are now free. Again, on top of the ones we've already seen, we should have the REST of the Marvel Universe too. Outside of the revamps and The Hulk and Dr Strange and the guys we've already covered we should see pretty much everyone else at this point. This is 50% of the Marvel heroes against the other 50%. This is what the kids have been waiting for and it obviously needs to be much, much bigger and more Perez than our first fight (which was just an appetizer for what comes next). Ooh, the excitement!

NO DIALOGUE

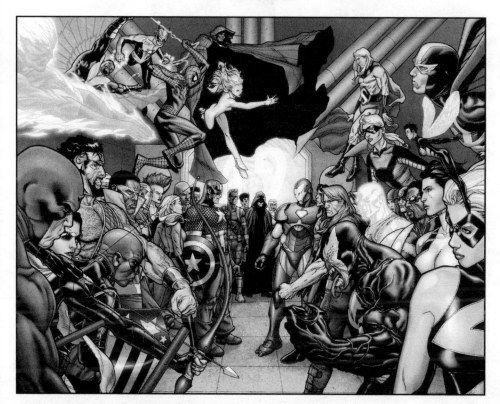

PAGE TWENTY-THREE

1/ Turn over and end with an awesome full-page splash of Cap's head and shoulders as he rubs his fist, ready for a fight. All his boys are behind him here and we get one of those nice fish-eye lens shots Hitchy often used on the last page of Authority as the team assembled behind Jenny Sparks. Cap's eyes just look fierce. He's never looked this cool.

 CAPT AMERICA : This might HURT.

TO BE CONCLUDED

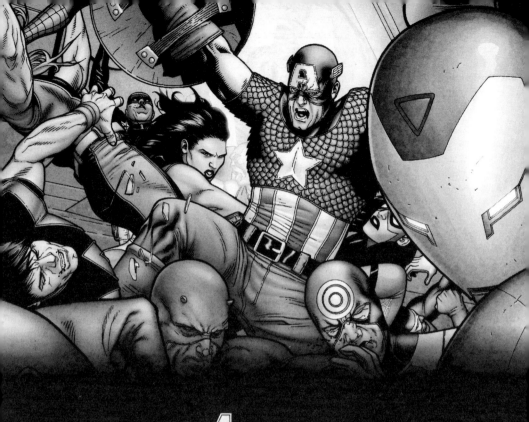

AVENGERS

CIVIL WAR
ISSUE #7
2006

By Mark Millar

Art by Steve McNiven, Dexter Vines,
John Dell, Tim Townsend, and Morry Hollowell

PAGE ONE

1/ Open the issue with the usual recap page filling everyone in on the non-stop excitement that is Marvel Civil War.

PAGE TWO

1/ Open with a full-page splash and the super hero fight of your dreams, every Marvel hero you can think of fighting every OTHER Marvel hero you can think of (plus the fifteen or so Thunderbolts tagged and forced to fight for Tony's side). This is the super hero apocalypse in the Negative Zone and all the major players are here upfront. However long this takes to draw will be outweighed by the sheer gasp from the kids (and the money you sell the original for, chum). Cap, by the way, should be smacking someone pretty prominently with his shield or fist.

> **CAPTION** : The Negative Zone:

> **CAPT AMERICA** : AVENGERS ASSEMBLE!

PAGE THREE

1/ Don't break these down into smaller panels, but five on this page should be enough as we focus on the smaller fights. The first one here should be one of Tony's guys stopping and looking irritated for a second.

> **TONY'S GUY** : What's he talking about?
> WE'RE The Avengers.

2/ Switch angles and see Captain America brutally taking this guy down.

> **NO DIALOGUE**

3/ Next up should be Tony smacking down one of Cap's powerhouses, one of the guys released from the super-compound in the previous issue.

> **NO DIALOGUE**

4/ The third image on the page has one of Tony's people brutalizing a couple of Cap's people. Naturally, crowded fights around going on in the background here.

> **CAP'S GUY** : UGH!

5/ Cut to the control room in the compound and we see two or three

S.H.I.E.L.D. people closing off all possible exits for Cap's team, locking them all in the Negative Zone.

> **S.H.I.E.L.D. ONE** : C'mon, HURRY UP!
>
> **S.H.I.E.L.D. TWO** : I'm FINISHED! It's DONE! The door back to Ryker's locks in T-MINUS FIVE SECONDS...

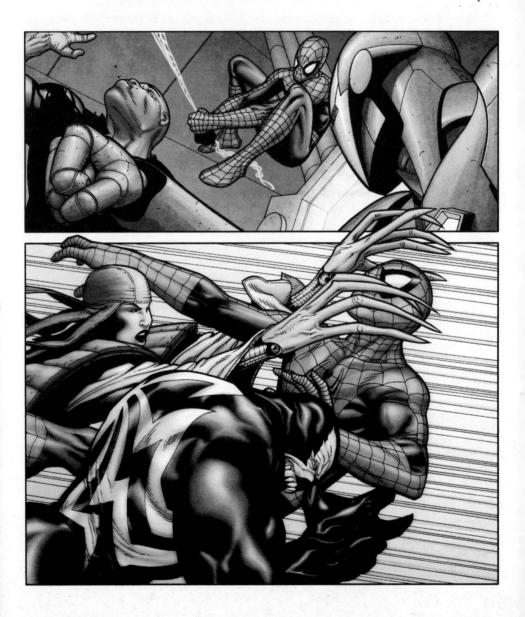

PAGE FOUR

1/ Close shot a huge zap from off as they're all taken down by sudden shards of light being fired by the off-panel Dagger.

NO DIALOGUE

2/ Switch angles as Dagger stands over these fallen S.H.I.E.L.D. guys, a serious look on her face. Black Panther is already working on the computer system, trying hard to reverse what these guys were doing.

DAGGER : Are we TOO LATE?

BLACK PANTHER : No such thing, Dagger. Ryker's was the OFFICIAL doorway from the Negative Zone, but there's still ONE MORE if I can remember that sixty-nine digit code...

3/ Cut back to the huge fight and Spidey leaps through the air towards Iron Man as he's embroiled in action with a couple of Cap's boys. Iron Man looks up, surprised.

SPIDER-MAN : I'm all ticked off and I brought my CAN-OPENER, Shell-Head!

IRON MAN : SPIDER-MAN!

4/ Amazing shot as a couple of Tony's guys appear from nowhere, smacking into Spider-Man and pulling him off-course. The whole atmosphere should be wild chaos. This is a classic Marvel battle-royale.

SPIDER-MAN : WHOOF!

VENOM : Just so long as you remembered the BANDAGES!

PAGE FIVE

1/ Cut back to the Ryker's Island entrance to the Negative Zone and we see Maria Hill here with her S.H.I.E.L.D. people. This area has been sealed off now and there's no way back for our heroes. She's even closing off the one Panther is trying.

S.H.I.E.L.D. TECH : Black Panther's overriding OUR SYSTEM, Commander Hill! Program says he's rerouting their bridge to THE BAXTER BUILDING!

> **MARIA HILL** : CLOSE IT DOWN! NOW! THEY
> ESCAPE AND IT'S YOUR ASS, DUBLONKSY!

2/ Cut to Panther as he seems panicked, realizing they're out of options. Dagger touches her ear, speaking to Cloak (wherever he is).

> **BLACK PANTHER** : They're ONTO us! They're
> closing REED'S PORTAL! We've got TEN
> SECONDS and COUNTING!

> **DAGGER** : CLOAK, it's me. We need
> the biggest teleport you've ever PULLED.
> T'Challa's sending the CO-ORDINATES.

3/ Cut to Cloak in the middle of this enormous brawl as he closes his eyes, lowers his head and starts to spread his cloak out. Everyone is fighting around him, unaware of what he's doing here.

> **CLOAK** : I CAN'T. It's too DANGEROUS.
> There must be a HUNDRED PEOPLE here--

> **RADIO BALLOON** : You either PULL THIS OFF
> or we're stuck in this FOREVER, Tyrone!
> DO IT!

4/ Close on Cloak, straining.

> **CLOAK** : I will TRY...

5/ Cut to other, distinct characters on both sides as they stop their fighting for a moment and look up as a huge shadow falls across them.

> **JOHNNY STORM** : What the HELL?!

> **IRON MAN** : Oh, God. Tell me
> that isn't CLOAK!

PAGE SIX

1/ Full page splash and an amazing, Perez-style picture of a giant Cloak throwing his head back and screaming as all these heroes on both sides (plus the villains) are engulfed in the blackness of his seemingly endlessly cloak. It would be cool and maybe look better if they're all still fighting here too, just to keep it all moving on a visual level and never slowing things down.

NO DIALOGUE

PAGE SEVEN

1/ Cut to a plain black panel stretched across the top of the page.

NO DIALOGUE

2/ Cut to New York City and this fifty, sixty or however many heroes suddenly teleporting high into the sky above the city and falling from Cloak's cape outside the Baxter Building. They're all screaming, panicked and shocked to find themselves here. Most of them can't even fly.

> **CAPTION** : The Baxter
> Building, New York:
>
> **CAPT AMERICA** : ALL THE FLYERS GRAB A
> FRIEND!
>
> **CAPT AMERICA** : NOW!

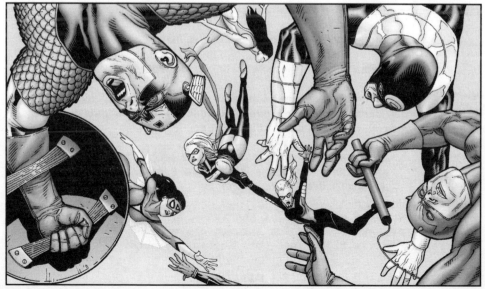

3/ Close as some of the flyers grab their friends, hands all clutching one another in the air here as they tumble.

NO DIALOGUE

4/ Pull back from a couple of blocks away and a Michael Bay kinda shot as we see cars and dust all blowing up into the air as the super-people hit the ground. We can see some flyers here too as dots, but I want to see the 9/11-style impact here and lots of ordinary people looking around at this and running towards us.

NO DIALOGUE

PAGE EIGHT

1/ Cut back to the action and we see an exhausted Cloak getting smacked down by one of Tony's guys as the battle rages on here in the streets. Iron Man is picking himself up and radioing, seemingly unaware The Human Torch is rocketing towards him.

> **TONY'S GUY** : That's for screwing up
> THE PLAN, creep!

> **IRON MAN** : Iron Man to all points:
> Evacuate the area and contain the fight to
> MIDTOWN! I want no civilian casualties!
> You HEAR me! NO CIVILIAN CASUALTIES!

2/ Cut to an amazing shot of Iron Man turning around punching out a flaming Human Torch in mid-air with the back of his fist, the battle raging around them here. We should really get the sense that this is spreading out fast at an uncontrollable rate.

> **IRON MAN** : You think I'm STUPID, son?

> **HUMAN TORCH** : UNGH!

3/ Cut to hundreds of screaming people being marshaled away by tense-looking cops as they do everything they can to get ordinary people away from the heart of the action.

> **COP ONE** : EVERYBODY THIS WAY! NICE
> AND CALM! YOU FOLKS TAKE YOUR TIME AND
> NOBODY'S GONNA GET HURT!

4/ Pull back for a wide shot of the scene as everyone appears as small figures, heroes smashing through one end and out the other of skyscrapers as the fight just goes absolutely nuts.

NO DIALOGUE

PAGE NINE

1/ Cut back to an amazing shot of Spidey as a multiple image, leaping around as he fights a bunch of Tony's guys on his own. They're firing at them here and he's taking them out one at a time. Don't break this up, Steve. Take a look at some Quitely (esp Earth 2) to see how this could all be done in a single, continuous moment to convey the speed. He's heading for an amazed Reed Richards, who's stretching his arms around and trying desperately to catch him.

> **TONY GUY ONE** : Ungh!
>
> **TONY GUY TWO** : Huff!
>
> **TONY GUY THREE**　: Ugh!
>
> **TONY GUY FOUR** : AGH!

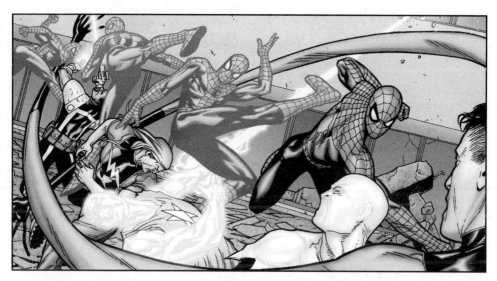

2/ Shocked reaction from Reed.

> **REED RICH** (small)　: Amazing.

3/ Cut to inside a building and an unbelievable shot of Spidey smacking Mister Fantastic through the glass and looking as cool as ██.

> **SPIDER-MAN** : Spectacular.

4/ Cut to Iron Man fighting through these crowds of super heroes, smacking as many people as he can, as he talks to one of the allies he's fighting beside.

> **IRON MAN** : Where's CAP? Somebody
> find CAPTAIN AMERICA! He's too DANGEROUS
> to be out there unchecked!

PAGE TEN

1/ Cut to Captain America being attacked by The Thunderbolts as he lays the smack-down on someone. Really make this look painful when we turn the page.

> **DEATHSTRYKE** : Doesn't look too dangerous
> to ME!

2/ Switch angles as another one of the Thunderbolts joins the fray and we see Cap getting the beating off his life here.

> **CAPT AMERICA** : UNH!

> **VENOM** : Me NEITHER!

3/ Another brutal shot from one of the Thunderbolts, the battle raging behind them as they focus their combined attention on Captain America.

> **BULLSEYE** : Man, is this the LIVING
> LEGEND of WORLD WAR TWO? Who was he
> FIGHTING? BING CROSBY?

4/ A couple of the Thunderbolts hold the bloodied Cap back here, Venom swirling his tendrils around him as Deathstryke strokes his face.

> **DEATHSTRYKE** : What's so FUNNY, Captain?
> You like our LITTLE JOKES? You share
> Bullseye's SENSE OF HUMOR?

> **CAPT AMERICA** : No, I'm just thinking
> about my PAL up there kicking your butts
> into NEXT WEEK...

5/ Overhead shot as The Thunderbolts turn around, looking up at us as a huge shadow falls across them. They look absolutely horrified.

> **DEATHSTRYKE** : What?

PAGES ELEVEN AND TWELVE

1/ Okay, turn over for a double page spread with just four panels. Please don't break these down as the big images are fanboy porn and this big image taking up 2/3rds of the first page is an amazing shot of The Sub-Mariner charging down towards us with his legions of bad-ass Atlanteans.

 NAMOR (huge) : IMPERIUS REX!

2/ Switch angles again for a huge impact panel where these guys descend upon the Thunderbolts and Tony's heroes with a massive crash, getting really stuck into them here.

NO DIALOGUE

3/ Okay, now the right hand page has another slim panel (much like panel two) where Tony's guys are getting worried and one of them feels the balance of power has just tilted towards Captain America's people. But Iron Man seems more confident and, among the chaos, points up towards his own sympathizers finally coming through.

 SHE-HULK : It's NAMOR. We're DEAD. With THEM on his side, Cap's going to WIPE THE FLOOR with us.

 IRON MAN : Take it easy. We're covered. You think we've been sitting on our HANDS these last few months?

4/ Now we have the opposite side of the spread. The page should be constructed symmetrically and we get an amazing Money shot of Thor leading The Champions and the other guys from The Initiative towards us. All the big ones at the front for maximum excitement and new costume tweaks where you like. This spread should essentially be thought of as your retirement fund, Steve.

 THOR (screaming) : HAVE AT THEE, VILE TRAITORS!!

 REVAMPED GUY : What HE said.

PAGE THIRTEEN

1/ Reaction shot as Thor's guys just impact with Cap's guys and the fight continues to get wider and wider. The previous image was the post shot; this is the big, painful impact as they all start hitting one another.

NO DIALOGUE

2/ Cut to elsewhere as Iron Man and Captain America suddenly find themselves facing off against one another here, the battle clearing a little around them, but raging like Lord of the Rings in the background. Unconscious bodies lie at their feet and they're pushing aside a couple of other opponents as they prepare for their final face off.

> **IRON MAN** : YOU AND ME again, Cap. Just like last time. Let's hope I don't have to put you through all that PAIN again, huh?
>
> **CAPT AMERICA** : Well, things are a little DIFFERENT this time, Tony...

3/ Cool shot of The Vision appearing from behind Iron Man and passing his intangible hand through him, sending Iron Man's armor into spasm and a wave of electricity around him.

> **IRON MAN** (huge) : AAAGGHH!!
>
> **THE VISION** : Iron Man armor is COMPROMISED, Captain.

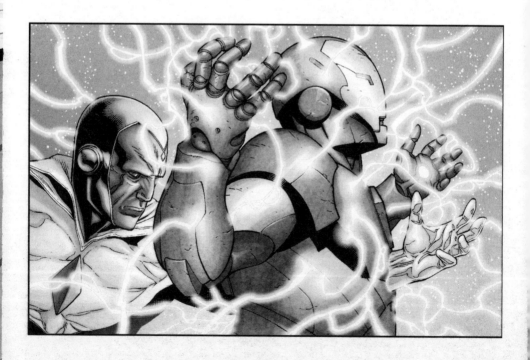

PAGE FOURTEEN

1/ Iron Man's armor sparking and useless as Captain America swings his shield around and takes him right off his feet.

> **CAPT AMERICA** : Now I'm fighting DIRTY.

> **IRON MAN** : UNGH!

2/ Cut to Thor looking up from a fight, shocked and menacing.

> **THOR** : IRON MAN!

3/ Cut to a cool shot of Hercules punching Thor down into the ground.

> **HERCULES** : Thou should fear for THYSELF, monster!

4/ Cut to lots of heroes and villains on both sides being caught up by an enormous bus that's lying on its side and being pushed through the streets, mowing down everything in its wake. Invisible Woman should be watching this in shock.

> **INVISIB WOMAN** : What in God's name-?

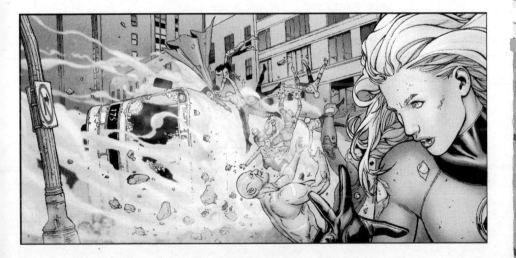

PAGE FIFTEEN

1/ Switch to the other side of the bus and we see Ben Grimm here with his fingers deep in the roof of the bus. He's used it to clear a path for the emergency crews to get injured people past, knowing full well that these heroes shouldn't be fighting each other. Sue should see him here and look pleased.

 INVIS. WOMAN : BEN?!

 THE THING : Ya really think I wuz gonna sit this one out eatin' CROISSANTS? Get your ACT together, Suzie! We got PEOPLE ta save!

2/ Cut back to the fight and Invisible Woman is getting stuck into someone, unaware that one of the Thunderbolts is pointing a blaster right towards her.

 TASK-MASTER : Sorry. Not in MY job description...

3/ Switch angles and a big, stretchy Mister Fantastic appears over Invisible Woman here, taking the full impact of this enormous light blast.

 REED RICHARDS : SUSAN! LOOK OUT!

 INVIS. WOMAN : REED!

4/ Sue is horrified as she looks down and sees Reed lying here unconscious, all stretched out and an absolute mess. He looks like a stringy stick of gum.

 THE THING : Aw, man...

 INVIS. WOMAN : What have you done to my HUSBAND?

PAGE SIXTEEN

1/ Sue turns around and looks at us, furious.

NO DIALOGUE

2/ Close on Task-Master, worried.

> **TASK-MASTER** : Okay.

> **TASK-MASTER** : This isn't good.

3/ Cool reaction shot as Sue focuses and makes a huge invisible tube hammer the assassin into a nearby wall.

NO DIALOGUE

4/ Cut back to the fight with Thor and Herc and they've just absolutely beaten the ▮▮▮▮ out of one another, but Hercules seems to have the upper hand for a moment as he grabs the big hammer, picking himself up at the same time.

> **HERCULES** : How dare thou wear the flesh of the Odinson! I KNEW Thor... Thor was a FRIEND of mine...

5/ Menacing shot of the battered and bloodied Hercules swinging the hammer back over his head. His eyes are full of rage and he ain't taking no ▮▮▮▮ anymore.

> **HERCULES** : And you KNOW something, impostor?

PAGE SEVENTEEN

1/ Pull back for a full page splash and the most bad-ass image ever as a furious, bloodied Hercules smashes the Hammer into the Thor cyborg, chunks of flesh and circuitry going everywhere as he's just smashed to pieces. This is the kind of injury you don't come back from and it should be genuinely jaw-dropping, the hammer breaking at the same time and the circuitry revealed.

HERCULES : THOU ART NO THOR!

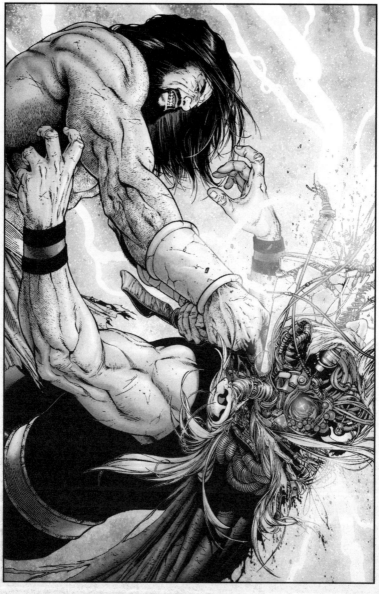

PAGE EIGHTEEN

1/ Cut back to the fight with Cap and Iron Man which is by now reaching a conclusion. Cap has Iron Man down on his back and he's smacking him hard with his shield. The beats are very important here.

NO DIALOGUE

2/ Switch angles again as Cap smacks Tony's helmet with the back of his shield, the attack on Iron Man just being relentless here.

NO DIALOGUE

3/ Cap swings his shield for the final time and just cracks open Tony's helmet.

> **IRON MAN** : UNGH!

4/ Pull back as the bloodied and desperate Cap swings the shield back over his head, eyes blazing and ready to bring this crashing down on Tony. Among the flames and rubble in the background, the super hero war continues.

NO DIALOGUE

5/ Close on Tony's bloodied face through the broken helmet, his eyes half-closed. He looks defeated.

> **TONY STARK** : What are you WAITING for, Steve?

> **TONY STARK** : FINISH it.

PAGE NINETEEN

1/ Close on Cap from Tony's POV and it's a close reaction shot, Cap looking down his nose at us in a Gil Kane perspective as his eyes go wide, his nostrils flaring. He's just hesitating for that crucial moment.

NO DIALOGUE

2/ Pull back and see the rescue workers (medics, firefighters, cops, etc) all grabbing Cap and pulling him back off Tony. This is a big shot and a turning point in the story.

> **FIREFIGHTER** : GET THE HELL AWAY FROM HIM!

> **CAPT AMERICA** : HURKH!

 PARAMEDIC : HOLD HIM DOWN! HOLD HIM
DOWN!

3/ Cut to the other super-people as they all stop fighting for a
moment, catching this through the corner of their eyes.

 DAREDEVIL : What in God's name...?

4/ Cut back to Cap being held back by a dozen rescue workers, all
straining and screaming at him. Cap wants to finish the fight, but
he doesn't want to hurt these people.

 CAPT AMERICA : Let me GO! Please, I
don't want to HURT you...

 LADY COP : Don't want to HURT us?
Are you trying to be FUNNY?

 ORDINARY GUY : It's a little late for
that, man!

PAGE TWENTY

1/ Pull back for a big, wide shot and we see all the devastation
to this area for streets and streets, the little figures just dots
down below.

NO DIALOGUE

2/ Close on Cap and he's broken, a look of absolute horror across
his face. He's just stunned by this, realizing the people aren't on
his side.

 CAPT AMERICA : Oh my God.

 THE FALCON : What's wrong?

3/ Cap drops his shield to the ground

 OFF-PANEL : They're RIGHT. We're
not fighting for THE PEOPLE anymore,
Falcon...

4/ Close on Cap and a true horror in his eyes, tears streaming down
his cheeks. He looks like he's gazing upon Hell itself.

 CAPT AMERICA : LOOK at us.

 CAPT AMERICA : We're just FIGHTING.

PAGE TWENTY-ONE

1/ Pull back and Cap stands here among the crowds looking broken. The other heroes are looking scared and confused, unsure what to do. Cap is really emotional for the rest of this scene, tears streaming down his cheeks as he realizes he's been out of step with America.

> **JOHNNY STORM** : Cap, what are you DOING? They'll throw you in JAIL if you surrender.

> **SPIDER-MAN** : We were BEATING them, man. We were WINNING back there.

2/ Close on Cap and he looks broken.

> **CAPT AMERICA** : Everything except THE ARGUMENT.

3/ Pull back as he peels off his mask. Everyone has stopped fighting and they're crowding around, awed by what they're seeing.

> **CAPT AMERICA** : Besides, they're not arresting CAPTAIN AMERICA...

4/ Steve drops the mask to the ground and offers himself to the cops.

> **STEVE ROGERS** : ...they're arresting STEVE ROGERS. That's a very different thing.

5/ Pull back and dozens of people and heroes standing around Steve Rogers as these shocked cops cuff his hands behind his back.

> **ANOTHER HERO** : Cap, PLEASE!

> **STEVE ROGERS** : STAND DOWN, troops...

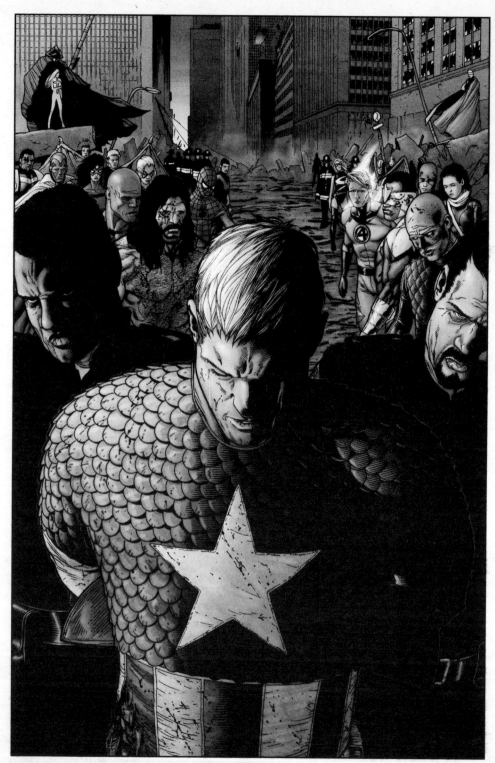

PAGE TWENTY-TWO

1/ Pull back for a full-page pic of the scene with Cap being taken away and all these heroes standing here unsure what to do next.

> **STEVE ROGERS** : That's an ORDER.

PAGE TWENTY-THREE

1/ Close on ground level and we see Captain America's mask lying here on the ground as the crowds move away and we see a white gloved hand reaching down and picking it up.

> **NO DIALOGUE**

2/ Head and shoulders shot of The Punisher (wearing a jacket, but with his emblem still mostly visible) as he stands here with the flames and smoke behind him and looks down at the mask in his hands with a sad, but determined expression. There's a sense of serious vocation in his eyes.

> **NO DIALOGUE**

3/ Close on Captain America's mask here in his hands. The captions here form a letter from Reed to Sue, a reprise of what happened in issue four, but reversed. Don't do anything too clever with the lettering. It needs to be easy to read.

> **CAPTION** : My dear, sweet Susan:

4/ Cut to some time later and an establishing shot of the Manhattan skyline afterwards with the sun setting in the background. This is mostly silhouette and we're too far away to see much of the damage that happened that day.

> **CAPTION** : Forgive my erratic handwriting. You know how difficult I find slowing my thoughts to a speed where the human hand can translate my sentiments into linear sentences.

> **CAPTION** : It has been two weeks now since that terrible battle and I was pleased to see that you accepted the hero amnesty given in the wake of Captain America's SURRENDER.

PAGE TWENTY-FOUR

1/ Cut to the big clean-up at ground-level and we see the costumed super heroes doing what they can alongside the rescue people. Sue should be helping to clear up here and, some distance away, we can see Reed looking around at her. She isn't looking at him, but he's transfixed by her.

> **CAPTION** : I saw you during the clean-up, but felt it was inappropriate to discuss our future while our adrenal glands might still impair our judgment in romantic matters.

> **CAPTION** : You looked so beautiful. So vibrant and clear-eyed. I cried for a full ninety-three minutes when I returned home that night.

2/ Cut to a big visual of Iron Man and his Avengers standing here and shaking hands with the new Champions as flashbulbs flare all around them and crowds of smiling people seem really happy about all the new heroes. This should be filled with Easter Eggs and hints as to what's coming in the Marvel Universe.

> **CAPTION** : By now, you will have seen the launch of THE INITIATIVE...

> **CAPTION** : ...at least one super-team in every US state.

3/ Cut to another big image of more new heroes, revamps of The Defenders and so on, as they each get their new state assigned and are standing smiling for big photo opportunities. Really make this as bright and optimistic as possible. Don't go for dark or unsure; this should feel like the best possible outcome as lots of old favorites get a makeover and the future looks really exciting.

> **CAPTION** : I'm sure you can appreciate the PRESSURE we were under...

> **CAPTION** : ...creating NEW heroes, revamping OLD ones...

> **CAPTION** : ...decentralizing this community from a single coast and building a super-power for THE TWENTY-FIRST CENTURY.

PAGE TWENTY-FIVE

1/ Cut to an establishing shot of the big Negative Zone prison with camera crews snapping pictures as serious-looking baddies are taken away here. These should be real heavy-duty super-villains who are a danger to the public.

> **CAPTION** : Even our controversial prison in The Negative Zone was met with rapturous applause when we finally went public.

> **CAPTION** : How FRIGHTENING the world must have seemed before this: Vigilantes, amateurs, super-villains brooding in cells that never seemed to HOLD them.

> **CAPTION** : The only surprise is how we were TOLERATED for as long as we WERE.

2/ Cut to Canada and likewise we have a meeting with a few of the new Beta Flight heroes standing here clearly scene, others obscured or in shadow. I'd like whoever is putting this team together from the original Alpha Flight to be shaking hands with someone here, an elevated shot where we read BETA-FLIGHT across the floor (Mike may have decided to go with Omega Flight instead of my Beta Flight suggestion, but Tom will be able to confirm).

> **CAPTION** : Of course, it would be
> a lie to suggest that EVERYONE is happy
> with our new arrangement.

> **CAPTION** : It's well-known that a
> number of heroes fled to Canada on the
> promise of a more OLD-SCHOOL CAREER...

3/ Cut to the shadows of an underground lair where a small cabal of Secret Avengers are meeting and plotting against the new order. Tom will be able to tell us exactly who's in this team, but it would be fun to have a couple only hinted at here. Their leader, or a main character, has his back to us here.

> **CAPTION** : Not to mention the tiny
> cabal of Cap's followers who remain
> RADICALIZED out there in the UNDERGROUND
> MOVEMENT...

> **LUKE CAGE** : Dig the outfit, man.

4/ Cool shot of Spidey standing at the head of this table and wearing his black outfit again. Could Mary-Jane and Aunt May be standing in the background with the other Secret Avengers? Just so we crisply know their status.

> **SPIDER-MAN** : Thanks.

> **SPIDER-MAN** : My Aunt made it for me.

5/ Cut to Cap sitting in his cell and looking sad.

> **CAPTION** : Not to mention Captain
> America HIMSELF...

PAGE TWENTY-SIX

1/ Cut to the front of Time magazine and a shot of Hank Pym in costume shaking hands with a couple of scientists from what was the opposing team (Black Panther perhaps?). Everybody is happy and the copy reads HANK PYM: MAN OF THE YEAR ON HIS GLOBAL REVOLUTION.

> **CAPTION** : But on the whole our
> experiment has been an enormous success.
> What once seemed like our darkest hour
> had been transformed into our greatest
> opportunity.

> **CAPTION** : Working with the government, our remit has moved beyond simply law and order and we're now tackling everything from the environment to global poverty...

2/ Cut to The President shaking hands with Tony in the Oval Office, Tony giving a big smile and reporters all around them. Again, no hint of anything bad here. This should be completely upbeat. Don't say what his job is yet as this surprise should come in the final pages.

> **CAPTION** : ...Tony in particular.

> **CAPTION** : Can you BELIEVE the new job the President has assigned to him?

3/ Cut to Reed sitting in costume (but wearing a lab-coat) as he tucks in his sleeping children.

> **CAPTION** : But the opinion polls and Utopian ideals mean nothing unless you're here BESIDE me, my darling.

> **CAPTION** : I promise: NO MORE TRAPS. NO MORE CLONES. None of those PAINFUL THINGS we had to do on that path to RESPECTABILITY.

4/ Cut to Reed at night as he stands and looks out of the windows on the upper-floors of the Baxter Building, a sad look in his eyes. He looks terribly alone here.

> **CAPTION** : No matter what we achieve in this NEW AMERICA we're trying to create... It can never be Heaven unless you're here too.

> **CAPTION** : Please, please, PLEASE come back to the family who need you more than 02 (oxygen).

PAGE TWENTY-SEVEN

1/ Pull back and a shot from behind Sue as she stands here with her back to us. Reed is turning around towards her, sensing someone behind him.

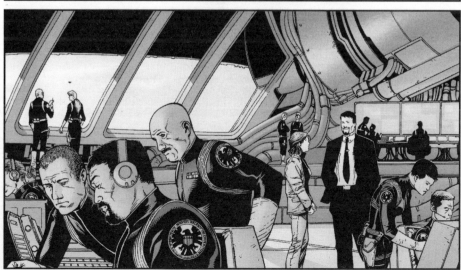

NO DIALOGUE

2/ Shot of Sue standing here, wet from the rain outside, and holding a couple of cases to show that she's coming up. She looks serious and it's clear that this is only the first step towards the rebuilding of their marriage.

NO DIALOGUE

3/ Cut to an establishing shot of the Helicarrier above the clouds over NYC.

> **CAPTION** : THE S.H.I.E.L.D.
> Helicarrier,
>
> **SUB-CAPTION** : Five miles over New York City:

4/ Cut to interior and a wide shot of Tony Stark standing here (dressed in a black suit) as Miriam Sharpe stands beside him. Loads of S.H.I.E.L.D. people are busily working them, Maria Hill standing going over papers with someone. She's now Tony's second-in-command.

> **MIRIAM SHARPE** : Director of S.H.I.E.L.D.?
>
> **TONY STARK** : Why not, Mrs Sharpe? As a man with close links to both the government and the superhuman community I think it makes perfect sense if Nick Fury's still unavailable.
>
> **TONY STARK** : Uh, could we have a couple of COFFEES over here, please, DEPUTY Commander Hill? Cream and plenty of sugar?

TWENTY-EIGHT

1/ Close on Maria Hill as she looks up from these papers and narrows her eyes.

NO DIALOGUE

2/ Cut to Tony and Miriam walking around here. She's awed by the surroundings, but Tony's keeping in touch because he's such a great guy.

> **TONY STARK** : We won the WAR and now we have to make sure we WIN THE PEACE. I want people to get ENTHUSED about this new way of working we're hoping to INITIATE.

> **TONY STARK** : Did you hear the state of Montana just requested THE THUNDERBOLTS as their official team?

> **MIRIAM SHARPE :** Yeah, well. As long as you drop one or two of the NUT-CASES, right?

3/ Close on Tony, proud of what he's accomplished.

> **TONY STARK** : Nevertheless, it's still a tremendous step. Giving offenders a second chance is something we tried to do as far back as the ORIGINAL AVENGERS.

> **TONY STARK** : Do you know why we called our prison Number Forty-Two?

4/ Pull back as they both walk towards a big observation deck.

> **MIRIAM SHARPE :** Nope.

> **TONY STARK** : Because it was number forty-two of a hundred ideas Reed, Hank and I wrote down the night your SON was killed.

> **TONY STARK** : A hundred ideas for a safer world and we aren't even at NUMBER FIFTY yet. Doesn't that sound EXCITING to you?

5/ Close on Tony.

> **TONY STARK** : Cleaning up S.H.I.E.L.D. is NUMBER FORTY-THREE.

> **TONY STARK** : Believe me, Ma'am: The super hero community just found the greatest friend they'll ever have.

PAGE TWENTY-NINE

1/ Switch angles and Miriam smiles.

> **MIRIAM SHARPE** : You're a GOOD MAN, Tony Stark. You risked EVERYTHING to get us to this place, but I truly believe you've given people heroes we can BELIEVE in again.

2/ Close on Tony with a little smile as he looks down here upon the world.

> **TONY STARK** : Oh, the best is yet to come, sweetheart...

3/ Pull back for an amazing shot of the Helicarrier floating over America. The image I have in my head here is kinda like the end of Empire with everyone looking out through the big observation deck, but I'm seeing this as a hi-tech Travis-style image with Tony and Miriam standing here looking down upon the country through the clouds

> **CAPTION** : "That's a PROMISE."

END

ALL-NEW, ALL-DIFFERENT AVENGERS (2015) BY MARK WAID

AN INTRODUCTION BY **TOM BREVOORT**
IN CONVERSATION WITH **ANDREW SUMNER**

All-New, All-Different Avengers was the post-Secret Wars Avengers title that was designed to shake up the image of the team, to shake up the understanding of what the Avengers were within the Marvel Universe, and to take advantage of the fact that in the now-unified Marvel Universe, we had a bunch of new characters occupying the very familiar roles of Captain America and Spider-Man. All-New, All-Different Avengers was a book designed to bring in the older, more established Marvel heroes, such as Iron Man and The Vision, and have them take on a mentorship role for the new, younger generation of Marvel heroes, characters like Nova and the Miles Morales Spider-Man, who are embracing that Avengers spirit and creating an Avengers legacy for a new generation.

All-New, All-Different Avengers was the Avengers title that launched out of Secret Wars, where the Marvel Universe had been taken apart and then put back together slightly differently. And that was all part of a larger launch for All-New Marvel, propagating the concept of everything post-Secret Wars being all-new. Going into this iteration of Avengers, we had a couple of potential deficits, one of which was that of the core big three Avengers, at least two of them had been replaced by other characters in those roles. Sam Wilson was Captain America, and Jane Foster was Thor (when we started, the public was aware that a woman had become Thor, but her actual identity was unknown). So right from the outset you know that we're going to have to build a different sort of Avengers book.

Also at this point, Miles Morales (after being created as an Ultimate Universe character) was being integrated into the core Marvel Universe, and the other younger characters in the Marvel Universe, Ms Marvel and Nova, were making a big splash. So the idea with this book was to build a

version of an Avengers book that was maybe closer in spirit to what DC's Justice Society was during the issues that Paul Levitz created in the 1970s. I don't know that Mark and I ever actually defined it this way, but as I look at these scripts now, *All-New, All-Different Avengers* shares that concept of more established veteran characters playing a mentorship role to the young, new, up and coming characters within their specific universe. And I thought that was a good structure for an Avengers book. I'm actually kind of disappointed that the Avengers didn't run longer in this iteration (we ultimately elected to launch a different book, 2016's *Champions*, starring those younger characters—and that meant that the *All-New, All-Different Avengers* book had to be kind of taken apart, stripped for parts, and the younger characters left to found the Champions). I would have liked to have done two or three more years with this sort of balanced team of younger characters learning not so much the ropes of being super heroes, but specifically learning how to be Avengers from the older characters. It was an interesting mix of older characters, because for all that Sam Wilson was as established a super hero as anybody in the Marvel Universe, Jane Foster was new to her role as Thor and, in a sense, no more experienced than Nova or Ms Marvel. I would have enjoyed playing with that a little bit more.

In *All-New, All-Different Avengers* #1, we set up that the Avengers Tower (where the Avengers had been headquartered for the last five or six years) had been sold to this new company. We created Qeng Enterprises, and that was all set up for a storyline featuring [key Marvel time-traveling super-villain] Kang the Conqueror. It would have been Kang who was behind Qeng Enterprises. And we wanted to pay that all off with a Kang story in this iteration of *Avengers*, but because the series had to be pulled apart to make *Champions* happen, we didn't ever get to deliver that in the way that we might have, with the idea that Kang was launching an economic conquest of the world. It wasn't the typical Kang storyline with Kang showing up with future armies and weapons of tomorrow—he was going to take over the world financially, right under everyone's noses, by manipulating the economy and the world's trading marketplaces, having foreknowledge of what was coming. And that would have led to a different sort of accounting, maybe one that we could have related back to the younger characters in a more interesting way than just punching the guy with the force fields and the big space blasters.

The script that's included here for issue #8 is a crossover script for the 2016 *Avengers: Standoff!* event. That was an Avengers-centric crossover that lived in the individual Avengers' titles but really grew out of the Captain America books and the work that writer Nick Spencer was doing there to set up what eventually became the *Secret Empire* event (an eleven-part 2017 series involving an alternate, evil Steve Rogers working for Hydra). Nick was the prime mover of the *Secret Empire* story, but this is a great example of Mark Waid being an excellent collaborator with the other writers working on the other books in the Marvel line. Mark crafts a script that hits all the marks, that moves all the pieces from point A to point B in the crossover narrative while delivering a full experience unto itself and retaining the flavor, tone, and the style of his home book.

I've worked with Mark Waid a lot over the years on a lot of different projects and I think we're very simpatico in our approach and in our vision for comics storytelling. Mark's work, universally, has a bedrock underlayer of positivity to it. His super heroes are aspirational, and are motivated to do the right thing, regardless of consequence. There's not a lot of cynicism in his approach, and not a lot of faux darkness. Mark is the quintessential craftsman. He knows how the game is played, he knows how to not just run the basics, but how to do it each time in a way that feels fresh and exciting. For all that he's very structure-oriented, Mark's also wildly improvisational. It's not an exaggeration to say that half the time we worked together Mark would come up with a cliffhanger to a particular story while having no idea how the characters would get out of that cliffhanger before he had to write the next script. And that resolution would not get figured out until the moment it was time to write that next script. Sometimes, that meant that Mark would call me up and go, "I got nothing." And we would then bounce around whatever ideas we had—and he would go off with whatever nuggets we laid down and figure it all out. Mark has remained the most rock-solid super hero writer in the industry throughout the last three decades. The fact that he's still held in such high regard and is still working so consistently is testament to that. Nobody from Mark's generation is as frequently employed in the super hero field as he is, nobody else remains the exemplar of storytelling excellence that Mark is.

AVENGERS

ALL-NEW,
ALL-DIFFERENT AVENGERS
ISSUE #1
2015

"Assemble!"

By Mark Waid

Art by Adam Kubert
and Sonia Oback

PAGE ONE

FULL-PAGE SPLASH. JUMPING AHEAD IN THE STORY A BIT. WE'RE IN THE WRECKAGE OF A MIDTOWN MANHATTAN BUILDING. MS. MARVEL IS YELLING ANGRILY (AND POINTING WITH ACCUSATION, USING AN EMBIGGENED HAND/ FOREFINGER) AT A STARTLED NOVA.

 1 MS. MARVEL/burst: You're a JERK!

 2 CAPTION: Avengers assemble.

PAGE TWO

PANEL ONE: ONE OF THE BRIDGES IN NYC, YOUR CHOICE. AN SUV, BANGED UP AND OBVIOUSLY THE VICTIM OF A VIOLENT COLLISION, IS STARTING A LONG PLUNGE OFF THE BRIDGE REAR-END FIRST. DOESN'T REALLY MATTER MUCH WHAT MAKE AND MODEL THE THING IS--WHAT'S IMPORTANT IS THAT IT HAS A LARGE REAR WINDOW.

 1 LOCATION CAPTION: 12 HOURS EARLIER

 2 LOCATION CAPTION: NEW YORK CITY

 3 TAILLESS/elec: --live at the [name of bridge], where our news van is caught in a MASSIVE PILE-UP that--

 4 TAILLESS/elec: --oh, my GOD--

PANEL TWO: MUCH CLOSER ON THE VEHICLE AS IT PLUMMETS TOWARDS US. INSIDE, SCREAMING WITH HORROR, ARE THE PASSENGERS--MOM, DAD, AT LEAST ONE KID.

 5 TAILLESS/elec: --A CAR'S JUST BEEN PUSHED OFF THE BRIDGE--!

PANEL THREE: BELOW, JUST ABOVE THE WATER'S SURFACE, CAPTAIN AMERICA FLIES IN AT TOP SPEED, STARTING AN ARC UPWARD.

PANEL FOUR: ARCING UP, ON THE FLY, CAP HEAVES HIS SHIELD WITH ALL HIS MIGHT--

 6 CAP: =hnnNNHH!=

PAGE THREE

PANEL ONE: --AND WE WATCH IT SMASH THROUGH THE BACK WINDOW OF THE VEHICLE AND OUT THROUGH THE WINDSHIELD AND KEEP GOING UP.

 1 SFX as appropriate

PANEL TWO: VOOM! CAP ARROWS UP OUT OF THE FALLING VEHICLE THROUGH WHAT USED TO BE THE FRONT WINDSHIELD, THE TERRIFIED PASSENGERS CLINGING TO HIS ARMS!

PANEL THREE: TIGHT ON CAP'S FACE, STRAINED--THIS ISN'T EASY BY A LONG SHOT, NOT FOR SOMEONE WITHOUT SUPER-SOLDIER SERUM IN HIS VEINS.

 2 CAP: ...c'mon...

 3 CAP: ...C'MON...!

PANEL FOUR: SHAKILY, HE MANAGES TO SET EVERYONE DOWN SAFELY AMIDST ONLOOKERS, MOST OF THEM USING THEIR PHONES TO TAKE PIX AND FOOTAGE. SNARLED TRAFFIC FROM THE ACCIDENT ON THE BRIDGE.

 4 CROWD: [will add cheers/ reactions to suit art, including people specifically referring to him as Captain America, natch. Some are cheering, some are disdainful and vocal about how Sam's not "their" Captain America.]

PANEL FIVE: MEANWHILE, REDWING CATCHES THE SPENT SHIELD AS IT STARTS ITS DOWNWARD ARC--

PAGE FOUR

PANEL ONE: --AND DROPS IT ONTO CAP'S ARM, EXTENDED UPWARD, SLIDING RIGHT DOWN THE ARM FOR A FLAWLESS CATCH.

PANEL TWO: CLOSE ON CAP, TAKING A KNEE, PUFFING OUT A SIGH OF RELIEF THROUGH PURSED LIPS AS REDWING APPROACHES TO JOIN HIM. AGAIN, EVERYONE'S WATCHING/PHOTOGRAPHING/FILMING.

1 CAP/small:	Thanks, Redwing.	
2 CAP/small:	Phew.	
3 TAILLESS:	AWESOME	
4 TAILLESS:	Upload that! UPLOAD!	
5 TAILLESS:	I got it!	
6 TAILLESS:	shake his HAND	

7 FROM OFF: CAPTAIN AMERICA! Will you buy our Girl Patrol cookies?

PANEL THREE: CAP PULLS A FIVER OUT OF HIS BELT, SMILES--HASN'T TURNED YET.

8 CAP: Heh.

9 CAP: Sure. I'm down to my last five bucks, but after that, I could definitely use the sugar...

PANEL FOUR: REDWING ON HIS SHOULDER, HE TURNS TO SEE SEVERAL GIRL SCOUT-_LIKE_ GIRLS--ACTUAL GIRL SCOUTS OF AMERICA BEING TRADEMARKED, AFTER ALL. THEY'RE ALL ABOUT EIGHT OR NINE YEARS OLD. FRONT AND CENTER ARE TWO SPECIFIC GIRLS--BOTH PROFFERING COOKIE BOXES EXPECTANTLY. ONE GIRL IS WHITE, THE OTHER IS BLACK.

10 CAP: ...boost...

PANELS: VARIOUS ANGLES ON BYSTANDERS AND MEDIA, ALL FILMING/ PHOTOGRAPHING IN ANTICIPATION TO SEE WHAT HE DOES NEXT--WHICH ONE HE'LL CHOOSE.

PAGE FIVE

PANEL ONE: ON CAP'S EXPRESSION--A WINCING, "AW, MAN, THIS ISN'T GONNA GO WELL" LOOK.

PANEL TWO: HE SEES TONY STARK IN THE CROWD--NICE SUIT, SUNGLASSES, TRYING TO LAY LOW.

 1 CAP/thot: Stark?

PANEL THREE: ON CAP, PLEADING LIKE HE'S TRYING TO SEND A TELEPATHIC SIGNAL, HOLDING UP FIVE FINGERS.

 2 CAP/thot: Lend me five?

PANEL FOUR: TONY, OVERACTING A "SORRY, MAN!" EXPRESSION, SHOWS HIS EMPTY WALLET.

PANEL FIVE: CAP GLARES AT HIM WITH A HALF-SURPRISED, HALF-ANGRY "DUDE, WHAT THE <u>HELL</u>?" EXPRESSION.

PANELS: THE BLACK GIRL. THE WHITE GIRL. THE EXPECTANT MEDIA.

PANEL: PUTTING ON A BIG, BROAD SMILE, CAP DRAWS THE SHOCKED GIRLS' ATTENTION TO A SURPRISED STARK.

> 3 CAP: Better idea:
>
> 4 CAP: Who wants their
> picture taken with TONY STARK?
>
> 5 GIRL #1: IRON MAN? Whoa!
>
> 6 GIRL #2: <u>YES, PLEASE</u>!

PAGE SIX

PANEL ONE: A MOMENT LATER. CAP (REDWING ON HIS SHOULDER) AND STARK KNEEL WITH THE TROOP, ARMS AROUND 'EM, AS THEY ALL POSE FOR PIX. STARK'S TRYING TO LOOK COOL AND COMFORTABLE, BUT HE'S GOT EIGHT-YEAR-OLD GIRLS ALL OVER HIM.

> 1 CAP/whisper: Thanks for the
> ASSIST.
>
> 2 TONY/whisper: I didn't see the
> ACCIDENT. I'm here in traffic like
> everyone ELSE. Or do you mean the CASH?
>
> 3 TONY/whisper: Also, why'd you drag
> ME into this?
>
> 4 CAP/whisper: Because there's
> nothing I enjoy more than watching you
> pretend to like children.
>
> 5 CAP/whisper: SMILE.

PANEL TWO: TONY AND CAP (WITH REDWING) CLIMB INTO TONY'S ABSURDLY EXPENSIVE CAR.

> 6 CROWD: You're not STARK!
> Where's your ARMOR?

7 STARK: In the shop. Hop in,
Cap. I'll give you and your
EAGLE a lift.

8 CROWD/tailless/small: ...man, did HE
get lucky.

9 CROWD/tailless/small: --was he
really gonna choose the--

10 CROWD/tailless/small: Well, of
course HE would--!

PANEL THREE: CAP, EYES NARROWED, SCANS THE CROWD TO SEE WHO WAS
THROWING SHADE.

11 STARK/off: Game face.

PANEL FOUR: CAP LEANS INTO THE CAR. STARK GLARES AT REDWING.

12 CAP: He's a FALCON. You
KNOW this.

13 STARK: An eagle would be
better branding. Tell him to mind the
upholstery.

14 CAP: You really think you
can make better time out of here than I can?

PAGE SEVEN

PANEL ONE: THE CAR LIFTS OFF, FLYING, THE CROWD AGAPE.

> 1 CROWD: I tell ya, that AIN'T--
>
> 2 STARK: Yeah.
>
> 3 CROWD: --STARK--
>
> 4 CROWD: --oh, WOW.

PANEL TWO: THE CAR SOARS OVER MIDTOWN AS CONVERSATION CONTINUES.

> 5 STARK: You handled that well, by
> the way.
>
> 6 CAP: That I had to "handle"
> it at ALL is the DRAINING part. Having
> camera phones and cable news agenda-izing
> your EVERY MOVE into a RACIALLY BASED
> NARRATIVE is--

PANEL THREE: TONY WAITS FOR CAP TO FINISH THE SENTENCE. NO
DIALOGUE.

PANEL FOUR: CAP LOOKS OUT THE WINDOW.

> 7 CAP: --the job. It's the job.
>
> 8 CAP: A bigger part than I'd
> like, but I knew the gig was dangerous
> when Rogers handed it over, right?
>
> 9 STARK/off: You guys TALKING yet? After
> the LITTLE ROCK thing?

PANEL FIVE: CAP SHOOTS HIM A LOOK THAT SAYS, "HELL, NO."

PANEL SIX: CAP, STARK.

> 10 CAP: Nice RIDE for a POOR man.
>
> 11 STARK: CASH-poor. YOU try spending
> six months in deep space in between IRON-
> MANNING, watch how meteorically YOUR
> company craters.

PAGE EIGHT

PANEL ONE: THE FLYING CAR PASSES AVENGERS TOWER—OR, RATHER, THE FORMER AVENGERS TOWER. A GIANT CRANE IS EVEN NOW REMOVING THE "A" INSIGNIA.

> 1 STARK: If every STARK DIME doesn't go into REBUILDING, I might as well start working at a GAS STATION.
>
> 2 STARK: Or, worse, Parker Industries.
>
> 3 STARK: Hhggh.
>
> 4 CAP: You had to make some good bank selling off the TOWER.
>
> 5 STARK: I did okay. The Avengers didn't want it.

PANELS: INTERIOR, THE TOWER—SPECIFICALLY, WHERE SEVERAL WORKMEN/ MOVERS ARE BUSY CRATING UP AND REMOVING HIGH-TECH EQUIPMENT ON A LOWER LEVEL.

CENTRAL TO ALL THIS ACTIVITY—SUPERVISING IMPERIOUSLY—IS OUR SERIES BIG-BAD VILLAIN. SPOILER: IT'S <u>KANG</u>, BUT HE DOESN'T LOOK AT ALL LIKE KANG. WE HAVE TO TREAD THE FINE LINE BETWEEN "GUY IN A BUSINESS SUIT" AND "INTERESTING," AND I'M NOT SURE HOW TO DO THAT— WE'RE LEADING READERS TO BELIEVE THAT HE'S JUST ANOTHER STARK-LEVEL SUPERBUSINESSMAN, BUT THAT'S NOT TRUE. SOMETHING THAT MIGHT HELP IS THAT WE ARE GOING TO DROP BIG, FAKE HINTS THAT IT'S LOKI. I'M HAPPY TO DISCUSS, BUT ANYTHING WE CAN DO TO MAKE HIM DISTINCT WITHOUT BEING CARTOONISH WOULD BE GREAT.

> 6 CAPTION: "Wait. Aren't YOU an Avenger?"
>
> 7 CAPTION: "I'm a little BUSY. SUNSPOT has a group carrying the name, right?"
>
> 8 CAPTION: "Not exactly. And Rogers's team is actually the UNITY SQUAD. It occurs to me, Tony...
>
> 9 CAPTION: "...I don't think there IS an AVENGERS right now."
>
> 10 KANG: ...and that's the LAST of Stark's JUNK! As the new OWNER of this skyscraper, I order you to MOVE IT OUT!

PAGE NINE

PANEL ONE: "KANG" DIRECTING MOVERS TO EXIT WITH THEIR HEAVY CRATE, CURIOUS THAT THERE SEEMS TO BE LIGHTNING/ENERGY CRACKLING INSIDE.

 1 KANG: WAIT! Whatever THIS is--you
DID cycle it DOWN?

 2 MOVER: We cut power to the whole FLOOR--

PANELS: HORROR. TO EVERYONE'S SURPRISE, MACHINES START ERUPTING WITH CRACKLING ENERGY--

--THINGS EXPLODE, BIG PYROTECHNICS AS (DRAWING POWER FROM ALL THE MACHINES) A MAN-SIZED ENERGY FIELD IS CREATED IN THE CENTER OF THE ROOM--

--SUCKING ALL THE SCREAMING WORKERS INTO IT, MELTING THEM INTO PROTOPLASM--

--WHICH, AS THE ENERGY FLARES DIE DOWN, RE-FORMS INTO A LARGE, HUMANOID SHAPE--

[Will add screams/SFX as appropriate]

PAGE TEN

PANEL ONE: --WHO STANDS REVEALED AS <u>WARBRINGER</u>, OUR HEAVY FOR THESE THREE ISSUES.

ADAM/TOM--SOME NOTES ON WARBRINGER. <u>ONE</u>--I'D THINK THAT STAFF/LANCE/WHATEVER OF HIS IS SOMETHING HE'D DEFINITELY USE AS A WEAPON BOTH AS A PHYSICAL THING HE CAN SWING AND AS SOMETHING THAT CAN EMIT DESTRUCTIVE ENERGY. LET'S LET HIM FLY WITH IT, TOO, WHAT THE HELL. LIKE SURFER'S BOARD, BUT WEAPONIZED. <u>TWO</u>-- BECAUSE THE LAST WE SAW OF HIM WAS THAT HE WAS RECONSTITUTED AFTER NOVA *THREW HIM INTO THE SUN*, I THINK WE CAN JUSTIFIABLY GIVE HIM INTERNALLY GENERATED HEAT/FIRE POWERS UNLESS TOM OBJECTS. <u>THREE</u>-- ALONG THOSE LINES, LET'S SHOW THAT BY MAKING HIM MELT-THINGS-TO- THE-TOUCH HOT <u>ALL THE TIME</u>. PAVEMENT BUBBLES AT HIS FEET, HE LEAVES FIERY FOOTPRINTS, AND YOU CAN'T BE WITHIN TEN YARDS OF HIM WITHOUT SWEATING. <u>FOUR</u>--HE'S IMPERIOUS AND ARROGANT.

 1 WARBRINGER: <It WORKED.>

PANEL TWO: WARBRINGER SPEAKS TO A LITTLE HOLO-IMAGE OF A CHITAURIAN SOLDIER PROJECTED BY HIS STAFF.

 2 HOLO/elec: <You have ARRIVED on Sol-3, Warbringer?>

 3 WARBRINGER: <As planned. Tell the relay team that cellular reconstitution was a SUCCESS.>

 4 FROM OFF: I'LL say it was!

PANEL THREE: WARBRINGER IS SLIGHTLY SURPRISED TO SEE KANG ENTERING, CLAPPING--NOT A HAIR ON HIS HEAD OUT OF PLACE.

 5 WARBRINGER: <You UNDERSTOOD me? I'm not speaking TERRAN-->

 6 SFX: clap clap clap

 7 KANG: I'm good with languages. CHITAURI, right? One hundred ninety-two words for "HATE." You should be on TWITTER.

PANEL FOUR: ALMOST CASUALLY, AS IF SWATTING A FLY, WARBRINGER UNLEASHES A FIRE-BLAST TOWARDS OFF-PANEL KANG.

 8 WARBRINGER: <Shut up.>

PAGE ELEVEN

PANEL ONE: TIGHT ON WARBRINGER'S SURPRISED EYES--

PANEL TWO: --AT THE SIGHT OF KANG GRINNING, HOLDING UP TWO FINGERS AS IF TO SAY "HOLD ON," CAUSING THE BLAST TO BEND HARMLESSLY AROUND HIM.

 1 KANG: That is a SMART
METHOD of TELEPORTATION, I have to say.

 2 KANG: Trust me--someday,
EVERYONE's going to realize that it's
more energy-efficient not to beam MATTER,
just INFORMATION, for on-the-spot CLONING
and THOUGHT TRANSFERENCE.

 3 KANG: Seriously, I'm a fan.

PANEL THREE: AS WARBRINGER FLIES UP AND AWAY, KANG WAVES A HAND CRACKLING WITH ENERGY, LOOKING LIKE HE'S CASTING A SPELL--

 4 WARBRINGER: <You're a FLEA. My business
is not with YOU.>

 5 KANG: Hey! Whoa!

PANELS FOUR and FIVE: WARBRINGER FLIES/VANISHES INTO A MIDAIR PORTAL--AND REAPPEARS THROUGH A MATCHING PORTAL RIGHT NEXT TO KANG.

 6 KANG: I didn't say you
could LEAVE.

 7 WARBRINGER: ?

 8 WARBRINGER: <Who-->

 9 WARBRINGER: --who ARE you?

 10 KANG: An ALLY.

 11 KANG: ESPECIALLY against
NOVA.

PAGE TWELVE

PANEL ONE/FLASHBACK: NOVA PUSHES WARBRINGER INTO THE SUN. (FROM NOVA #31--REFERENCE ATTACHED.)

> 1 KANG CAPTION: "I believe you suffered DEFEAT at that whelp's hands when he pushed you into the SUN, no?"

> 2 WARB. CAPTION: "HOW DID YOU--"

> 3 KANG CAPTION: "It was in all the papers."

PANEL TWO: ANGRY WARBRINGER BEARS DOWN ON KANG, WHO DOESN'T LOOK THE LEAST BIT THREATENED OR CONCERNED.

> 4 WARBRINGER: I have no idea what that means, but I recognize "sarcasm," the linguistic tool Earthlings are FAMOUS for. Do not MOCK me.

> 5 KANG: It's an anachronistic phrase, anyway. And don't ASSUME where I'm FROM.

> 6 KANG: I realize you're here to save FACE by wreaking havoc on this planet for spawning your attacker. You'll be the talk of all CHITAURI. BUT--

> 7 KANG: --I promise you, if you take advantage of the opportunity I'm OFFERING you, you'll go down in HISTORY as a GALACTIC LEGEND.

PANEL THREE: AS IF BY MAGIC, KANG CONJURES UP FOR WARBRINGER'S BENEFIT IMAGES OF THREE CHITAURIAN ARTIFACTS OF DIFFERENT SHAPES-- SIMPLE METAL DESIGNS THAT, NEXT ISSUE, WILL FIT TOGETHER INTO ONE LARGE SIMPLE ARTIFACT--DON'T FRET ABOUT DESIGNING SOMETHING OVERLY COMPLEX.

> 8 KANG: You're not the FIRST of your race to visit Earth. Millennia ago, one of your ANCESTORS left an ARTIFACT behind--

> 9 KANG: --broken into THREE PIECES lest it be discovered--

PAGE THIRTEEN

PANEL ONE: KANG CONJURES UP AN IMAGE WHICH WE CANNOT SEE BUT WHICH GLOWS BRIGHTLY FROM OFF-PANEL--AND WHICH AMAZING THE HELL OUT OF WARBRINGER.

 1 KANG: --for HERE is what it can ACCOMPLISH.

 2 WARBRINGER: !

PANEL TWO: HIGH ON THE SHADOWS ON A NEARBY WALL (TO THE EXTERIOR OF THE BUILDING, FYI). A SINGLE WORD BALLOON EMERGES FROM THIN AIR.

 3 THIN AIR: Uh-oh.

PANEL THREE: BOTH WARBRINGER AND KANG, BOTH ANGRY, SNAP THEIR HEADS AROUND TOWARDS THE SOURCE OF THE VOICE. KANG RAISES HIS ENERGY-CRACKLING HAND TOWARDS THE OFF-PANEL VOICE.

 4 KANG: Tch-TCH.

 5 KANG: Someone's EAVESDROPPING.

PANELS FOUR-SIX: SURROUNDED BY KANG'S CRACKLING ENERGY, THE SOURCE OF THE VOICE SLOWLY FADES FROM INVISIBILITY INTO VISIBILITY: IT'S MILES MORALES, SPIDER-MAN, CLINGING TO THE WALL, EAVESDROPPING.

 6 SPIDEY: Crap!

 7 SPIDEY: --out LOUD--

 8 SPIDEY: --is BAD--

[Note: that sounds choppy, but at some point soon we'll revisit this scene and realize that Miles had a lot more to say--what's happening here is that Kang's using his time-manipulation powers to "stutter-jump" Miles a few seconds into the future to bust his concentration, which is why the invisibility fades. SCIENCE!]

PAGES FOURTEEN THROUGH FIFTEEN

[Adam: however you like--a two-page spread, two single pages, whatever works for you.]

PANEL ONE, HUGE: (OR ACROSS THE SPREAD, WHATEVER WORKS FOR YOU!)

EXTERIOR, THE TOWER. SPIDEY'S <u>BLOWN</u> OUT BY A MASSIVE CONCUSSIVE BLAST FROM WARBRINGER'S STAFF!

SFX as needed

PANEL TWO: SPIDEY, HALF-CONSCIOUS, TUMBLES THROUGH THE AIR--

 1 SPIDEY/weak: ...nnNNnnhh...

PANEL THREE: --SEES A BIG CHUNK OF THAT BUILDING FALLING TOWARDS AN INNOCENT BYSTANDER WHO CAN'T GET OUT OF THE WAY FAST ENOUGH--

PANEL FOUR: --STRAINS TO FOCUS AND SHOOT HIS WEBS EVEN AS HE CONTINUES TO FLIP HELPLESSLY THROUGH THE AIR--

 2 SPIDEY/weak: ...don't black out, Spidey...

 3 SPIDEY/weak: ...DON'T black out...

PANEL FIVE: --SHOOTS A WEB TOWARDS THE DISTANT BYSTANDER IN AN ATTEMPT TO SAVE HIM/HER--

 4 SFX: THWIP

PANEL SIX: --AND JUST BARELY <u>MISSES</u> AS THE BUILDING CHUNK IS INCHES AWAY FROM FLATTENING THE TERRIFIED BYSTANDER!

SFX if necessary

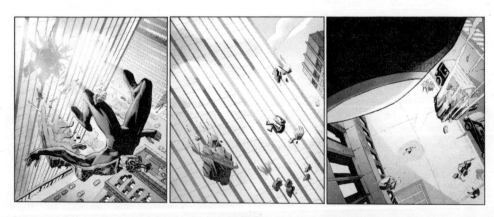

PAGE SIXTEEN

PANEL ONE: CAPTAIN AMERICA FLIES IN LOW, PULLING THE BYSTANDER OUT OF HARM'S WAY AS THE PULVERIZING DEBRIS CRASHES INTO THE PAVEMENT!

> 1 CAP: Go limp.

> 2 CAP: I've got you.

PANEL TWO: MEANWHILE, HIGH ABOVE, TIGHT ON TONY STARK'S HAND AS IT SNAGS SPIDEY'S ANKLE OR WRIST--

> 3 SFX: thap

PANEL THREE: --AND PULL BACK TO SEE TONY, ARM OUT THE DRIVER'S-SIDE WINDOW, HOLDING SPIDEY WHILE PILOTING HIS FLYING CAR.

> 4 TONY: Hey, look! It's TRADEMARK-INFRINGEMENT KID! I know you!

> 5 TONY: You want to tell me why I had to double back because you just BLEW UP WHAT USED TO BE MY BUILDING?

PANEL FOUR: ON SPIDEY.

> 6 SPIDEY: Wasn't...wasn't ME...! I SWEAR!

> 7 SPIDEY: I was just swinging BY when I saw an ELECTRICAL FLARE! I went to check it OUT and--

> 8 SPIDEY: --ALIEN! BIG, ANGRY ALIEN!

PAGE SEVENTEEN

PANEL ONE: TONY DROPS SPIDEY AS SPIDEY SHOOTS A WEBLINE OFF AND AWAY.

> 1 TONY: Well, that's DIFFERENT, then. You okay to meet me DOWN there?

> 2 SPIDEY: Yes, sir.

3 TONY: Good. Don't bother
looking for TONY STARK, though.

PANELS: TONY PILOTS HIS CAR STRAIGHT TOWARDS THE BUILDING,
ACTIVATING DASHBOARD CONTROLS--

--WHICH CAUSE HIS CAR TO, TRANSFORMERS-LIKE, RESHAPE ITSELF AROUND
HIS BODY--

--TO FORM A MASSIVE IRON MAN SUIT AROUND HIM!

PAGE EIGHTEEN

PANEL ONE, HUGE: IRON MAN, HEROIC AS HELL.

1 IRON MAN: Look for IRON MAN.

PANEL TWO: INSIDE, WARBRINGER'S MILDLY SURPRISED TO SEE KANG
DISAPPEARING.

2 KANG: Headed out.

3 KANG: You can take it from
here. I have faith in you.

PANEL THREE: IRON MAN BURSTS INTO THE BUILDING.

4 IRON MAN: Big, angry alien.
CHECK.

PANEL FOUR: A REPULSOR-RAY BLAST KNOCKS THE STAFF OUT OF
WARBRINGER'S HAND.

5 IRON MAN: First rule of combat:
DISARM THE ENEMY.

PAGE NINETEEN

PANEL ONE: CAP AND SPIDEY ENTER THE ROOM BEHIND IRON MAN, POSED TO
JOIN THE ATTACK.

1 IRON MAN: Second rule: SURROUND
AND--

PANEL TWO, HUGE: WITHOUT WARNING, WARBRINGER UNLEASHES A FLASH OF
HEAT-ENERGY FROM HIS BODY LIKE A SOLAR FLARE, IN ALL DIRECTIONS--
PANEL IS MOSTLY ORANGE-WHITE. OUR HEROES RECOIL HARSHLY. THE ONLY

THING THAT SAVES CAP IS THE SHIELD. THE ONLY THING THAT SAVES
SPIDEY IS THAT HE'S BEHIND IRON MAN.

PAGE TWENTY

SPLASH: A SECOND LATER. SMOLDERING (BUT OTHERWISE UNHARMED)
WARBRINGER STANDS LOOMING OVER THE FALLEN, UNCONSCIOUS HEROES IN
THE MELTED RUINS OF THE ROOM. CAP IS BADLY BURNED IN WHATEVER AREAS
OF HIS BODY THE SHIELD COULDN'T PROTECT--PRESUMABLY LOWER BODY.
SPIDEY'S SINGED.

IRON MAN, HAVING TAKEN THE BRUNT OF THE BLAST, LIES UNCONSCIOUS IN
ARMOR THAT'S BADLY MELTED, TO THE POINT WE SHOULD ASSUME THAT HE'S
SEVERELY INJURED.

> 1 WARBRINGER: <This is going to be
> easier than I THOUGHT.>

TO BE CONTINUED

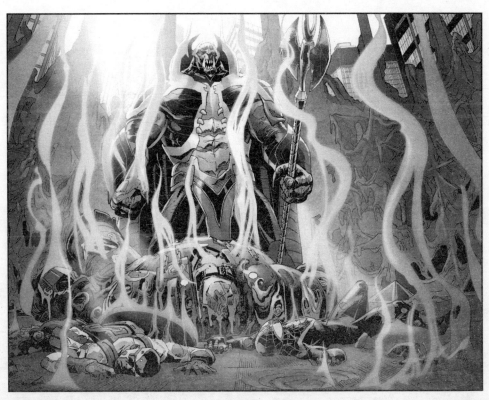

AVENGERS

ALL-NEW, ALL-DIFFERENT AVENGERS
ISSUE #8
2015

"Standoff--Assault on Pleasant Hill"

By Mark Waid

Art by Adam Kubert, Sonia Oback,
Edgar Delgado, and Israel Silva

[**WHERE WE ARE IN THIS CROSSOVER**: After confabbing with Nick Spencer, UNCANNY AVENGERS #8 now ends with all our heroes "awake" in Pleasant Hill. Though no one has a costume or their gadgets, the heroes who have powers still have powers. *Note: Thor looks like Maskless Thor, not like Jane Foster. Vision is flesh-colored and bald, in civvies. Cable has one arm. Everyone else just looks uncostumed But at least there are lots of colorful villains.*

 All our assembled heroes know is that they were on their way to Pleasant Hill; two obviously not-really-Maria-Hills manipulated them into a fight; everything went white; and they awoke in Pleasant Hill as civilians imprinted with false memories--all that from the end of AVENGERS #7. But now that they've awakened (UNCANNY #8), they're confronted with Kobik, who orders them all to go back to sleep and blinks to make it so...]

PAGE ONE

PANELS: JUMPING FORWARD IN THE NARRATIVE A FEW MINUTES--TIGHT SHOTS ON VARIOUS HEROES LYING BROKEN, BLOODY AND UNCONSCIOUS. VISION'S BEEN TORN INTO, REVEALING HIS ANDROID/MECHANICAL PARTS; TONY STARK AND SAM ALEXANDER ARE LYING UNCONSCIOUS AND NEAR-DEATH UNDER DEBRIS; ROGUE, UNCONSCIOUS, IS BEING FLUNG WITH BONE-BREAKING IMPACT INTO SOMETHING; QUICKSILVER'S LEGS ARE BROKEN HORRIBLY.

PAGES TWO AND THREE

TWO-PAGE SPREAD. A DOWN SHOT ON PLEASANT HILL. IT'S AN ABSOLUTE WAR ZONE FULL OF SUPERVILLAINS LAYING WASTE TO ANYTHING AND EVERYTHING IN SIGHT. AS MANY OF OUR HEROES AS YOU FEEL LIKE DRAWING, WITH THE EXCEPTION OF DEADPOOL--ALL BADLY WOUNDED, SOME EVEN PRESUMABLY DEAD--ARE SCATTERED ABOUT, UNCONSCIOUS.

 CAPTION: Fifteen minutes from now.

PAGE THREE-A

Synopsis and credits.

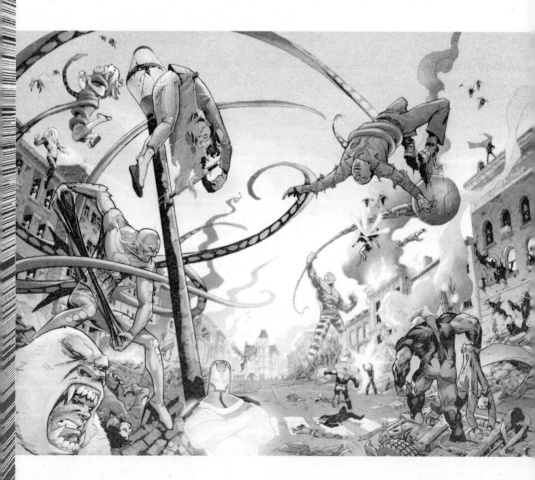

PAGE FOUR

PANEL ONE: ADAM, I HATE TO DO THIS TO YOU. DON'T SHOOT THE MESSENGER. THESE ARE THE CROSSOVER CARDS WE'VE BEEN DEALT, BUT I PROMISE TO DO MY BEST NOT TO ASK FOR ALL THIRTEEN CHARACTERS IN ONE SHOT AFTER THIS OPENING. BUT! YOU ONLY HAVE TO DRAW TWO PANELS ON THESE TWO PAGES, SO THERE'S THAT!

AS NOTED ABOVE, WE'RE PICKING UP A SPLIT-SECOND AFTER THE END OF UNCANNY AVENGERS #8. BY THE TIME YOU GET TO THIS, ADAM, YOU SHOULD HAVE ALL AVAILABLE REFERENCE ON SETTING, CLOTHING, ETC.

THIS PANEL IS A TIGHT SHOT OF (FORGIVE ME) ALL THIRTEEN OF OUR CIVILIAN-CLOTHED HEROES GAPING SLIGHTLY UP AND OFF.

CAPTION:	Now.
FROM OFF:	Go
FROM OFF:	to

PANEL TWO: CLOSE-UP ON KOBIK--GLOWY, CREEPY--SPEAKING.

KOBIK:	Sleeee

PANEL THREE: SAME EXACT AS PANEL ONE (LITERALLY, JUST LET THE COLORIST STAT IT AND DO THE WORK)--BUT THE LEFT THIRD OF THE GROUP (DOESN'T MATTER WHO, SO LONG AS QUICKSILVER'S PART OF IT) IS NOTHING BUT A BLUR ZOOMING OFF-LEFT.

PANEL FOUR: SAME AS TWO.

KOBIK:	eeeee

PAGE FIVE

PANEL ONE: SAME AS PANEL THREE ON PREVIOUS PAGE, BUT THE LEFT THIRD IS EMPTY--AND NOW THE RIGHT THIRD BLURS OFF TO THE RIGHT. (WHAT WE'RE SEEING IS A FROZEN SPLIT-SECOND IN WHICH QUICKSILVER IS EVACUATING THE HEROES FROM THE AREA AT SUPER-SPEED.)

PANEL TWO: SAME CLOSE-UP OF KOBIK AS BEFORE.

KOBIK:	eeeee

PANEL THREE: SAME AS PANEL ONE, BUT NOW THE LEFT AND RIGHT THIRD ARE EMPTY AND THE GROUP IN THE MIDDLE IS NOTHING BUT A COLORED BLUR

BEING ZOOMED OFF.

PANEL FOUR: SAME AS PANEL TWO.

 KOBIK: eeeep--

 KOBIK: ?

PAGE SIX

PANEL ONE: KOBIK, PUZZLED, SURVEYS THE AREA. SHE'S ALONE.

PANEL TWO: ELSEWHERE IN TOWN (YOUR CALL). MS. MARVEL, SURPRISED, WINDBLOWN, IS DROPPED BY A BLUE BLUR (ENTERING AND EXITING) NEXT TO SPIDER-MAN, SYNAPSE AND TORCH.

 MARVEL: Who is--

 MARVEL/small: --that girl--?

 MARVEL: Wait. Where are we--

PANEL THREE: SIMILARLY, AT THE ZOO (SAME BLUE BLUR ENTERING AND EXITING), IRON MAN FINDS HIMSELF NEXT TO THOR, ROGUE AND CABLE.

 IRON MAN: --NOW?

PANEL FOUR: LAST GROUP--DEADPOOL, VISION, NOVA AND VOODOO, WHEREVER YOU LIKE. THE BLUR, SLOWING TO SHOW ITSELF AS QUICKSILVER, SKIDS TO A STOP BEFORE THEM.

 QUICKSILVER: I got us AWAY from her as quickly as POSSIBLE.

 QUICKSILVER: Until we know what's going on--or who or what has CHANGED us--

 QUICKSILVER: --I thought it best that we not amass as one large target.

PAGE SEVEN

PANEL ONE: FROM THE SHADOWS, HEAVILY SHADOWED AND SINISTER SUPERVILLAINS LURK/WATCH/EAVESDROP: <u>DIAMONDHEAD</u> AND <u>THE LIVING LASER</u>. AGAIN, HEAVILY SHADOWED, DON'T FEEL LIKE YOU HAVE TO GO NUTS WITH DETAIL. THIS AND NEXT PANEL ARE JUST TO ESTABLISH THAT VILLAINS ARE WAKING UP AND SCOPING OUT TARGETS--TO GIVE AN OMINOUS SENSE OF GROWING MENACE SURROUNDING OUR UNSUSPECTING HEROES.

> QUICKSILVER/off: We don't know who may be AFTER us.

PANEL TWO: VOODOO, VISION.

> VOODOO: Vision, you were saying something a moment ago about detecting a certain ENERGY...?

> VISION: Strikingly similar to that of a COSMIC CUBE--an artifact of reality-bending POWER.

PANEL THREE: NOVA, AMUSED, LOOKS AT VISION LIKE HE'S IMPRESSED AS QUICKSILVER BLURS OFF AND AWAY.

> VISION: Traditionally, however, it does not take the form of a small CHILD.

> NOVA: Did you just make a JOKE? Am I SURE I'm awake?

PANEL FOUR: QUICKSILVER RACES PAST SPIDER-MAN'S GROUP TO INFORM THEM.

> QUICKSILVER: Synapse, you're a telepath. Relay our conversations across all groups, please.

> QUICKSILVER: Vision suggests there's a Cosmic Cube in play somehow.

PAGE EIGHT

PANEL ONE: HE SKIDS TO A STOP BEFORE IRON MAN'S GROUP.

> QUICKSILVER: Our APPEARANCES have been altered, but our memories have been restored--

> QUICKSILVER: --and those of us with natural abilities still RETAIN them.

> IRON MAN: That's no small advantage.

PANEL TWO: FROM ANOTHER NEARBY SPOT, SAME CREEPY FROM-THE-SHADOWS LURKING OF <u>MEGATON</u> AND <u>GYPSY MOTH</u>--LOOKING ON WITH SINISTER INTENT, SIZING UP THEIR PREY.

> MEGATON/whisper: Avengers? Unity Squad? Looks like BOTH.

> MEGATON/whisper: Pass it ON.

PANEL THREE: TORCH LOOKS AT A SMALL BUILDING CLEARLY SIGNED UP AS THE PLEASANT HILL POST OFFICE.

> TORCH: Our powers haven't kept us from being PUPPETS so far.

> TORCH: Last thing I remember, we were all summoned to SLEEPYTOWN here by Steve Rogers and Sam Wilson. I THINK that was LEGIT--

PANEL FOUR: CABLE SEES THE TWO MARIA HILLS FROM LAST ISSUE RUNNING TOWARDS HIM, CALLING OUT TO HIM. THEY LOOK FRIGHTENED.

> CABLE: --but the two Maria Hills who ESCORTED us here were certainly NOT.

> CABLE: Here they COME. Stand at the READY--!

PAGE NINE

PANEL ONE: ON THE HILL "TWINS," RUNNING UP TO CABLE'S GROUP, PANICKED, FRANTIC, PLEADING FOR HELP.

> HILL #1: NO! You don't understand!

> HILL #2: You have to HELP us! We're
> PRISONERS just like YOU! <u>DON'T LET HER
> NEAR US</u>!

PANEL TWO: THOR AND ROGUE POSE PROTECTIVELY IN FRONT OF IRON MAN AND CABLE--THOR, EVEN IN CIVILIAN GARB, HAS THOR-STRENGTH, AND ROGUE'S GOT HER POWERS, TOO, SO THEY'D BE THE FRONT LINE AGAINST ATTACKS.

> THOR: Who? The GIRL?

> HILL #1: We're not who you THINK we
> are! NO one is in Pleasant Hill!

PANEL THREE: THE TWO MARIA HILLS, STILL PLEADING FRANTICALLY, TEAR AWAY AT THEIR SKIN AND HAIR GROTESQUELY (LIKE IT'S A COATING

OF SILLY PUTTY) TO REVEAL WHO THEY REALLY ARE--<u>BLOODLUST</u> AND
<u>MINDBLAST</u>.

> HILL #2: The REAL Maria Hill--she's
> CORRUPTED a little girl named KOBIK who
> can rewrite REALITY!
>
> HILL #1: Together, they CREATED
> this town as a HOME for mindwiped
> SUPERCRIMINALS like US!
>
> HILL #1: You KNOW us! She's
> MINDBLAST, I'm BLOODLUST! We fought
> SPIDER-MAN and CAPTAIN AMERICA!

<u>**PANEL FOUR**</u>: SUDDENLY, THE WOMEN BEGIN TO FADE AWAY.

> HILL #2/fades: Kobik REMADE us and
> ordered us to keep you AWAY from Pleasant
> Hill because
>
> FROM OFF/UP: Ssssh.

PAGE TEN

PANEL ONE: CABLE'S GROUP LOOKS UP TO SEE KOBIK HOVERING ABOVE THEM, ENERGY FROM HER HANDS CAUSING MINDBLAST AND BLOODLUST TO COMPLETELY VANISH.

> KOBIK: I just want everybody to CALM DOWN and stop FIGHTING.

> KOBIK: You two are BAD. Back to your ROOMS.

PANEL TWO: KOBIK SPLITS INTO THREE.

> KOBIK/middle: This isn't what's supposed to happen.

> 2nd KOBIK/echo: supposed to happen.

> 3rd KOBIK/echo: supposed to happen.

PANELS THREE AND FOUR: ONE OF THE THREE IDENTICAL KOBIKS HOVERS OVER VISION'S GROUP, ONE OVER SPIDER-MAN'S.

> VISION'S KOBIK: Everyone's supposed to FORGET the ugly world OUTSIDE--

> SPIDEY'S KOBIK: --and be peaceful HERE. But something's WRONG.

> SPIDEY'S KOBIK: The BAD PEOPLE...

PANEL FIVE: TORCH AND HIS GROUP ARE UNAWARE THAT THE LIVING LASER IS BEHIND HIM, GEARING UP TO FIRE ON THEM.

> KOBIK/off: ...they're starting to WAKE UP.

PAGE ELEVEN

PANEL ONE: AS KOBIK WATCHES, THE LIVING LASER CUTS DOWN BOTH TORCH AND SYNAPSE, BRUTALLY. IF WE DIDN'T HAVE A MAGIC LITTLE GIRL TO WISH THEM BACK TO HEALTH BY PAGE 18 OR SO, THEY WOULDN'T LIVE THROUGH THIS.

> SFX: SZAAAAAK

PANEL TWO: BACK TO VISION'S GROUP. VISION SHIELDS NOVA FROM A BARRAGE OF THORNS FROM <u>PLANT-MAN'S</u> GUN.

 VISION: Nova, find COVER!

[Here and throughout, we'll add SFX as needed to final art]

PANEL THREE: AT THE ZOO, <u>MAN-APE</u>, <u>FLYING TIGER</u> AND <u>ARMADILLO</u> CONVERGE ON IRON MAN'S GROUP.

 CABLE: Synapse, we've lost your MINDLINK! Are you THERE?

 CABLE: <u>SYNAPSE?</u>

PAGE TWELVE

PANEL ONE: SPIDEY AND SHRINKING MS. MARVEL DODGE FIRE FROM LIVING LASER.

> MS. MARVEL: Why didn't your SPIDER-SENSE <u>WARN US</u> we were under attack?

> SPIDEY: Are you KIDDING? It's been buzzing non-stop since we came TO!

PANEL TWO: KOBIK, AGHAST, LOOKS DOWN ON WOUNDED, UNCONSCIOUS SYNAPSE AND TORCH.

PANEL THREE: AN EVEN MORE ALARMED AND FRIGHTENED KOBIK WATCHES AS CABLE IS BRUTALLY BODY-SLAMMED BY MAN-APE WITH WHAT WE CAN PRESUME FROM THE FORCE OF IMPACT IS BONE-SHATTERING FORCE. CABLE WON'T BE GETTING UP FROM THIS.

[I'm sure I'll add some brilliantly witty bon mots and snippets of dialogue to these fight moments once the art comes in.]

PANEL FOUR: NOVA GETS STABBED AND TAKEN OUT HARD BY <u>COLDHEART'S</u> ICY SWORDS. KOBIK, ABSOLUTELY TERRIFIED AT WHAT'S BEEN UNLEASHED, IS CRYING. WE REALLY OUGHT TO FEEL SORRY FOR HER AT THIS POINT-- SHE'S ONLY A LITTLE GIRL AND ALL THE CHAOS IS FREAKING HER OUT.

PAGE THIRTEEN

PANEL ONE: THOR AND ROGUE HAVE NO PROBLEM WALLOPING MAN-APE AND FLYING TIGER--

> ROGUE: You okay without your HAMMER?

> THOR: I am UNCOMFORTABLE--and thanks to Kobik's magic, UNCHANGED--

> THOR: --but I still strike like a THUNDER GOD!

PANEL TWO: --BUT THEY'RE THROWN FOR A LOOP WHEN <u>NUKLO</u> LANDS BETWEEN THEM LIKE THE HULK COMING DOWN, SHATTERING THE GROUND!

PANEL THREE: QUICKSILVER AND DEADPOOL PUMMEL ARMADILLO.

> QUICKSILVER: I'll handle THIS one! Go gather the AVENGERS! HURRY!

> DEADPOOL: And miss out on a fight
> with a GIANT ARMADILLO? Are you KIDDING
> me?
>
> QUICKSILVER: <u>GO</u>!

PAGE FOURTEEN

PANEL ONE: MEANWHILE, VOODOO HITS <u>MEGATON</u> WITH MAGIC, BUT MEGATON
SHRUGS IT OFF.

PANEL TWO: THE LIVING LASER SLICES INTO SCREAMING VISION AS PER
PAGE ONE.

PANEL THREE: MS. MARVEL AND SPIDEY RUN FOR COVER AMIDST VARIOUS
EXPLOSIONS/BURST OF ENERGY/ETC.--

PANEL FOUR: --AND, TO THEIR SURPRISE, FIND A VERY FRIGHTENED,
CRYING KOBIK HIDING OUT FROM THE FIGHT.

> SPIDEY: LOOK! There she IS!
> She's just as scared as I--
>
> SPIDEY: --as YOU are! Doesn't
> she have the magic of a
> GOD, pretty much?
>
> MS. MARVEL: She's still a KID! Maybe we
> can talk her DOWN!

PANEL FIVE: SPIDEY AND MS. MARVEL ARGUE.

> SPIDEY: Don't say the WRONG
> THING!
>
> MS. MARVEL: I've GOT this!
>
> SPIDEY: Be CAREFUL!
>
> MS. MARVEL: Look, just be grateful it's
> US doing the talking and not--

PANEL SIX: WHOOM! A GIANT EXPLOSION FLATTENS 'EM BOTH.

PAGE FIFTEEN

PANEL ONE: AS THE SMOKE CLEARS, WE REVEAL DEADPOOL STANDING OVER THEM--OUR "SAVIOR" TO BE, THE ONE WHO'S GONNA HAVE TO TALK KOBIK DOWN.

> DEADPOOL: Uh-oh.

PANEL TWO: CUT BACK TO IRON MAN TRYING TO HELP THE VISION BUT GETTING STRUCK DOWN BY <u>BUSHWHACKER</u>.

PANEL THREE: DEADPOOL CROUCHES DOWN NEXT TO TERRIFIED, SOBBING, HANDS-OVER-HER-EARS KOBIK, STARTS HIS SALES PITCH.

[Award-worthy dialogue from Deadpool to come once I confab with Gerry Duggan for tips.]

PANEL FOUR: BACK TO ROGUE AND THOR GETTING ABSOLUTELY, HOPELESSLY DOGPILED BY <u>NUKLO</u>, <u>GARGANTUA</u>, AND <u>ZZZAX</u>.

PAGE SIXTEEN

PANEL ONE: KOBIK STUTTERS SOMETHING OUT TO DEADPOOL.

> KOBIK: It's nuh-not SAFE anymore,
> this p-place.
>
> KOBIK: I just w-want to buh-be
> SAFE.

PANEL TWO: ELSEWHERE, WHICHEVER HERO YOU LIKE GETTING SMACKED AROUND BY WHATEVER VILLAIN YOU FEEL LIKE DRAWING.

PANEL THREE: RANDOM VILLAINS RAMPAGING. GO NUTS. JUST UNDERSCORE THAT THINGS ARE <u>DIRE</u>.

PANEL FOUR: DEADPOOL, KOBIK. DESPITE HER FEAR, SHE GIGGLES.

> DEADPOOL: YOU want to be safe? A few
> minutes ago, I got punched by a GIANT MONKEY!
>
> KOBIK: Heh.
>
> KOBIK: I like the MONKEY MAN.
>
> DEADPOOL: Somebody's making you do
> all this, aren't they? I know what that's
> LIKE. Wanna SEE?

PANEL FIVE: HALF-CONSCIOUS SPIDER-MAN, UNABLE TO LIFT HIMSELF TO HIS FEET, SEES SOMETHING OFF-PANEL THAT HORRIFIES HIM. HE YELLS, REACHES OUT IN A "NOOOO!" GESTURE.

> DEADPOOL/off: Go ahead. Or, I guess, GO!
> A HEAD!
>
> DEADPOOL/off: Reach IN.
>
> SPIDEY: ?
>
> SPIDEY: ...wait...WAIT...!

PANEL SIX: AS SPIDEY SCREAMS IN HORROR, KNOWING THAT THIS IS THE VERY DEFINITION OF A BAD IDEA, KOBIK LITERALLY REACHES HER HAND INTO DEADPOOL'S HEAD. HE BENDS DOWN, OFFERING THE TOP OF HIS HEAD TO HER TO MAKE IT EASY.

> DEADPOOL: Take a look INSIDE.
>
> SPIDEY/burst: NOOOOOOO!

PAGE SEVENTEEN

PANEL ONE: ELSEWHERE, MORE VILLAIN-ON-HERO SLAUGHTER.

PANEL TWO: BATTERED, RAGGED SPIDER-MAN HAS CRAWLED NEXT TO DEADPOOL. KOBIK STILL HAS HER IMMATERIAL HAND LITERALLY INSIDE DEADPOOL'S HEAD.

> SPIDEY: She's in your brain. We're all going to DIE.

> DEADPOOL: That's up to HER.

> KOBIK: Whoa.

PANEL THREE: KOBIK GAZES AT DEADPOOL IN REVERENT AWE.

> KOBIK: You were a PLAYTHING.

> DEADPOOL: Not LITERALLY...but yeah. Some bad people gave me POWERS, then made me a TOOL.

> SPIDEY/off: PHRASING!

> DEADPOOL: She knows what I mean. And she's got the same PROBLEM.

PANEL FOUR: HAVING WITHDRAWN HER HAND, SHE LETS DEADPOOL CROUCH BEHIND HER AND, LIKE A GOLF COACH TEACHING SOMEONE A SWING, HE MANIPULATES HER GLOWING ARMS TO HELP HER CAST HER NEXT WHAMMY. DEADPOOL'S AND SPIDEY'S COSTUMES ARE BEGINNING TO FADE IN OVER THEM.

> KOBIK: I don't want to be scared anymore.

> DEADPOOL: Then take CONTROL. It's EASY. For YOU, it's a CAKEWALK. You didn't MEAN to, but you made my friends into YOUR toys.

PAGE EIGHTEEN

PANELS: OVER THE COURSE OF THE PAGE, WE CUT TO VARIOUS SHOTS OF OUR HEROES BEING RESTORED TO THEIR HEALTHY, COSTUMED FORMS BY KOBIK'S ENERGIES.

> CAPTION: "Make it RIGHT."

PAGE NINETEEN

PANEL ONE: THOR'S HAMMER BOWLS VILLAINS OVER.

PANEL TWO: IRON MAN TAKES OUT VILLAINS WITH REPULSOR BLASTS.

PANEL THREE: MORE HEROES ON THE UPSWING. CLEARLY, THEY'RE NO LONGER ON THE ROPES.

PANEL FOUR: BACK TO FULLY-RE-COSTUMED DEADPOOL, SPIDEY AND MS. MARVEL. THEY'RE SURPRISED TO SEE KOBIK FADING AWAY.

 MS. MARVEL: Oh, no! Where's she GOING?

 DEADPOOL: Dunno. Maybe she got some sort of CALL.

PANEL FIVE: MS. MARVEL LOOKS DOWN AT HER CELLPHONE.

 PHONE: Bdeep

 MS. MARVEL: Well, so are WE...

PAGE TWENTY

FULL-PAGE SPLASH. STEVE ROGERS AND CAPTAIN AMERICA SIDE-BY-SIDE ON THE STEPS OF PLEASANT HILL TOWN HALL, BELLOWING THEIR CALL TO ACTION.

 CAPTION: "...and it's the call we've been WAITING for!"

 CAPTAIN A/burst: <u>AVENGERS</u>--

 ROGERS/bigger burst:--<u>ASSEMBLE</u>!

 BOTTOM TEXT: TO BE CONCLUDED IN AVENGERS STANDOFF: OMEGA!

 BOTTOM TEXT: And NEXT ISSUE--meet the ALL-NEW WASP!